drawing now

drawing now: eight propositions

laura hoptman

The Museum of Modern Art, New York

Published in conjunction
with the exhibition
Drawing Now:
Eight Propositions,
at MoMA QNS, New York
from October 17, 2002
to January 6, 2003
organized by Laura Hoptman

This exhibition is supported by
The Friends of Contemporary Drawing
of The Museum of Modern Art
and Martin and Rebecca Eisenberg

Additional funding is provided by
Patricia and Morris Orden,
Mondriaan Foundation, Dianne Wallace
and Lowell Schulman, Pro Helvetia,
Dorothy Bandier, Hilary Jane Rubenstein,
and The International Council of
The Museum of Modern Art

The accompanying publication is made possible by an anonymous donor

The accompanying educational programs
are made possible by BNP Paribas

Produced by
the Department of Publications
The Museum of Modern Art
New York

Edited by
David Frankel

Design by
Emanuela Frigerio and Tom Geismar
of Chermayeff & Geismar Inc.

Production by
Marc Sapir

Printed and bound by
Stamperia Valdonega S.R.L., Verona

This book is typeset in
ITC Century Book

The paper is
150 gsm PhoenixMotion Xenon

Published by
The Museum of Modern Art
11 West 53 Street
New York, New York 10019
(www.moma.org)

Library of Congress Control Number:
2002107967

ISBN: 0-87070-362-5

Printed in Italy

Cover: Details of one work by each artist represented in *Drawing Now*, shown
left to right, top to bottom, in the order
in which they appear in the book

contents

preface

The idea for this exhibition was introduced several years ago by Laura Hoptman, then Assistant Curator in The Museum of Modern Art's Department of Drawings. When I joined the Museum as Chief Curator of Drawings, in May 2000, I quickly asked her to proceed with her plans. The Museum has a long history of organizing exhibitions that present a selective overview of contemporary art—the periodic surveys assembled by Dorothy Miller in the 1940s and '50s, for example. It has also periodically attempted to rethink the function and importance of whole fields of artistic practice—as, in the Department of Drawings, Bernice Rose did in her landmark *Drawing Now* exhibition of 1976, and again in *Allegories of Modernism* in 1991. Laura's *Drawing Now* exhibition—guided by a focused idea and a personal point of view, and introducing relatively young and emerging artists to the Museum and to a broad public—is a new analysis in the tradition of these enduring practices.

In the decade covered by this exhibition, drawing has sustained an enormous vitality, unfazed or perhaps in part even energized by the proliferation of mechanical and electronic means of image-making—photography, film, video, the ever growing range of computer technologies. Works we can legitimately call drawings are being made today that could not have been imagined were more traditional practices their only foil. As both concept and craft, drawing is remarkably resilient, residing as closely as any art to the immediacy of the mind, with its recalcitrant and inventive resistance to summation or closure. Yet the strong presence of drawing in contemporary art remains relatively unrecognized, because drawings often stay in the galleries' drawers and back rooms, or may not even leave the artists' studios.

This exhibition brings much of the most interesting contemporary drawing into the limelight. It gives the art a public face; it gives the public a conceptual structure for approaching the art. And yet, despite its richness, *Drawing Now* is far from being exhaustive or inclusive—other frameworks would yield equally opulent arrays, so fertile is the field. What the show can and does do is firmly make the case for drawing's renewed importance in contemporary art.

Gary Garrels
Chief Curator, Department of Drawings

acknowledgments

We would like to extend our deepest thanks and appreciation to everyone who has helped in the conception and realization of this exhibition and publication. First and foremost we want to thank the artists in the exhibition: Franz Ackermann, Kai Althoff, Kevin Appel, Los Carpinteros, Russell Crotty, John Currin, Toba Khedoori, Graham Little, Mark Manders, Barry McGee, Julie Mehretu, Takashi Murakami, Yoshitomo Nara, Paul Noble, Jockum Nordström, Chris Ofili, Laura Owens, Jennifer Pastor, Elizabeth Peyton, Neo Rauch, Matthew Ritchie, Ugo Rondinone, Shahzia Sikander, David Thorpe, Kara Walker, and Richard Wright. Without exception they have given time and attention to our queries, both intellectual and logistical, with generosity and graciousness. In many cases they have helped to locate or secure drawings, completed new work, or made works on site for the exhibition.

Drawing Now: Eight Propositions would not have been possible without the generosity of the lenders who agreed to share works from their collections. Their names appear on page 191. It is difficult to part with works that are often lived with closely, and the lenders' willingness to share their works for the exhibition is deeply appreciated.

Among the many who helped to facilitate the exhibition, special thanks go to: David McAuliffe, Angles Gallery, Santa Monica; Alison Jacques and Caroline Hancock, asprey jacques Gallery, London; Tim Blum and Jeff Poe, Blum & Poe, Santa Monica; Gavin Brown, Corinna Durland, and Frederique Baumgartner, Gavin Brown's enterprise, New York; Sadie Coles, Sadie Coles HQ, London; Jeffrey Deitch and Julia Chiang, Deitch Projects, New York; Gerd Harry Lybke, Galerie EIGEN + ART, Leipzig and Berlin; Kanisha Raja, Kenneth Freed Collection, Boston; Kay Pallister in conjunction with Gagosian Gallery, London; Carol Greene, Greene Naftali Gallery, New York; Anton Kern and Fernanda Arruda, Anton Kern Gallery, New York; Tomio Koyama, Tomio Koyama Gallery, Tokyo; Matthew Marks and Adrian Rosenfeld, Matthew Marks Gallery, New York; Thilo Wermke and Alexander Schröder, Galerie Neu, Berlin; Tim Neuger, Burckhard Riemschneider, and Salome Sommer, neugerriemschneider, Berlin; Kris Kuramitsu, Curator of the Norton Family Collection, Santa Monica; Maureen Paley and James Lavander, Maureen Paley Interim Art, London; Christian Haye, Jenny Liu, and Lori Salmon, The Project, New York; Alessandra Soldaini, Fondazione Prada, Milan; Shaun Caley Regen and Lisa Overduin, Regen Projects, Los Angeles; Andrea Rosen, Sarah Cohen, and Laura Mackall, Andrea Rosen Gallery, New York; Mark Coetzee, Director, Rubell Family Collection, Miami Beach; Shannon Timms, Shoshana Wayne Gallery, Santa Monica; Brent Sikkema, Michael Jenkins, and Ellie Bronson, Brent Sikkema, New York; Richard Telles, Richard Telles Fine Art, Los Angeles; Frank Demaeghd, Zeno X Gallery, Antwerp; and David Zwirner, Bella Hubert, Angela Choon, Hanna Schouwink, Amy Davila, and Eugenia Lai, David Zwirner Gallery, New York.

For the publication we owe a special thanks to the book's designers, Tom Geismar and Emanuela Frigerio of Chermayeff & Geismar Inc. With insight, focus, patience, and tenacity, they transformed abstract ideas into a book that would bring this work to a wide audience.

The exhibition would not have been possible without the inspiration, encouragement, and financial support of the Friends of Contemporary Drawing, a group affiliated with the Department of Drawings and founded by the collector Patricia Orden. Several of its members, including Dorothy Bandier, Martin and Rebecca Eisenberg, Morris and Patricia Orden, Hilary Jane Rubenstein, and Dianne Wallace, made individual contributions for the exhibition, and one member who wishes to remain anonymous provided imaginative leadership and the funds to produce and publish the catalogue. The enthusiasm, knowledge, and commitment of this group are without peer. Financial support has also come from other individuals and organizations noted in this book, and we are deeply grateful for their excitement about the project.

At The Museum of Modern Art, Glenn D. Lowry, Director, provided early and sustained encouragement. His commitment to new art and artists as vital parts of the Museum's program is deeply appreciated.

I would like to acknowledge Museum staff across many departments for their invaluable con-tributions to the production of the exhibition and book: Michael Margitich, Deputy Director for External Affairs; Jennifer Russell, Deputy Director for Exhibitions and Collections Support; Maria De Marco Beardsley, Coordinator of Exhibitions, and Carlos Yepes, Assistant Coordinator of Exhibitions; Jerome Neuner, Director of Exhibi-tion Design and Production, Mari Shinagawa-Thanner, Production Manager, and Peter Perez, Framing Conservator, in the Framing Department; Michael Maegraith, Publisher, Marc Sapir, Director of Production, Harriet Schoenholz Bee, Editorial Director, and David Frankel, Senior Editor; Monika Dillon, Director of Development, Jennifer Grausman, Manager, Exhibition Funding, and Mary Hannah, Development Officer; Ramona Bronkar Bannayan, Director of Collections Management and Exhibition Registration, and Terry Tegarden, Associate Registrar; Pete Omlor, Manager of Art Preparation and Handling, and the preparators; our conservators Karl Buchberg and Erika Mosier; Stephen Clark, Associate General Counsel, and Nancy Adelson, Assistant General Counsel; Kim Mitchell, Director of Communications, and Daniela Carboneri, Senior Publicist; Josiana Bianchi, Public Programs Coordinator; Deborah Schwartz, Deputy Director for Education, and Francesca Rosenberg, Assistant Director, Department of Education; Ed Pusz, Director, Burns Magruder, Senior Designer, and Claire Corey, Production Manager, Department of Graphic Design; Mikki Carpenter, Director of Imaging Services, Erik Landsberg, Head of Collections Imaging, Tom Griesel, Fine Arts Photographer, and John Wronn, Fine Arts Photographer; Katherine Krupp, Paper Products Manager, MoMA Retail; Ethel Shein and the Special Programming and Events Department; and Carol Coffin, Executive Director, International Council. Everyone on the staff of the Department of Drawings has worked on and contributed to this project: Kathleen Curry, Assistant Curator for Research and Collections; Kristin Helmick Brunet, former Assistant Curator; Michelle Tirado, Department Coordinator; Lauren Harrar, Secretary; and David Moreno, Preparator. I would also like to acknowledge the assistance of our interns Isabel Erban, who toiled for almost a year on the initial research for the exhibition; Elli Kanata, who put in almost as much time further

along in its development; and Ildiko Haffner, who helped enthusiastically on various tasks in the project's final stages. We extend our warm appreciation to everyone on this team.

Special thanks and recognition are due to two members of the Museum staff. David Frankel, Senior Editor, Department of Publications, not only brought sharp incisiveness to the text but bolstered and deepened its content through his engagement with its ideas and his dedication of thought and time; and Francesca Pietropaolo, Curatorial Assistant, Department of Drawings, assumed the greater responsibilities for the exhibition with Laura Hoptman's departure from the Museum. Francesca brought intelligence and diligence, imagination and grace to complex and often daunting tasks.

Finally I would like to thank my former colleague Laura Hoptman. In midstream on *Drawing Now* Laura accepted the position of Curator of Contemporary Art at the Carnegie Museum of Art, Pittsburgh, and almost immediately had to set the gears in motion for the next Carnegie International exhibition. She had crystallized the concept of the exhibition, and the selection of artists and works, before she accepted her new post, but a project that includes many living artists, some of them making new works specifically for the exhibition, invariably takes many turns. Laura stayed involved to finalize the selection of works, to contribute to this book, and to oversee the installation of the exhibition, fulfilling a vision begun under very different circumstances. I thank her for the commitment and imagination she has given to this project and for her many years of work at The Museum of Modern Art.

Gary Garrels

The idea for this exhibition was born almost seven years ago, at the same moment that Patricia Orden, a fiercely devoted connoisseur of drawing and a steadfast friend of The Museum of Modern Art, inaugurated the Friends of Contemporary Drawing, a group dedicated to the development of the Museum's collection of contemporary works on paper. Patricia, her husband Morris, and some thirty other members who have lent their energy and expertise to the Department of Drawings deserve the credit for the initial energy to create a contemporary drawing show. The Department's previous Chief Curator, Margit Rowell, was an early advocate, and colleagues from the Department of Painting and Sculpture, most notably Robert Storr, Senior Curator, Lilian Tone, Assistant Curator, and Paulo Herkenhoff, Adjunct Curator, gave kind advice. Outside the Museum, I owe Cornelia Butler, whose exhibition *Afterimage: Drawing through Process* (at the Museum of Contemporary Art, Los Angeles, in 1999) was a catalyst for the show, my thanks for her inspiration. Amada Cruz, Werner Kramarsky, and Lynn Zelevansky also supplied opinions and advice.

Last but not least, I must not only reiterate my profound thanks to all of those mentioned above by Gary Garrels but must also thank Gary himself. Upon his arrival as Chief Curator, Gary was immediately supportive of the exhibition, and was a crucial collaborator in refining and creating the organizational structure for the show. It is safe to say that without his active advocacy the exhibition would not have come to fruition. For this, and for his passionate devotion to the cause of contemporary drawing, I owe him my deepest thanks.

Laura Hoptman

introduction:

drawing is a noun

It is possible to envision a time when there wasn't oil painting (before the fifteenth century), or video art (before 1964), but drawing seems to have been with us always. Barnett Newman swore that the first man, who happened to be an artist, made a line in the dirt with a stick, creating the first drawing and simultaneously the first artwork. For Newman and other postwar modernists, drawing was the most direct and unmediated method of catching the creative process as it happened. Even through the changes in American and European art in the 1960s, the core of this view endured in a new emphasis on drawing that celebrated its purity, its experiential nature, the way it seemed to privilege the artist's hand, its aspect of *non finito*. All of these qualities became synonymous with the term "process," which broadly speaking referred to art that physically bore the traces of its own making over time. "There is no way to make a drawing—there is only drawing," Richard Serra remarked in a well-known interview. "Anything you can project as expressive in terms of drawing—ideas, metaphors, emotions, language structures—results from the act of doing." Simply put, for Serra and for many artists of his generation, "Drawing is a verb."[1]

This celebration of drawing's perpetual state of becoming made for a rich flowering of work in the late 1960s and early '70s, when the materiality of the art object underwent a profound reassessment. Freed from the confines of the page, drawing seemed to be everywhere—in scarifications of the landscape, in site-specific installations, in performance. The actions that went into these works—actions like scratching, scattering, walking—manifested a kind of drawing, but even as artists engaged in these

metaphoric and ephemeral acts of draftsmanship, many of them also continued to use the more conventional medium of pencil and paper as a means of transcription. By diagramming their performances and recording their installations, artists made visible and concrete what could not be considered material. This idea of drawing as an analogue to activity became essential to the development of Conceptual art, and it continues today among post-1980s conceptualists as the preferred method of translating artful actions into art objects.

Pamela Lee has written that to say "drawing is process" is almost tautological, for "nothing could seem more obvious than the way in which drawing registers the process of the artist's making."[2] Perhaps, however, this notion of drawing as process should be seen as developing from specific moments in time and taste, rather than as a given. In fact the history of drawing has seesawed between appreciation of the sketch and of the finished work: if sixteenth-century Florentine connoisseurs prized the *primi pensieri* of the Renaissance masters, the French collectors of the early eighteenth century competed hotly for "presentation drawings" by master draftsmen like Watteau. Individually mounted, drawings of this kind were framed or kept in volumes arranged by school, subject (landscape, seascape, grotesque), or category (academic drawing, architectural drawing, ornamental drawing). By 1745, connoisseurs had returned to prizing works that revealed the first glimpse of the artist's genius, but finished drawings flourished again in the nineteenth century, particularly in England, with the Pre-Raphaelites. The appreciation of process-oriented work returned with renewed strength in the

twentieth century, reaching its apogee over the last fifty or so years.

After a hiatus in the 1980s, the 1990s ushered in an efflorescence of contemporary drawing not seen since the heyday of Post-Minimalism. A significant number of these drawings of the last decade, however, challenge many of the givens so carefully husbanded over the past half century. Although the works in *Drawing Now: Eight Propositions* vary tremendously in technique, medium, size, scale, and imagery, they share a similar rejection of the orientation toward process, exhibiting more affinities with nineteenth-century drawings than with the graphic effusions of American artists in the 1970s. By and large these drawings are finished and autonomous and to some degree representational. They are also what Yve-Alain Bois has called "projective," that is, they depict something that has been imagined before it is drawn, as opposed to being found through the process of making.[3] Since many of the works are both descriptive and narrative, affinities with popular illustration should come as no surprise; other works share the techniques and formal vocabularies of varieties of precision drawing elsewhere considered industrial or commercial. Such close relationships to popular cultural forms, architectural plans, scientific drawing, ornamental embellishment, and vernacular and fashion illustration further distance these drawings from process-oriented work, which exists entirely in the realm of "art." To generalize, the artists in this exhibition are creating a kind of drawing that refers as much to the language of life around us as it does to fine art—that can communicate information, narrate a story, create a scenario, or conjure a world or a system of belief. With all respect to Serra, for many artists today drawing is not a verb but a noun.

The present exhibition contains over 200 works on paper by twenty-six artists from Europe, Asia, and the Americas. It does not pretend to cover all of the important drawing being made today, but it does represent a significant strain of this work as practiced by some of the strongest artistic voices of the past decade. It also marks a moment when drawing has become a primary mode of expression for the most inventive and influential artists of the time. Much as in the drawing albums composed with such discipline by eighteenth-century collectors, the arrangement of the works in this book is devised as a kind of taxonomy of current drawing, not only singling out the significant techniques and genres of the past several years but proposing a way to look at the field's recent history. The "Eight Propositions" of this structure argue for the renewed importance of drawing in the discourse of recent contemporary art. As these works so clearly display, what once was becoming has become.

1. Richard Serra, quoted in Lizzie Borden, "About Drawing: An Interview," 1977, in *Richard Serra: Writings, Interviews* (Chicago: at the University Press, 1994), p. 51.
2. Pamela M. Lee, "Some Kinds of Duration: The Temporality of Drawing as Process Art," in Cornelia H. Butler, *Afterimage: Drawing through Process*, exh. cat. (Los Angeles: Museum of Contemporary Art, and Cambridge, Mass.: The MIT Press, 1999), p. 26.
3. See Yve-Alain Bois, "Matisse and 'Arche-Drawing,'" in *Painting as Model* (Cambridge, Mass.: The MIT Press, 1990), pp. 3–64.

one

science and
art, nature
and artifice

jennifer pastor
russell crotty
ugo rondinone

The hand of a great master at real work is never free; its swiftest dash is under perfect government.

John Ruskin, *The Elements of Drawing*, 1857

Behind the impulse to explore natural phenomena by recording them graphically lies the longing to understand something at its deepest level, a desire that might seem to belong to the realm of empirical science but that can also be traced to Romanticism. Careful, minutely detailed renderings of preexisting objects found a new vogue during the nineteenth century, a period when the publication of natural history and medical science manuals, illustrated histories, architectural pattern books, and archaeological and astronomical journals flowered. These works were meant for scientific study, but from the 1840s on they were produced during a period when photography was an increasingly available resource—when a more exact recording method than drawing was at hand. Beyond their documentary purposes, then, the drawings that appeared in these publications seem also to have been made to encourage the aesthetic understanding of the mysteries of the natural world, what the German Romantic philosopher Johann Gottlieb Fichte referred to by the German verb for "knowing," "*sehen*."

Among the most passionate nineteenth-century advocates of drawing from nature was the British aesthete and critic John Ruskin. In his *Elements of Drawing*, an influential manual and treatise published at mid-century and reissued regularly since, Ruskin argued for a kind of drawing whose purpose was to "set down clearly and usefully, records of such things as cannot be described in words, either to assist your own memory of them, or to convey distinct ideas of them to other people." Tellingly, though, he added that nature drawing could be useful "to obtain quicker perceptions of the beauty of the natural world, and…preserve something like a true image of beautiful things that pass away, or which you must yourself leave."[1] Never a mere visual record, the drawing of an object from nature was for Ruskin almost that object's equivalent.

Contemporary artists like Jennifer Pastor, Russell Crotty, and Ugo Rondinone may strive to know (*sehen*) their natural subjects by drawing them, but they are also aware of the paradox involved in drafting copies of the real thing. Pastor's careful pencil drawings of plant and insect life display the detail that can only come from minute, almost scientific observation. Practicing what has been called "an overstated realism,"[2] Pastor makes renderings so precise that it is difficult to believe they are not taken directly from nature. Yet like her inspiration John James Audubon, the nineteenth-century painter and natural historian who made his stunningly lifelike renderings of birds from setups of specimens that he had killed and stuffed,[3] Pastor does not draw from a living motif; she prefers artificial sources, such as photographs, scientific models, props, and mass-produced decorations. Hybrids more lifelike than their live counterparts, these kinds of photographs and objects are, in Pastor's words, nature made "more fabulous."[4]

In her more recent drawings of the Hoover Dam, the architecture of the inner ear, and a series of motion studies of a rodeo rider on a bucking bull, Pastor is not so much sketching

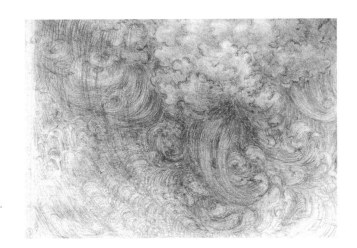

an object as tracing various circulation systems that she renders visually similar, creating what she has termed a "forced equality through drawing."[5] She does not draw the dam, for example, but traces the patterns of the water's movement as the dam manipulates it. Her rodeo studies similarly are less about the rider and his mount than about the parabolic trajectory of the body in motion.

Russell Crotty, a Southern Californian like Pastor, began drawing motion studies almost a decade ago. An amateur astronomer, a passionate nature-lover, and an avid surfer, Crotty used stick figures and a few sure pen-strokes to record observations of surfers, from the moment the board hit the wave crest to its plunge through the curl. Arranged sequentially like a series of hand-drawn film strips on a large sheet of paper gridded out like a Minimalist painting, these works had a quasi-scientific aura to which the artist readily admits: "There's taxonomy here," he has said, "there's levels of collecting images, ordering them."[6] A practitioner who surfs only at night, the better to be alone with and part of the sea, Crotty drew not just to understand the waves but, in a Romantic sense, to understand them viscerally and experientially.

Crotty is perhaps best known for his journals of astronomical observations, a project he began after abandoning the surfer drawings. A member of the Association of Lunar & Planetary Observers (ALPO), he watches the stars from a homemade observatory perched on a cliff in Malibu and transcribes what he sees into custom-made bound "atlases" that can range from a few inches to several feet in length. Crotty records planetary activity and phenomena such

as comets in a chiaroscuro drawing style of pen-and-ink crosshatches inspired on the one hand by methods of recording lunar observations accepted by ALPO and on the other by underground comics. As in a comic book, he sometimes divides his page into individual panels and sometimes spreads out entire nightscapes luxuriously across double pages and gatefolds, creating an almost panoramic view.

Since virtually all astronomical data is today collected by computer, Crotty's kind of stargazing is fundamentally a nineteenth-century pastime. The giant atlases are another throwback, to books like the codices of Leonardo — one-of-a-kind volumes produced for the delectation of committed amateur scientists and connoisseurs alike (fig. 1). Signing some of his atlases with the quaint appellation "Principal Investigator" (a term still used among astronomers), Crotty acknowledges the anachronism of his project, citing the nineteenth-century naturalist and adventurer John Muir as his primary inspiration. A conservationist *avant la lettre*, Muir attributed individuality and personality to plants, flowers, and trees, and argued forcefully for preserving them in their natural habitats. For Crotty the telescope is a tool to bring him as close as possible to the stars, and the astronomical observations he records are not merely data but evidence of his experience with (not in front of) nature. Said Crotty recently, standing on a high peak in Malibu and squinting at the night sky, "What is this? This is not an intellectual construct. This is actual."[7]

In a sense, Crotty's quest for an authentic outdoor experience is the opposite to that of the Swiss artist Ugo Rondinone, although both

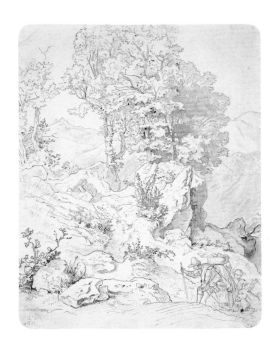

2. Ludwig Richter. *Serpentara.* 1825. Sepia, bistre, and watercolor on paper, 11¼ x 8⅝" (28.5 x 22 cm). Kupferstichkabinett der Akademie der bildenden Künste, Vienna

sketch directly from nature. Beginning in 1989, Rondinone began packing a tiny sketchbook, locking his Zurich studio, and taking Alpine walks. The tradition of sketching tours of the Alps is a long and venerable one that begins with Albrecht Dürer. At the beginning of the nineteenth century the writings of German Romantic philosophers and of authors like Ludwig Tieck, whose novel *Franz Sternbalds Wanderungen* (Franz Sternbald's travels, 1798) chronicles the adventures of a pupil of Dürer's who comes of age as an artist by walking from Nuremberg to Rome, inspired hordes of artists to take to the hills, experiencing nature firsthand by sketching it. These *Wandermäler* (wandering painters), as they came to be known, produced a distinctive kind of landscape drawing: eschewing awesome vistas for more picturesque scenes of craggy knolls and tumbledown shacks, they drew highly finished, detailed compositions in pen and ink, outlining forms and inking in dramatic contrasts of light and dark (fig. 2). Pen-and-ink *vedute* of outdoor scenes, drawn for touristic or commercial purposes, were common by the middle of the nineteenth century.

Rondinone uses a similar technique—writ large—and his enormous scenes of bosky woods and charmingly rotting bridges might at first be mistaken for ironic appropriations of stock illustrative drawings from the genre of the nineteenth-century picturesque. But Rondinone's drawings in fact come directly from nature; true topographical renderings, they are careful enlargements of sketches he has made on his mountain walks. However, if the *Wandermäler* went hiking on a quest for oneness with nature, Rondinone undertakes his journeys to bring him closer to art.

The division between the scientistic renderings of Pastor and Crotty and the modeled pictorial approach of Rondinone mirrors a nineteenth-century polemic that pitted the accurately observed rendering of nature against that which "derived meaning not from 'laws' and the 'tree of knowledge' but from what Ruskin called 'local association and historical memory.'"[8] According to Ruskin's *Elements of Drawing*, nature could not be recorded exactly, but the light and dark shading of masses in space produced the effects closest to it, and thus offered the only way to depict it in drawing. Rondinone adopts the light/dark method not just for its old master connotations but because it signifies how nature is drawn art-historically. He likewise chooses scenes resembling those in picturesque art. Committed to the artificial as the most honest method of depiction, Rondinone presents in his gargantuan nature studies a kind of natural depiction of fine art(ifice).

1. John Ruskin, *The Elements of Drawing*, 1857 (reprint ed. New York: Dover Press, 1971), p. 25.
2. Susan Kandell, "An Interview with Jennifer Pastor," *Index Magazine*, June 1996, p. 29.
3. See Amada Cruz, "Blatant Artifice," in *Jennifer Pastor*, exh. cat. (Chicago: Museum of Contemporary Art, 1996), p. 16.
4. Jennifer Pastor, quoted in David A. Greene, "Openings: Jennifer Pastor," *Artforum* 35, no. 1 (September 1996): 99.
5. Pastor, in an interview with the author, Los Angeles, November 28, 2000.
6. Russell Crotty, in an interview with the author, Los Angeles, February 14, 2001.
7. Crotty, quoted in Hunter Drohojowska-Philp, "Drawing the Universe," www.artnet.com/magazine/reviews/drohojowska-philp/drohojowska-philp3-20-01.asp.
8. David Brett, *C. R. Mackintosh: The Poetics of Workmanship* (Cambridge, Mass.: Harvard University Press, 1992), p. 50.

SPACE
OF BODY
BTWN WINGS

CLEAR

END BODY

63%
ANTENNA

1. Jennifer Pastor
Study for *Spring.* 1996
Ink and pencil on paper,
18 x 12½" (45.7 x 31.8 cm)

2. Jennifer Pastor
Study for *Fall*. 1995
Ink on paper,
24 x 16" (60.9 x 40.6 cm)

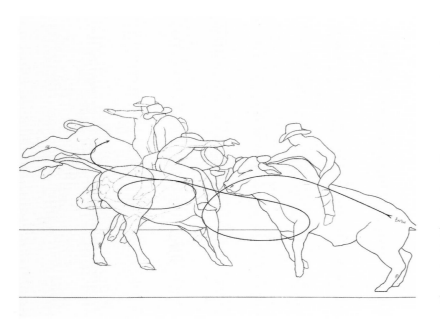

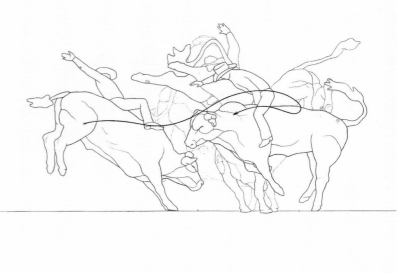

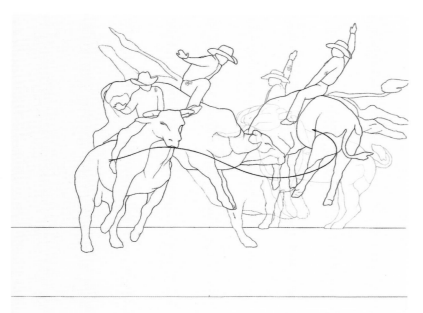

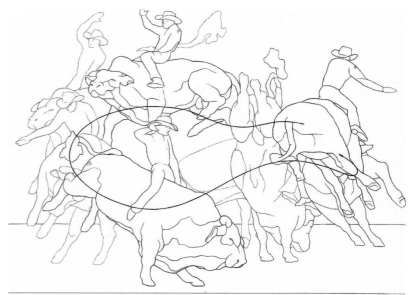

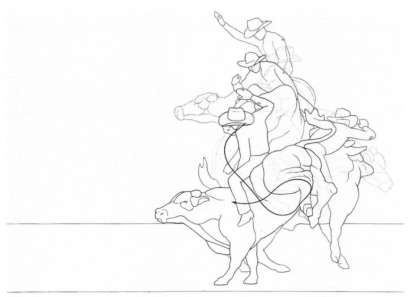

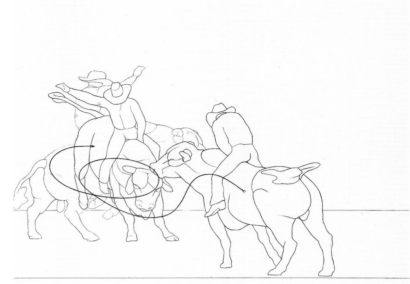

3–9. Jennifer Pastor
*Flow Chart for the "Perfect Ride"
Animation.* 1999–2000
Pencil on paper, seven sheets,
each 13½ x 17" (34.3 x 43.2 cm)

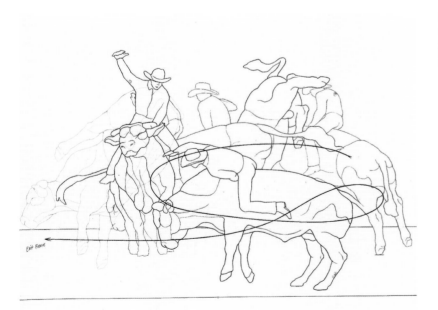

10. Russell Crotty
Five Nocturnes. 1996
Ink on paper in bound book,
one of five drawings,
closed: 62 x 31½ x 2" (157.5 x 80 x 5.1 cm),
open: 62" x 9' 9" (157.5 x 297.2 cm)

11. Russell Crotty
Five Nocturnes. 1996
Ink on paper in bound book,
one of five drawings,
closed: 62 x 31½ x 2" (157.5 x 80 x 5.1 cm),
open: 62" x 9' 9" (157.5 x 297.2 cm)

12. Ugo Rondinone
No. 135 VIERTERJUNINEUNZEHNHUNDERT-
NEUNUNDNEUNZIG
(No. 135 Fourthofjunenineteenninetynine). 1999
Ink on paper, 6' 7" x 9' 10" (200.6 x 299.7 cm)

13. Ugo Rondinone
No. 249 EINUNDZWANZIGSTER-
SEPTEMBERZWEITAUSENDUNDEINS
(No. 249 Twentyfirstofseptember-
twothousandandone). 2001
Ink on paper, 6' 7½" x 9' 10" (201.9 x 299.7 cm)

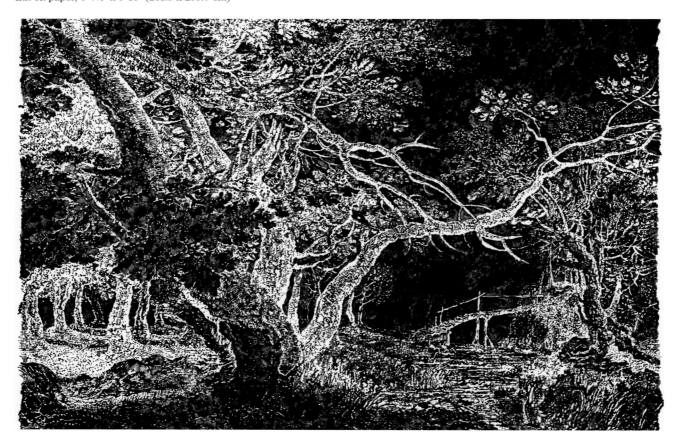

ornament and crime: toward decoration

laura owens
chris ofili
richard wright

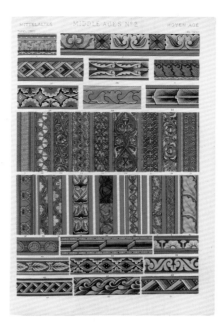

1. Page from Owen Jones. *The Grammar of Ornament*. 1856. Reprint ed. London: B. Quaritch, 1868

"Ornament was never a problem until the Victorians made it one," writes Sir John Summerson, "This is when ornament became an issue, not an irrational outpouring."[1] The nineteenth-century discourse of decoration pitted the scientific concept of two-dimensional designs loosely based on the accurate, analytical drawing of forms found in nature against a pictorial approach that also favored scientific accuracy but encouraged reliance on painterly effects like light and dark shading, producing the illusion of three-dimensionality.[2] John Ruskin, apostle of the nature sketch, favored the latter; advocates of the former position included the architect Owen Jones, whose book *The Grammar of Ornament* (1856), a handbook of decorative motifs from around the world, defined ornament as the platform upon which styles across the globe could intermix (fig. 1). Modeled on methods of comparative biology, *The Grammar of Ornament* argued that all ornament, internationally and throughout the ages, held in common certain characteristic shapes, patterns, and rhythms. With a fervor that would spark both William Morris's utopian experiments[3] and the Victorian designer Christopher Dresser's characterizations of ornament in moral terms,[4] Jones described his lexicon of decoration as an artistic Esperanto—a vast language that was universally relevant and comprehensible.[5]

If, in the nineteenth century, the issues around ornament had to do with values like honesty, integrity, naturalness, and authenticity, by the early twentieth century the decorative, among the more advanced designers, had become synonymous with all that was superficial, unsophisticated, and popular in the word's most pejorative sense. In 1908, the Austrian modernist architect Adolf Loos published an influential essay that famously equated ornament with crime: "Weep not…," he wrote, "We have vanquished decoration and broken through into an ornamentless world."[6] Echoing Loos, Le Corbusier wrote in 1925 that "the more cultivated a people becomes, the more decoration disappears."[7]

This prejudice against decoration continues to linger in the discourse of contemporary art. In an essay that explores, and lauds, the polymorphous painting style of the Los Angeles artist Laura Owens, Russell Ferguson contrasts what he calls the artist's "significant form" with "decoration," observing that her integration of fabric patterns into her collages is "part of a more general inclusiveness that regards any possible way of covering the surface of the canvas as equally available and equally legitimate."[8] To question the seriousness or even the legitimacy of decorative form is a modernist given—a received notion that has somehow survived through the last few decades of art-critical housecleaning. Owens, Chris Ofili, and Richard Wright recognize their use of ornament as the challenge that it is, and to a certain extent see it not so much as transgressive (as some American painters of the 1970s had) or ironic (like the appropriated patterns of 1980s painters like Philip Taaffe) but rather as aesthetically or socially ameliorative. They embrace decoration cheerfully but wield it knowingly.

Owens's drawings, whether they are cheeky homages to vinyl wallpaper and Marimekko fabrics or detailed interpretations of nineteenth-century *toiles de joie*, are meant to press art-critical buttons, and do. "Such work may not be intended as decoration," one critic observed

recently, "but it comes close enough to keep the situation off-balance and somewhat disturbing."[9] Owens specializes in depictions of innocence; her unrepentant joy in flora, pale pastels, and jaunty patterns cannot be mistaken for ironic appropriation.[10] Over the past several years her favorite subject matter in her gouaches, collages, and drawings has been flowers, rendered in a number of styles that range from a formally rigorous geometry suggesting Shaker ornament or a flat-form *japonisme* to a full-blown trompe l'oeil.

In 2001, Owens made a curious drawing of an elaborately decorated oval wall mirror, omitting the mirror itself. It is as if the work's expected subject had been removed to make way for its real subject—the carefully drawn and colored fronds and flowers, closely inspired by eighteenth- and nineteenth-century European textiles, that frame the void in the work's center. With drawings like this, claims a critic, "A new level of crisis is achieved, as though the work were escaping a conventional paradigm for being understood as art."[11] This is exactly Owens's triumph.

Ornament is one of a number of weapons in the arsenal that the British artist Ofili uses to upset convention. He is perhaps best known for using balls of elephant dung to decorate the surfaces of paintings already resplendent with beads, glitter, West African textile patterns, and cutouts from glossy magazines. In his works on paper, particularly in a series of large pencil drawings produced over the past five years, Ofili draws a signature ornament of his own—an "Afro head," a detailed head with a crown of hair, about the size of a grain of rice. Deployed merrily across the paper—marshaled into formations

that silhouette full-size Afro heads, or organized into patterns resembling the notes of a musical score[12]—these motifs are the humorous embodiment of an ornament that is radical in both form and content. In works like *Prince among Thieves with Flowers* (1999), Ofili combines the Afro-head motif with a more traditional one, surrounding his stylized head of a bearded royal with a Victorian-inspired background of delicately drawn flowers. Though not exactly a synthesis of styles, this jumbling of vernacular doodles, West African pattern, and Victorian Arts and Crafts—what Ofili has described as "an approach to making things and looking at things with no hierarchy"[13]—is a hip update of Jones's vision of a grammar of ornament pertaining to the many visual languages of a hybrid world.

In 1989, after working in oil on canvas for ten years, Wright apprenticed himself to a sign painter, concentrating specifically on the art of lettering. He did this, he says, to "get away from the object,"[14] but also to learn the fundamentals of ornament, which he saw as connected to the processes of calligraphy and typography.[15] Wright tells a story of trying to learn French so that he could read Symbolist poetry in the original. Although he reached a point where he could figure out the first two lines of a favorite poem, "There was the entire cultural landscape informing the language that was beyond my reach."[16] Sign painting, it seems, was for Wright the first step toward a method of artmaking that would connect high art to the vernacular.

After his stint as a commercial painter, Wright turned to a mural practice at which he has now been hard at work for over a decade.

Using an ornamental vocabulary that includes
motifs inspired by tattoos, Sienese painting,
Gothic and Celtic symbols, and designs from
Jones's *Grammar of Ornament*, Wright makes
elaborate hybrid drawings freehand on the
wall, using not only the flat surfaces but the
corners where walls meet, or the sites of archi-
tectural details. If architecture frames Wright's
drawings, his work bears an analogy to book
illustration or illumination: just as those
ornaments give structure to the page and make
the text easier to read, so Wright's clarify the
architecture of a space, breaking up the bland
expanse of a white wall—which, like Owens's
drawing of a frame without a mirror, comes
to read like a Psalter page voided of words, with
only decoration remaining.

1. Sir John Summerson, "What Is Ornament and What Is Not," in
 Stephen Kieran, ed., *Ornament*, an issue of *Via III: Journal of the
 Graduate School of Fine Arts, University of Pennsylvania*, 1977, p. 5.
2. See David Brett, *C. R. Mackintosh: The Poetics of Workmanship*
 (Cambridge, Mass.: Harvard University Press, 1992), p. 50.
3. The poet, painter, and craftsman William Morris (1834–96) saw ornament
 as an agent of social change. He started a series of craft guilds and
 factories to produce high-quality handmade goods for sale to the general
 public. Morris's novel *News from Nowhere* (1889) is a vision of a utopian
 future London in which machines have been banished and every object
 used is beautiful as well as useful.
4. Christopher Dresser (1834–1904), who studied both design and botany,
 is perhaps best known for his furniture. Where Morris saw ornament as
 an agent of social change, for Dresser good ornament had an ameliorative
 purpose, a power to "ennoble and beautify." Bad ornament, on the other
 hand, was "base and wrong." See Dresser, *The Language of Ornament:
 Style in the Decorative Arts*, 1876 (reprint ed. New York: Portland House,
 1988), pp. 8–9. This volume, first published in London, was the bible of
 England's Aesthetic movement.
5. See Summerson, "What Is Ornament and What Is Not," p. 5.
6. Adolf Loos, quoted in David Moos, *Theories of the Decorative:
 Abstraction and Ornament in Contemporary Painting* (Edinburgh:
 Inverleith House, Royal Botanic Garden, and Wichita: Edwin A. Ulrich
 Museum of Art, Wichita State University, 1997), n.p.
7. Le Corbusier, "The Decorative Arts of Today," quoted in Moos,
 Theories of the Decorative.
8. Russell Ferguson, *Laura Owens: New Work at the Isabella Stewart
 Gardner Museum* (Milan: Edizioni Charta, and Boston: Isabella Stewart
 Gardner Museum, 2001), pp. 48–49.
9. Carmine Iannacone, "Entertainment Complex," *Frieze*,
 November–December 1999, p. 90.
10. "Owens does not build a critical distance into the way her paintings enter-
 tain questions of style, design or taste," writes Iannacone. This implicates
 her as "a full participant" in the creation of "empty forms." See ibid., p. 91.
11. Ibid.
12. Lisa Grazioso Corrin has noted the similarity of the dot motifs in Chris
 Ofili's paintings to the cave paintings of Matapos, Zimbawe, a country the
 artist has visited. See Corrin and Godfrey Worsdale, *Chris Ofili*, exh. cat.
 (Southampton: Southampton City Art Gallery, and London: Serpentine
 Gallery, 1998).
13. Ofili, quoted in Paul Miller, "Deep Shit: An Interview with Chris Ofili,"
 Parkett 58 (2000), p. 164.
14. Richard Wright, quoted in "Richard Wright and Thomas Lawson in
 Conversation," in *Richard Wright*, exh. cat. (Newcastle upon Tyne: Locus,
 and Milton Keynes: Milton Keynes Gallery, 2000), n.p.
15. Wright, in an interview with the author, New York, October 16, 2001.
16. Wright, in "Richard Wright and Thomas Lawson in Conversation."

15. Laura Owens
Untitled. 2000
Cut and pasted colored
papers, acrylic, pencil, and
watercolor on paper,
39⅛ x 27⅝" (99.4 x 70.2 cm)

16. Laura Owens
Untitled. 2001
Photograph, watercolor, colored
pencil, and collage on paper,
14 x 10" (35.6 x 25.4 cm)

17. Laura Owens
Untitled. 2001
Pencil and watercolor on paper,
30 x 22½" (76.2 x 57.2 cm)

18. Laura Owens
Untitled. 2001
Watercolor and pencil on paper,
44 x 30¼" (111.8 x 76.8 cm)

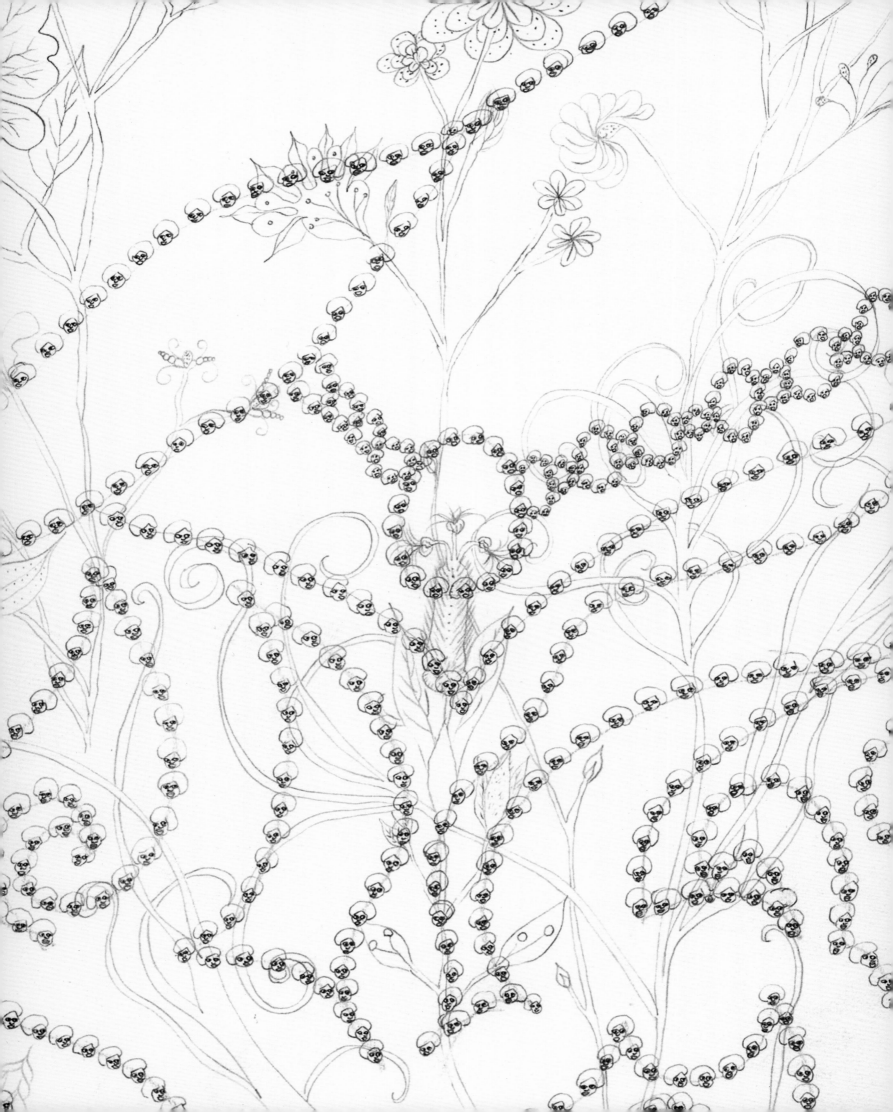

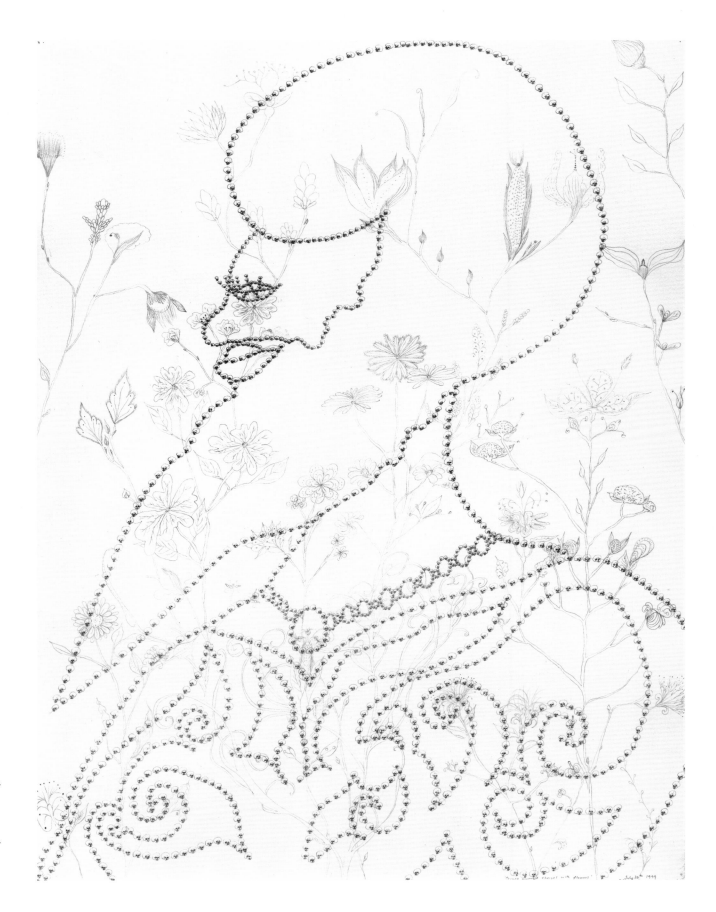

19, opposite: Chris Ofili
*Prince among Thieves with
Flowers*. Detail, actual size

20. Chris Ofili
*Prince among Thieves with
Flowers*. 1999
Pencil on paper,
29¾ x 22¼" (75.5 x 56.5 cm)

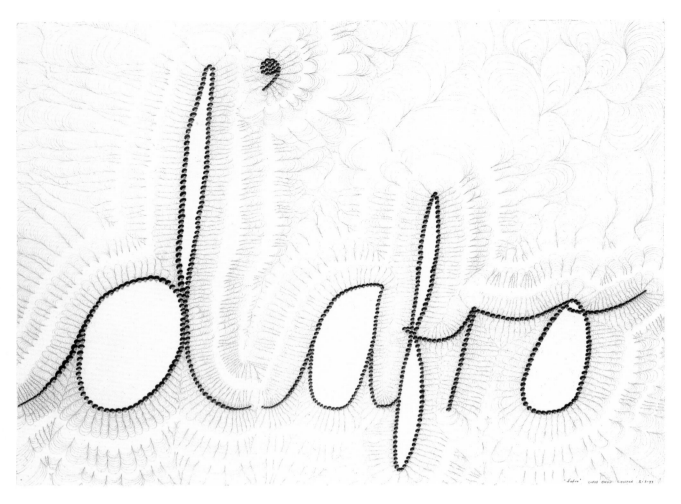

21. Chris Ofili
D'Afro. 1999
Pencil on paper,
20 x 30" (50.8 x 76.2 cm)

22. Chris Ofili
Albinos and Bros with Fros. 1999
Pencil on paper,
22¼ x 29¾" (56.5 x 75.6 cm)

23. Chris Ofili
Untitled (Woman). 2000
Pencil on paper,
30 x 22" (76.2 x 56 cm)

24. Richard Wright
Untitled. 2000
Gouache on wall, dimensions
variable. Installation view,
Gagosian Gallery, New York

25. Richard Wright
Untitled. Detail

26. Richard Wright
Method (detail). 2000
Gouache and gold leaf on wall,
dimensions variable.
Installation view, Talbot Rice
Art Centre, Edinburgh

27, opposite: Richard Wright
Untitled. 1999
Gouache on wall, dimensions
variable. Installation view,
The Drawing Center, New York

three

drafting an architecture

kevin appel
toba khedoori
julie mehretu
los carpinteros

Like language, certain visual conventions are codified by mutual agreement and exist to ease communication. In architectural drafting, for example, drawings of structures in section (exposing the interior), plan (a section from above), elevation (a frontal view of the facade), perspective (in perspectival recession), and so on, are generally agreed-upon conventions. Even the techniques and tools of drafting are conventionalized: line and tonal drawing, using a fine-pointed crayon, pen, or pencil.

Drawing has its own conventions—until recently, the orientation toward process—and the idea that artists might consciously reject one set of conventions only to embrace another, those of architectural drafting, might seem paradoxical. Arguably, however, it is exactly through the visual language of an applied art like architecture that a refutation of drawing's givens might be achieved. The Californians Kevin Appel and Toba Khedoori, the Ethiopia-born New York artist Julie Mehretu, and the Cuban artists' team Los Carpinteros do this by adopting, adapting, and appropriating the language of architectural illustration in diverse ways.

Appel's works might be straight-up architectural perspectives but for their art-world context. Although he is not an architect, he has a dedicated amateur's knowledge of architecture and architectural drawing, and his works on paper are sets of views of imaginary homes he has designed on the computer. Classically modernist with a mid-century-California twist, Appel's single-story open-plan bungalows are beautifully orchestrated compositions of horizontal and vertical planes, lusciously colored and made semitransparent by the use of liquid acrylic rather than paint or ink. Like architectural elevations for structures meant to be built, Appel's compositions exist in sequential groups of four, each a directional view from a certain compass point. The invention of computer imaging techniques for architectural drawing has been compared in importance to the discovery of paper,[1] in large part because the computer offers three-dimensional as well as two-dimensional visualization, allowing the easy manipulation of planes between dimensions. Appel's drawings virtually illustrate this potential, achieving a transparency that allows a distinction between masses and voids rivaling that of the traditional ink and vellum.

So close are Appel's images to architectural drawings that the buildings they depict could perhaps be built.[2] Khedoori's structures—bridges, buildings, architectural details—are not supposed to be. Khedoori has worked exclusively on paper since 1988, using a cold clear style reminiscent of technical drafting. Although she never trained as an architect, her tools are T-squares, fine-line pens, and others associated with the applied arts, and her compositions have the look of architectural illustration. The drawings are large in scale and minute in detail, their motifs placed in careful two-point perspective in or near the centers of vast fields of blank paper. Sometimes they cross a carefully delineated horizon. A horizontal line was a delineator of illusionistic space for the old masters, and it remained a firm spatial cue, moving between two and three dimensions, until modern artists reinterpreted it as a trace of the movement of the artist's body. This rechristening of a spatial marker as a temporal one has been considered, in artist Richard

Serra's words, "the convention of the discipline of drawing."[3] Khedoori explodes this certainty. There is no movement in a Khedoori drawing. A single dark window, a door ajar, a house sectioned like an écorché to expose its interior—each of these images is firmly anchored across a horizon line in an enormous void. For the architectural historian Anthony Vidler the result is an "autodidactic" kind of perspective that eschews conventional perspective's "laws and underlying principles." Isolated in space and frozen in time, Khedoori's allusive images "reject all appeals to history and narrative."[4] In "their stubborn resistance to history and temporality," writes Vidler, they fail as allegories and even as symbols, so alienated are they "from ideal worlds, past, present or future."[5]

If Khedoori's works fail as allegories of history, they can perhaps be interpreted as allegories of drawing, metaphors for rational techniques of picturing space and ordering the world. If Appel uses advanced technological tools to create the illusion of a three-dimensional structure, Khedoori uses the traditional language of architectural drawing to examine minutely—in fact to expose—the elements used to build a house, or an image of one.

Mehretu may work on architect's vellum but she doesn't so much draw plans, elevations, and sections as make them her subject matter. Grabbing images off the computer, she fuses sources that range widely both chronologically and geographically, superimposing airport plans over Palladian facades, weather maps over stadium seating charts. Using the impersonality of architectural diagrams as a kind of code, Mehretu creates recognizable but unidentifiable cities, both hybrid and generic. Like Appel, she is fascinated by transparency, but where he uses transparency to describe volume, she makes it depict simultaneity and motion. Her drawings have linear trajectories; directional arrows and vectors shoot across and through planes of translucent vellum like fireworks. Although the works' perspectival cues and sectional imaging create the illusion of three-dimensionality, they are in fact literally multidimensional in that Mehretu borrows still another architectural convention: the layering of drawings on translucent material, one atop the other.

Unlike Appel and Khedoori, Mehretu puts the conventions of applied drawing on display rather than making them her tool. The drawings of Alexandre Arrechea, Marco Castillo, and Dagoberto Rodriguez, who together call themselves "Los Carpinteros," exemplify yet another strategy: their entire program in drawing emphasizes the medium's applied-arts aspect, which, however, like the name of the group itself, they use more for its social symbolism than for its descriptive utility. The artists chose the name "Los Carpinteros"—the carpenters—not only because, in their sculptural practice, they worked with traditional carpenter's tools but, more important, because they did not want to identify with what Rodriguez calls the "hyper-artistic."[6] Arrechea has explained, "Giving ourselves this name implied a sort of guild affiliation."[7] Castillo adds, "We're inspired by materials that have to do with human labor. With traditional vocations of all types."[8]

Los Carpinteros' works on paper deal almost entirely with buildings and their materials—resonant subjects in Cuba, with its decaying

infrastructure. The group also conflates architectural structures with furniture, in a hilarious if sometimes unsettling mixture of the domestic and the public. Working in a style of skilled realism, with plump lines and sweeping strokes of gouache that skirt as close to illustration as to drafting, Los Carpinteros produce both finished drawings for their own sake and to-scale working drawings for at least theoretically buildable (though half-size) public buildings and monuments. Although these works relate to sculpture and sculptural ideas, the artists specify that the drawings are not precisely preparatory; as Rodriguez puts it, they are "neither cause nor effect."[9]

The building-scale wall drawings that Los Carpinteros periodically create stand between their freestanding objects and their works on paper. Line drawings often embellished with three-dimensional details, these depictions of buildings as big as buildings often show meaningful types—neoclassical banks, lighthouses resembling sniper's bunkers, panopticon prisons. The prototypical jail built in Cuba, as well as in the United States, in the nineteenth century, the panopticon was the brainchild of the British philosopher Jeremy Bentham. Its design—a wheel of cells around a central observation post—offered jailers perpetual surveillance of inmates, who were locked in solitary confinement and constantly observed, like so many inanimate objects securely tucked in individual drawers.

The choice of the prison as subject might seem to refer to Piranesi's "Carceri d'Invenzione," those well-known eighteenth-century drawings of fantastic, almost cathedrallike prison interiors. Los Carpinteros' depiction of a jail as an enormous bureau stocked with human souls, however, might relate more closely to the "architecture parlante" of slightly later French architects such as Etienne-Louis Boullée, Claude-Nicolas Ledoux, and Jean-Jacques Lequeu. Believing that architecture could literally shape its users' lives, these men dreamed of buildings whose design would clearly announce their purpose—a brothel would take the form of a phallus, a library that of an open book. Significantly, most of these ideas were never built. A gentle but pointed send-up of the persistence of such fantasies of social engineering, Los Carpinteros' drawing lasts only as long as the exhibition in which it is included. The work is as ephemeral as the wall's next coat of paint.

1. James S. Ackerman, "The Conventions and Rhetoric of Architectural Drawing," in Ackerman and Wolfgang Jung, eds., *Conventions of Architectural Drawing: Representation and Misrepresentation* (n.p., 2000), p. 24.
2. In fact Kevin Appel is working on a project to build a house he has designed.
3. Richard Serra, quoted in Lizzie Borden, "About Drawing: An Interview," in *Richard Serra: Writings, Interviews* (Chicago: at the University Press, 1994), p. 51.
4. Anthony Vidler, "Home Pages: Notes on the Work of Toba Khedoori," in *Toba Khedoori*, exh. cat. (Los Angeles: Museum of Contemporary Art, 1997), n.p.
5. Ibid.
6. Dagoberto Rodriguez, quoted in Rosa Lowinger, "The Object as Protagonist: An Interview with Alexandre Arrechea, Marco Castillo, and Dagoberto Rodriguez," *Sculpture Magazine*, December 1999, p. 25. Gary Garrels notes that the name also refers to the "*carpinteros*"— skilled slaves—of eighteenth- and nineteenth-century Cuba. See Garrels, *New to the Modern*, exh. brochure (New York: The Museum of Modern Art, 2001), n.p.
7. Alexandre Arrechea, quoted in Lowinger, "The Object as Protagonist," p. 25.
8. Marco Castillo, quoted in ibid., p. 28.
9. Rodriguez, quoted in ibid., p. 31.

28. Kevin Appel
Light Model: Northwest View (2). 2002
Liquid acrylic and pencil on paper,
22½ x 30" (57.2 x 76.2 cm)

29. Kevin Appel
Light Model: Southeast View. 2002
Liquid acrylic and pencil on paper,
22½ x 30" (57.2 x 76.2 cm)

30. Kevin Appel
Light Model: Northwest View. 2002
Liquid acrylic and pencil on paper,
22½ x 30" (57.2 x 76.2 cm)

31. Kevin Appel
Light Model: West View. 2002
Liquid acrylic and pencil on paper,
22½ x 30" (57.2 x 76.2 cm)

32. Toba Khedoori
Untitled (Doors). 1999
Oil and wax on paper,
11' 6" x 15' 11½" (350.5 x 486.4 cm)

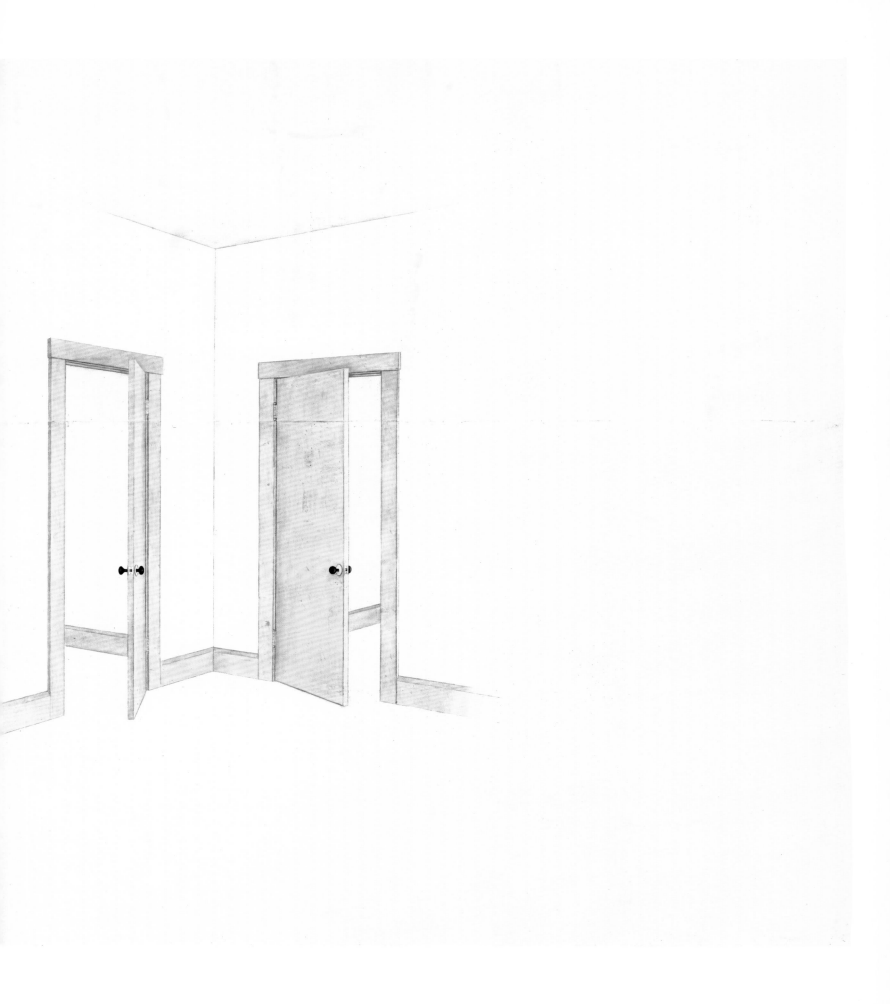

33. Toba Khedoori
Untitled (Rooms). 2001
Oil and wax on paper,
12 x 12' (366 x 366 cm)

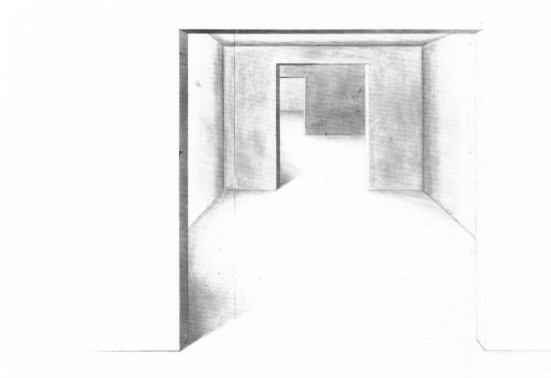

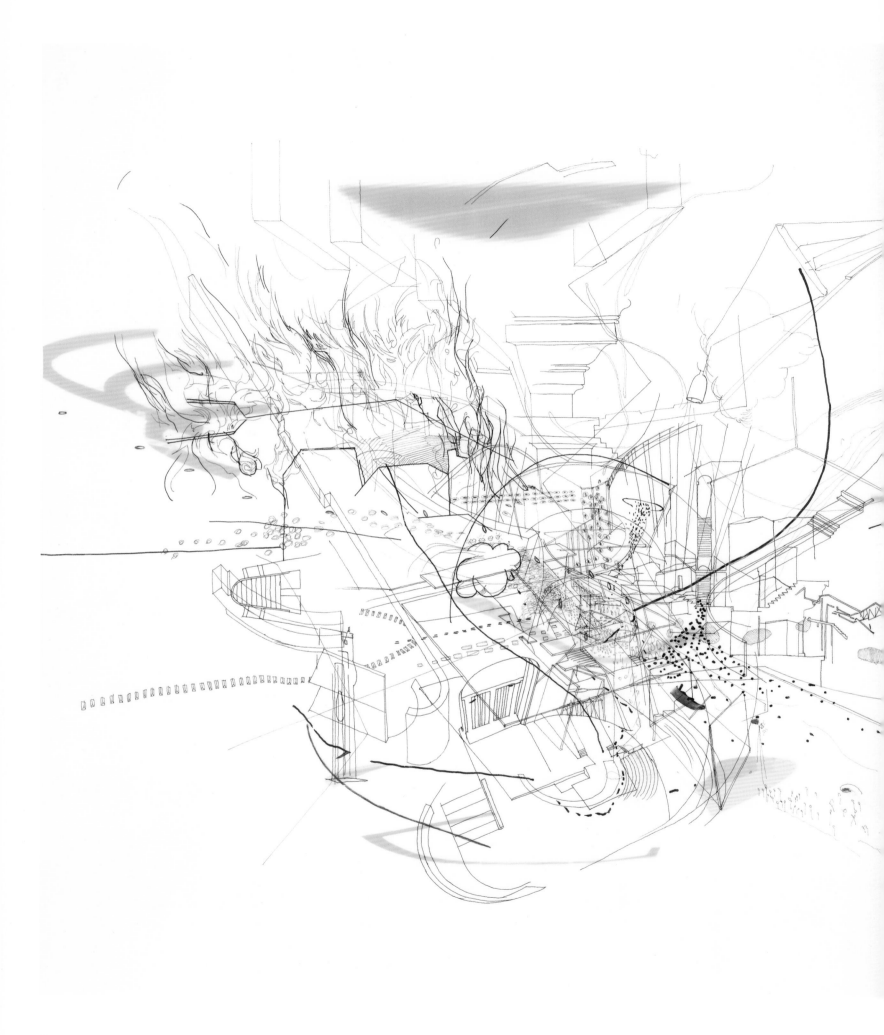

34. Julie Mehretu
Untitled. 2000
Ink, colored pencil, and
cut paper on Mylar,
18 x 24" (45.7 x 61 cm)

35. Julie Mehretu
Untitled. 2000
Ink, colored pencil, and
cut paper on Mylar,
18 x 24" (45.7 x 61 cm)

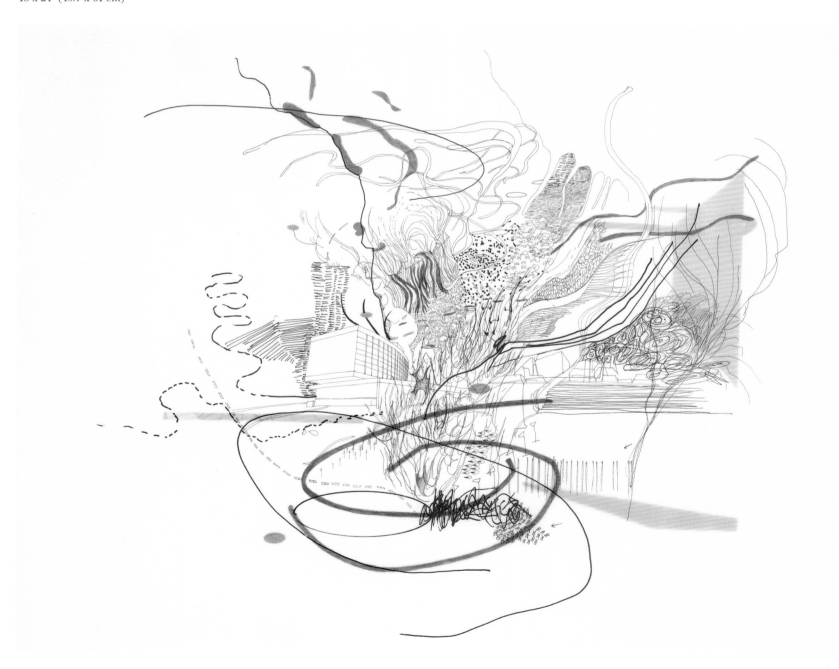

36. Julie Mehretu
Untitled. 2000
Ink, colored pencil, and
cut paper on Mylar,
18 x 24" (45.7 x 61 cm)

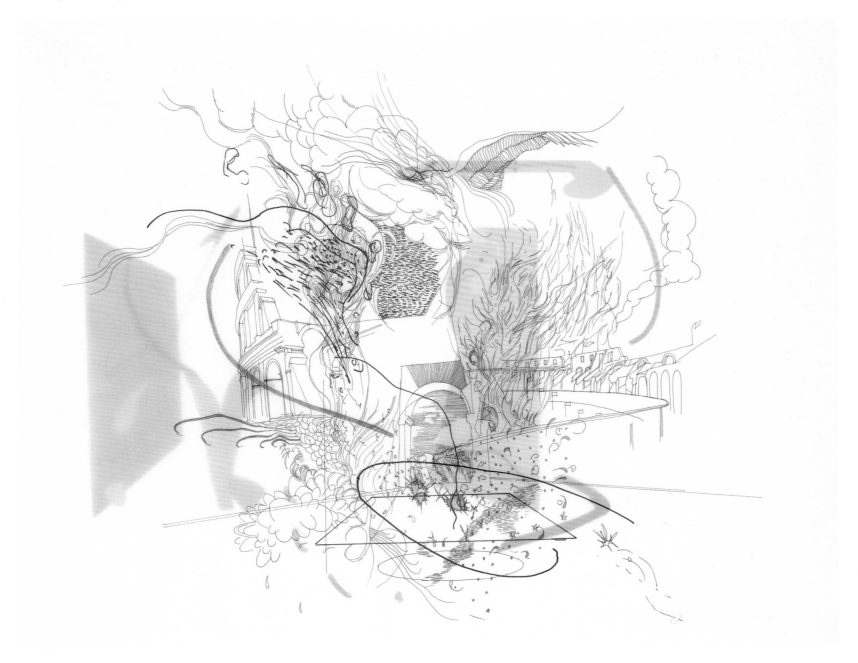

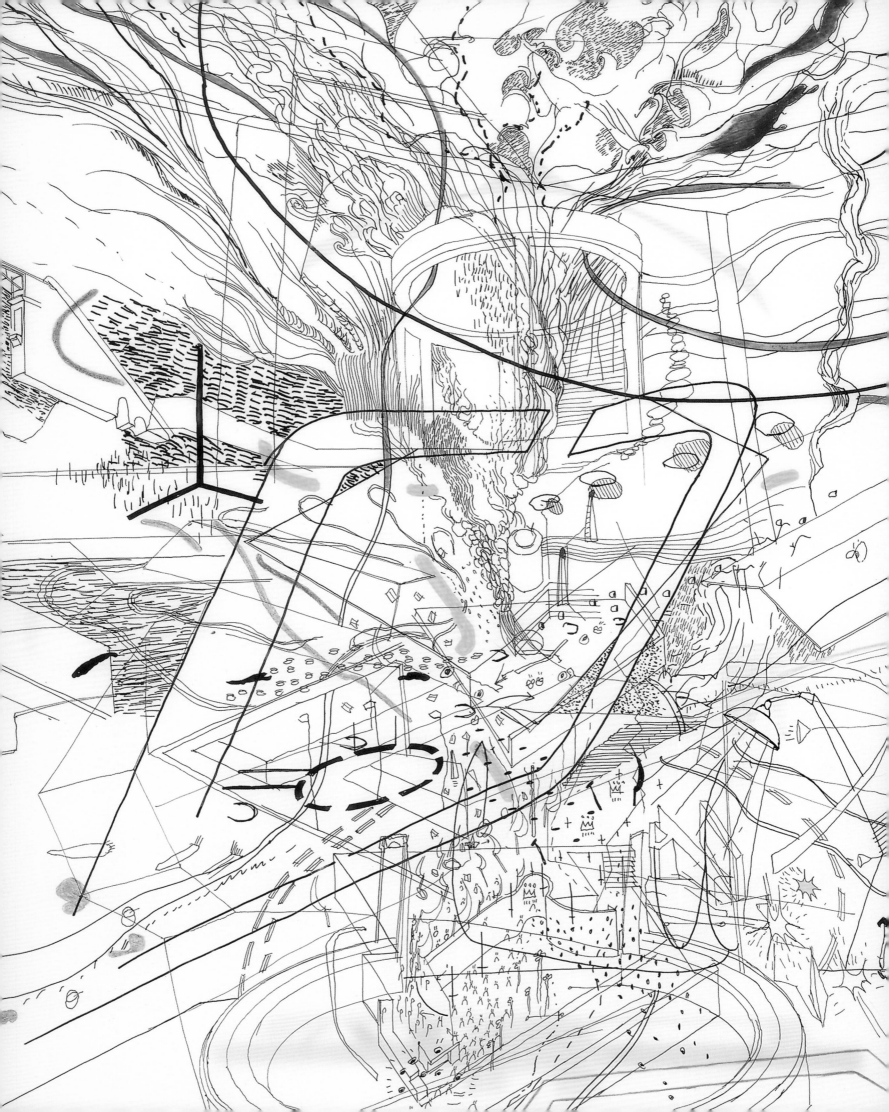

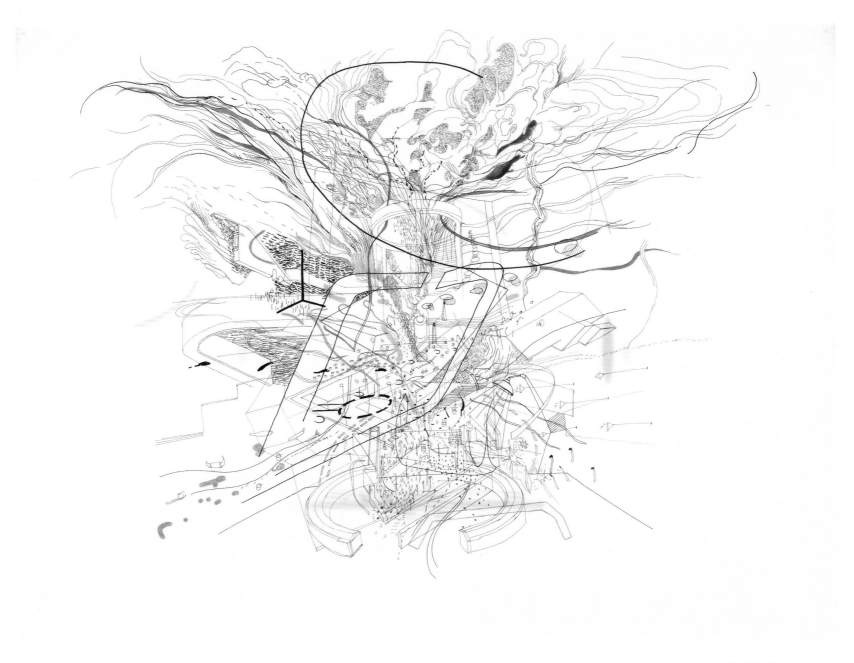

38. Julie Mehretu
Untitled. 2000
Ink, colored pencil, and
cut paper on Mylar,
18 x 24" (45.7 x 61 cm)

37, opposite: Julie Mehretu
Untitled. Detail, actual size

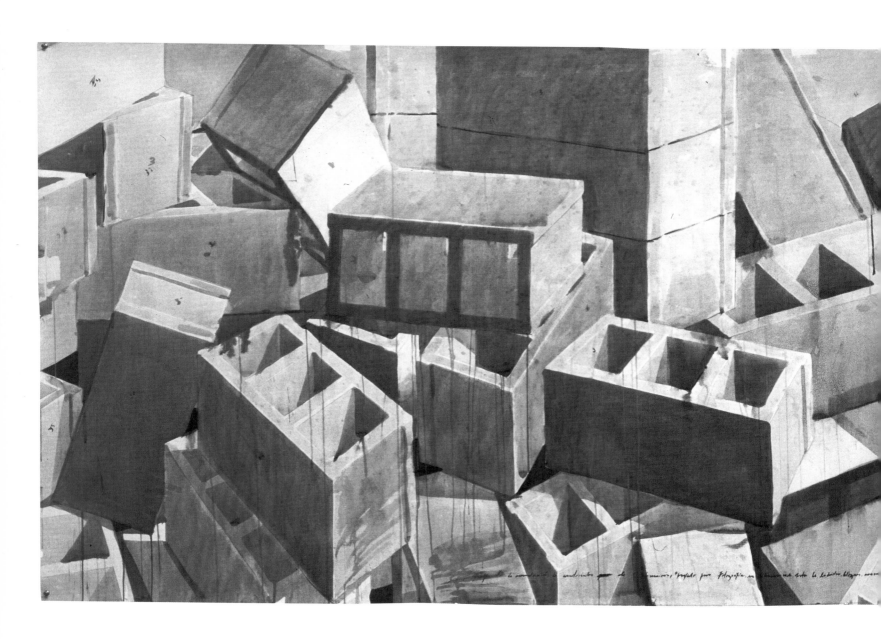

39. Los Carpinteros (Dagoberto Rodriguez, Marco Castillo, Alexandre Arrechea)
Proyecto de Acumulación de Materiales (Project of accumulation of materials). 1999
Watercolor and pencil on paper, 46¼" x 11' 7⅞" (117.5 x 355.3 cm)

40. Los Carpinteros (Dagoberto
Rodriguez, Marco Castillo,
Alexandre Arrechea)
Cárcel (Prison). 2001
Mixed mediums on paper,
64" x 8' (162.6 x 243.8 cm)

drawing happiness

paul noble
neo rauch
david thorpe

1. Claude-Nicolas Ledoux. Oikéma (House of sexual instruction) for Ideal City of Chaux (detail). c. 1790. Elevations, section, and plans. Engraving, Saline Royal, Photothèque Institut Claude-Nicolas Ledoux, Arc-et-Senans

Can one draw happiness?

Bruno Taut, *Die Auflösung der Städte*, 1920

The critic Barry Schwabsky notes that "rational planning and utopian fantasy have always been surprisingly difficult to disentangle." "Both," he adds, "take form, above all, in drawing."[1]

In 1773 the French architect Claude-Nicolas Ledoux began work on a design for a salt-works at Arc-et-Senans, in the Franche-Comté region of eastern France. Completed in 1779, the complex, with its workers' barracks, workshops, and customs houses, became the inspiration for a purely visionary project, the model city of Chaux, which, like the saltworks, was to contain facilities designed for perfect communal self-sufficiency, including housing, a brothel (fig. 1), a "house of virtue" (which took the place of a house of worship), and a meeting hall optimistically called the "palace of concord." Believing that "architecture is to stonemasonry what poetry is to letters,"[2] Ledoux chose each building carefully to procure the social and physical well-being of his imaginary city's inhabitants, and designed the structures so that their shape, size, and situation clearly described their function in the community (obeying the principle of *architecture parlante*). This impulse to envision a world and draw it out in all its detail is shared by the artists Paul Noble, Neo Rauch, and David Thorpe, but there is not a utopian among them. The skill and attention to detail with which all three describe their respective fantasies in pencil, paint, and colored paper are almost cruel in their effective delineation of just how problematic a perfect community can be.

"No style, only technique. No accidents, only mistakes."[3] This is the motto for the imaginary town that Noble has illustrated in a series of over twenty pencil drawings (some room-size) that he has created since 1991. Taken together, the works depict an industrial dystopia in which fetid factories disgorge smoke into the air and pipe muck into the river, and housing consists of horrid huge modernist cubes for the rich and horrid small modernist cubes for the poor. This nightmarish locale, futuristic in an anachronistic sort of way, is called "Nobson Newtown," the name an ironic reference to the suburban "new towns" dreamed up by early-twentieth-century British city planners and built throughout England until thirty years ago.[4]

Hyperrealistic in detail, every drawing also utilizes a wobbly aerial perspective, because, Noble says, he wants "everyone to fly over the space." The pictorial structure is not meant to be "tricksy," he claims, but viewer-friendly.[5] The same goes for the peculiar alphabet that determines the shapes of the buildings in Nobson Newtown: in a literalization of and perhaps a joke on the concept of *architecture parlante*, each structure is formed by letters that spell out the building's name in a custom-made, illusionistically three-dimensional font. In this respect Noble's Nobson drawings may owe something to Ledoux's for Chaux, but the aim of these drawings of a city with no town hall, no house of worship, no theater, no pub, no stadium,[6] is to take an activist swipe not only at Ledoux but at his descendants: the twentieth-century architects such as Frank Lloyd Wright, Le Corbusier, and others who laid utopian plans and dreamed of a society made perfect—and perfectly controlled by architecture. Like Nobson Newtown, and to our great good luck,

most of these megalomaniacal dreams were realized only on paper.

Flying over Nobson Newtown like Dickens's Ghost of Christmas Future, we see from our "God's eye" perspective[7] what might be, not what has been or is. Nobson Newtown is not a dream but a warning spelled out in drawing, which Noble has called "the most universally understandable of mediums."[8] The German artist Rauch shares the notion of a drawing as a warning; indeed one of his works is literally titled *Warner* (1999), which is roughly translatable as "Prophetic warning."

Raised by his grandparents in Leipzig, in what was then East Germany, Rauch studied painting at the city's arts *Hochschule*, learning both the history and the craft of what Thomas Wagner has called "East Bloc figuration."[9] Rauch admits a love/hate relationship with his academic past,[10] and his paintings and works on paper adopt the children's-book realism and the "pastel shades of a frustrated ideology of progress."[11] In a language cribbed from comic books and political posters, 1950s serigraphs and trade manuals, Rauch depicts a world that is at once anachronistic and bristling with technology.[12] It is populated by generic human figures—"functional" agents[13] who bustle purposefully amid propellers, tubes, and other bits of often unidentifiable machinery parked in front of official-looking buildings or on impressively crowded work sites. Like Noble, Rauch seems to be using a consciously anachronistic drawing style to warn us about what might be. His world contains elements of past, present, and future, and although it has aspects of the old East Germany, the artist sees it as a place with no origin save his own

subconscious. This is not to imply that Rauch's work on paper should be seen as a spontaneous search for an illusory subject. In his words, "A piece of art is instinct under control." Although he never makes sketches but attacks the paper directly, the accuracy of his figurative drawing adds credence to his claim, "I have come to know before I start what I will do."[14]

Just as Noble's Newtown depicts a purposefully anachronistic idea of the future, Rauch combines his memories of a past place and time—the German Democratic Republic of the 1950s and early '60s—with the futuristic predictions articulated by the films and particularly the comic strips of the same period. Unlike Noble's, his works create no scene out of which a story unfolds; like tableaux rather than narratives, they have a metaphoric aspect. Although no one has claimed to decipher the meaning of individual works, Bernhart Schwenk has noted an abundance of references to painting in these quasi-industrial scenes, where much labor is expended for no discernible result. He has extrapolated from this that Rauch's entire project may be a metaphor for the artmaking process.[15] This could be true, but, intriguingly, so could its opposite—that is, the act of drawing could be a metaphor for the ability not to bring a world into being but to exorcise the memory of one made obsolete only a decade ago. As fantastical as Rauch's depictions might seem, like dreams (or perhaps nightmares) they retain elements that link them to actual experience.

Thorpe's early work is in photography and painting, but for the last several years he has used the medium of intricately cut paper to create fantastic land- and cityscapes. This découpage

technique is unexpected in the context of contemporary British art, but it is familiar in the world of European and American material culture, where it has been used to decorate objects since the seventeenth century. Craft techniques have a difficult history in modernist art, but Thorpe adopts his medium advisedly. He remembers having been impressed that Luc Tuymans's quietly poignant paintings were painted on cheap canvases, and having consciously looked for a similar way to lighten the historical burden that picture-making seemed to carry. That way, Thorpe has said, "You can avoid the debate."[16]

Thorpe's recent collages depict dramatic mountainous landscapes, entirely imaginary but loosely based on representations of the mountains of the American West.[17] Each also contains examples of visionary domestic architecture, in shapes ranging from bunker to trailer to pentagram, that speak eloquently of the kinds of inhabitants they house. Fantasies set in a landscape that is a fantasy itself, these buildings embody and even celebrate a sense of remove—but in distance there is uncertainty and in strangeness there is menace. Less ski chalets than survivalists' redoubts, albeit architecturally creative ones, Thorpe's structures seem built for self-sufficiency in extreme isolation and under the threat of natural peril. "We Are Majestic in the Universe" is the triumphant trumpet-blast title of a collage in which an impossibly steep mountain rises up to fill the center of the picture. Parked audaciously on the peak's pointy pinnacle, huddled up under a small sliver of bright sky, is a little trailer. There seems no question that nature triumphs over the human attempt to be one with it.

1. Barry Schwabsky, "Drawing on the New Town: Chad McCail and Paul Noble," *Art on Paper*, July–August 2000, p. 34.
2. Claude-Nicolas Ledoux, quoted in Jean-Claude Lemagny, *Visionary Architects: Boullée, Ledoux, Lequeu*, exh. cat. (Houston: University of St. Thomas, 1968), p. 67.
3. Paul Noble, "Introduction to Nobson Newtown," in Reiner Speck et al., eds., *Nobson Newtown* (Cologne: Salon Verlag, 1998), p. 1.
4. See Schwabsky, "Drawing on the New Town," p. 36.
5. Noble, in an interview with the author, January 29, 2001.
6. See Dave Beech, "Paul Noble," *Art Monthly* no. 215 (April 1998): 24–25. In fact, as Noble points out in this interview, the town has not only no public buildings but no inhabitants, save one: the artist himself.
7. Schwabsky, "Drawing on the New Town," p. 36.
8. "The pen-to-paper thing—we all do it. We're never far from drawing," Noble has said, adding that he chose drawing because "I decided that drawing was the most populist [medium]." Noble, in an interview with the author, January 29, 2001.
9. Thomas Wagner, "A Chunk of Antarctica on Its Return Flight," in Klaus Werner, ed., *Neo Rauch: Randgebiet*, exh. cat. (Leipzig: Galerie für Zeitgenössische Kunst, 2000), p. 15.
10. Neo Rauch, in an interview with the author, June 11, 2001.
11. Wagner, in *Neo Rauch*, exh. cat. (Berlin: Deutsche Bank and Deutsche Guggenheim, 2001), p. 11.
12. Noting the influence of late-1950s East German comics on his imagery, Rauch particularly mentions *Dig Dag Digdag*, a strip in which the time-traveling title character has adventures in the past, present, and future. Rauch, in an interview with the author, June 11, 2001.
13. Wagner, "A Chunk of Antarctica," p. 17.
14. Rauch, quoted in ibid.
15. Bernhart Schwenk, "'Night Work' in Defence of Red, Yellow and Blue," in Werner, ed., *Neo Rauch: Randgebiet*, p. 24.
16. David Thorpe, in an interview with the author, January 29, 2001.
17. When he made this series of works Thorpe had never visited the western United States but had read accounts and seen pictures of survivalist compounds in Idaho and Montana.

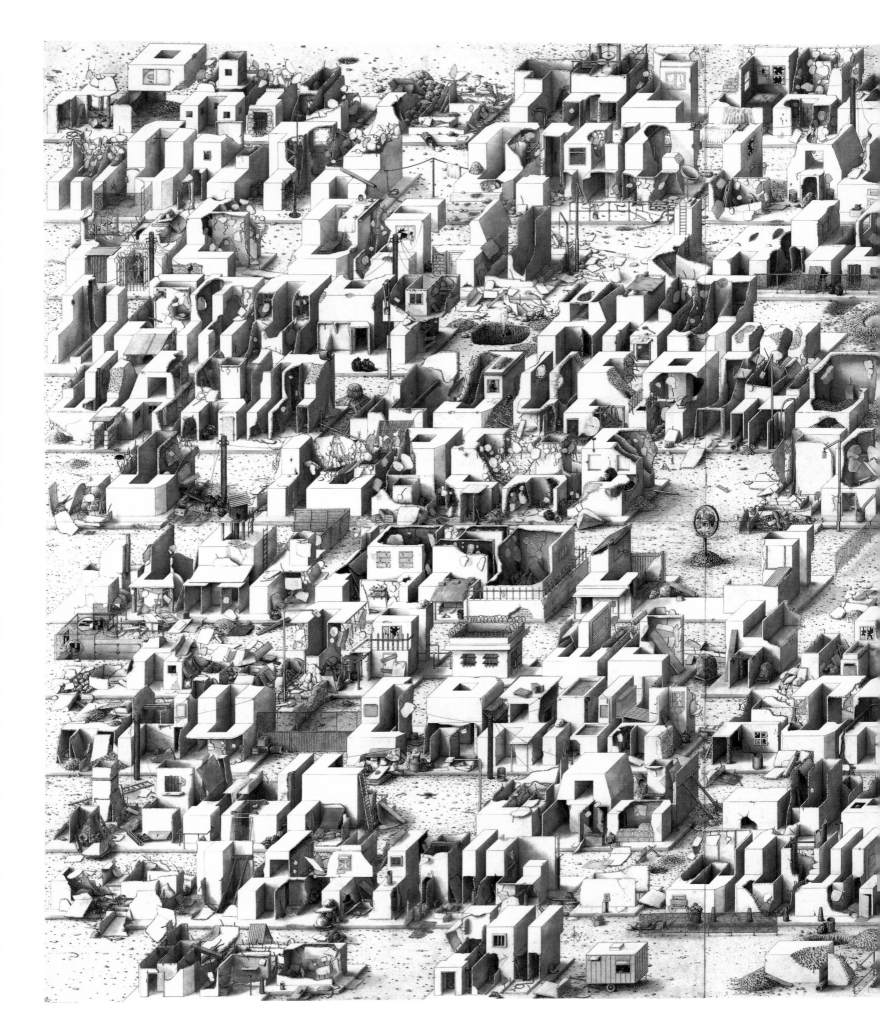

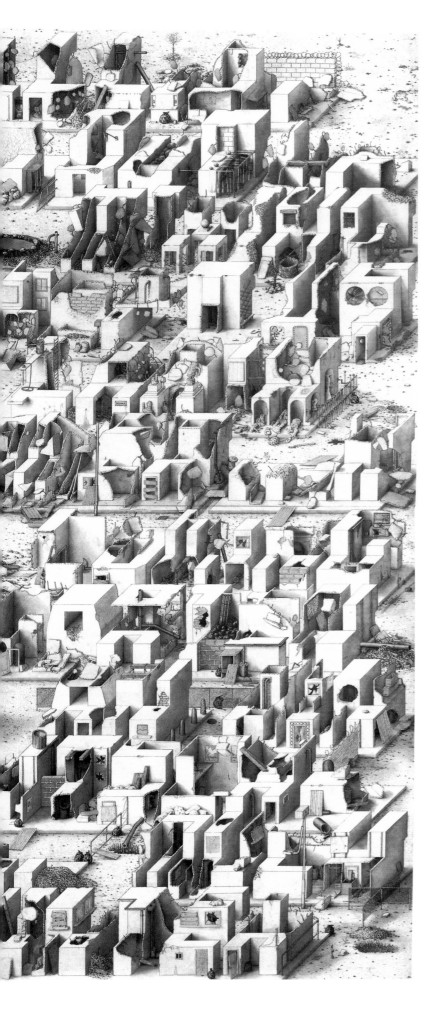

41. Paul Noble
Nobson Central. 1998–99
Pencil on paper,
9' 10" x 13' 1¾" (299.7 x 400.7 cm)

42. Paul Noble
Nobspital. Detail

43. Paul Noble
Nobspital. 1997–98
Pencil on paper,
8' 2½" x 59" (250 x 150 cm)

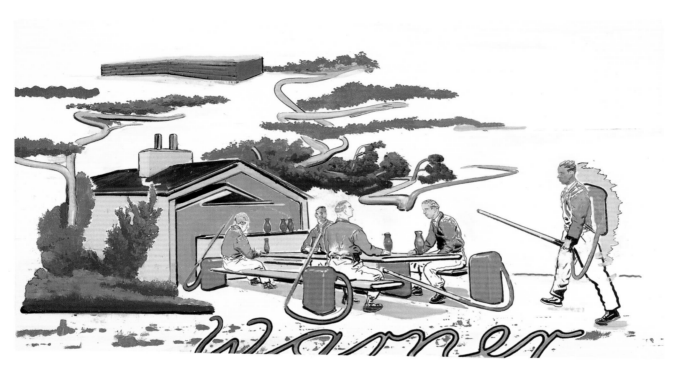

44. Neo Rauch
Warner. 1999
Oil on paper,
31⅞ x 60¼" (81 x 153 cm)

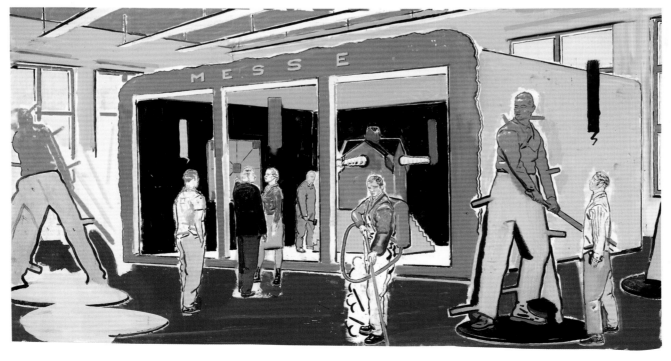

45. Neo Rauch
Messe. 1999
Oil on paper,
31⅞ x 60¼" (81 x 153 cm)

46. Neo Rauch
Busch. 2001
Oil on paper,
6' 6¾" x 6' 6¾" (200 x 200 cm)

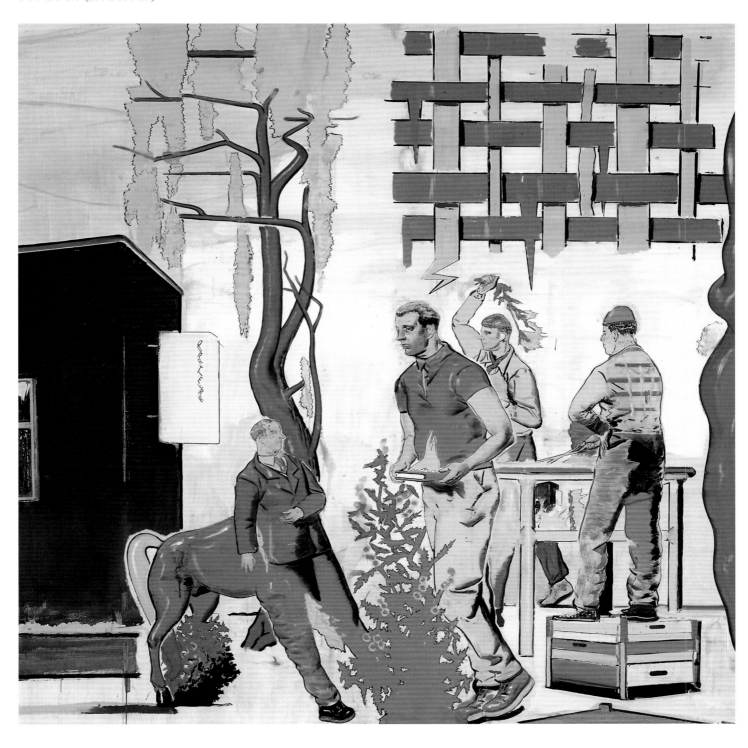

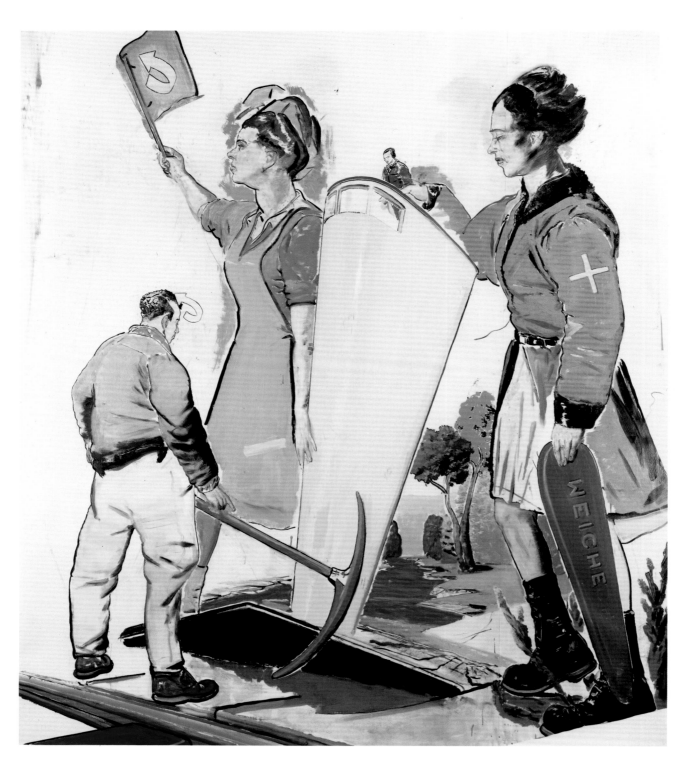

47. Neo Rauch
Weiche. 1999
Oil on paper,
7' 5⅝" x 6' 2¹³⁄₁₆" (215 x 190 cm)

48, opposite: Neo Rauch
Weiche. Detail, actual size

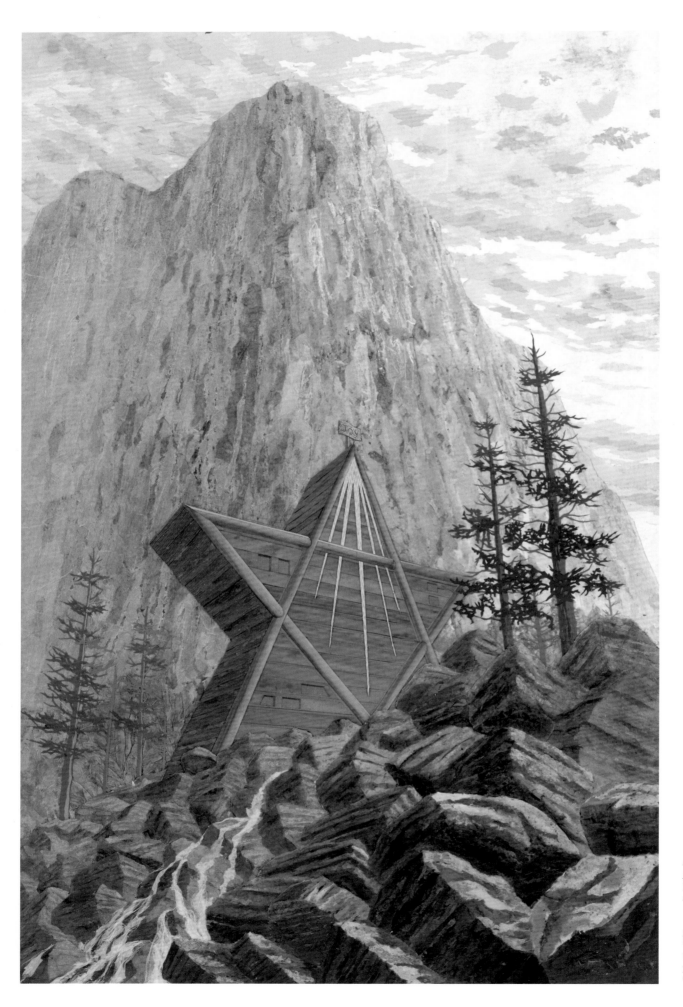

49. David Thorpe
Evolution Now. 2000–2001
Paper collage,
43¼ x 27½" (110 x 70 cm)

50, opposite: David Thorpe
We Are Majestic in the Wilderness. 1999
Paper collage,
70⅞ x 57⅛" (180 x 145 cm)

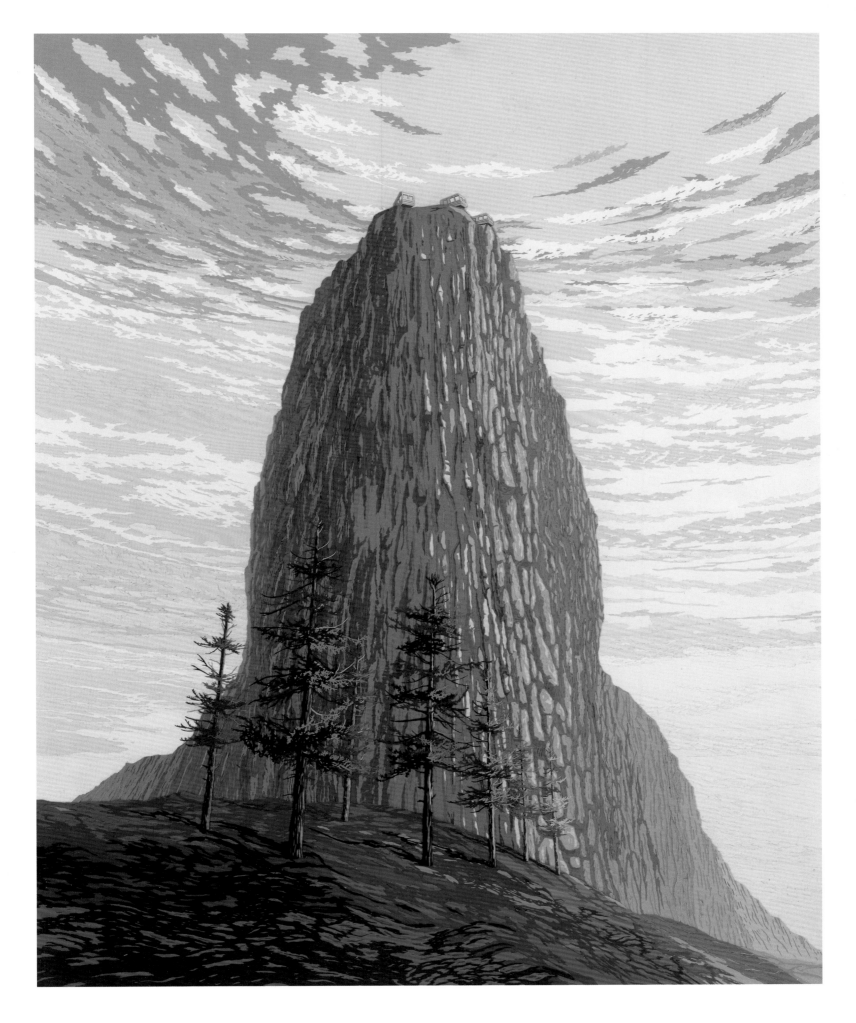

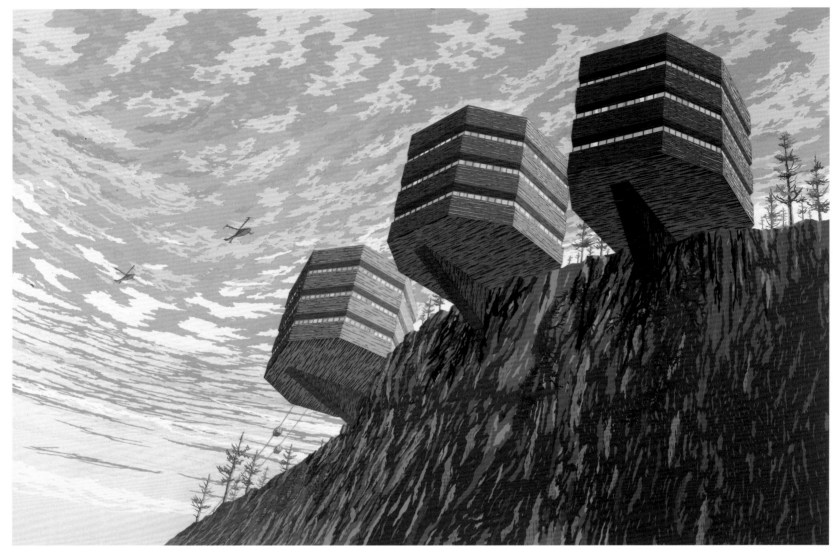

51. David Thorpe
Pilgrims. 1999
Paper collage,
46¼ x 68" (117.5 x 173 cm)

52. David Thorpe
House for Auto-Destiny,
Imaginative Research. 2000
Paper collage,
23¾ x 39½" (60 x 100 cm)

53. David Thorpe
Out from the Night, the Day
Is Beautiful and We Are
Filled with Joy. 1999
Paper collage,
31⅞ x 27¹⁵⁄₁₆" (81 x 71 cm)

five

mental maps and metaphysics

franz ackermann
mark manders
matthew ritchie

Only he can be an artist who has a religion of his own, an original view of the infinite.

Friedrich von Schlegel, c. 1800

At the turn of the eighteenth century, the German Romantic philosopher Friedrich von Schlegel described the German artist as "righteous, ingenuous, thorough, precise and profound…thereby innocent and a little clumsy."[1] In this perfect conjunction of character traits Schlegel saw the ideal candidate to create a new mythology for a philosophically exhausted world. This notion—that the artist's personal vision could offer new archetypes, fresh allegories, and alternative explanations of the visible world—has reappeared in the drawing projects of Franz Ackermann, Mark Manders, and Matthew Ritchie, each of whom has embarked upon a multiyear endeavor of making drawings that exemplify, describe, or map out new structures through which to perceive the world.

Traveling to all of the world's continents except, so far, Australia and Antarctica, Ackermann is engaged in a kind of perpetual state of wandering and recording out of which he has produced a series of exquisite gouaches based on the cities he has visited, from Hong Kong to Rio de Janeiro, from Rome to Pittsburgh. Ackermann's peregrinations owe something to the German Romantic tradition of the *Wandermaler*, but, although he emphasizes that his drawings are "pictures of something real,"[2] they are not precisely views of the places through which he walks; instead, swirling psychedelic patterns reconstitute themselves as aerial maps, out of which recognizable landmarks emerge— a skyscraper, a mountain. In fact Ackermann describes all of his drawings as "mental maps," an appellation suggesting that each is a picture of his mind as it reacts to the stimulus of a particular environment.

Literalizing the trope of drawing as directly connected to the artist's thoughts, Ackermann insists that his mental maps are two-dimensional equivalents of his thought processes rather than transcriptions of what he sees or experiences during his walks. That the drawings themselves are the artwork and not merely a charting of one illustrates a crucial distinction between Ackermann and older artists such as Richard Long or Hamish Fulton, whose works map the trajectories of their walks. In fact Ackermann's works offer a radically different view of drawing and its relationship to a performed action: not souvenirs of the travel experience, they *are* in fact the experience. "Drawing shouldn't be a projection or a reduction," Ackermann has said. "I want to oppose this form of drawing."[3]

Ackermann's mental maps argue for a definition of reality based on what is perceived rather than what is materially present. More than plans for how to walk through a city, they are prescriptions for viewing the world in which we live. The equation of mind and architecture, or the positing of mind *as* architecture, is one of many connective tissues between Ackermann's work and Manders's, and offers a concise introduction to Manders's notion of the "self-portrait as a building." For the past sixteen years this Dutch artist has been producing "fragments" of a self-portrait project in the form of sculptures, installations of found objects, and above all drawings. Positing himself as a single body comprising an ongoing collection of images, he

has imagined himself as an edifice, each of its many rooms containing a symbolic form, a drawn analogue of an existing object or sculpture in the artist's oeuvre. The structure of the building, which Manders has illustrated with a series of carefully drawn "provisional floor plans" that he updates as he fills rooms with fragments, is flexible enough to accommodate an ever accumulating description of what Antonin Artaud described as "the landscape of the outside inner self."[4]

The symbols that Manders uses over and over again—the generic outline of a sexless human form, a baby on its back, a Ganesha-like elephant figure with a snout as large as its body, a dead bird—are recognizable, evocative, even archetypal, but the meanings of individual drawings are opaque until they are considered in relation to one another and to the artist's entire project. "In this building all words created by mankind are on hand," as Ronald van de Sompel has noted,[5] and indeed, if the drawings are read like part of a language, strains of myths can be knit together from them and fables familiar to all cultures can be conjured, albeit in incomplete and abbreviated form. "All things which I think are brought to a standstill in the building,"[6] Manders has said; this concretization of thoughts into two-dimensional drawings recalls Ackermann, but Manders, unlike the German artist, is trying to explain a world beyond his personal perceptions, however much he relies on them to create his symbolic language. There are many precedents for the use of an architectural structure as a metaphoric embodiment of the subconscious,[7] but "Self-Portrait as a Building" is not simply an architectonic mapping of an individual psyche. Rather, Manders's

vocabulary of images articulates narratives that are not merely part of "an individual mythology"[8] but are shared by anyone who can follow the floor plan and find symbolic resonance in the images there.

"People with imaginary cosmogonies are a dime a dozen,"[9] Ritchie has said, jokingly downplaying the hubris involved in his project: the creation of a new symbolic language and an alternative creation myth. Although Ritchie uses an array of art forms and techniques, including the artist's book and the computer, he has made drawing his primary means; his tenebrous line, in pencil and ink on Mylar, recalls the delicacy of the Victorian artist Sir John Tenniel (most famous as the illustrator of Lewis Carroll's *Alice's Adventures in Wonderland*), while his fantastic imagery brings to mind a science fiction comic book. Existing in sets of seven or forty-nine, his drawings are made sequentially, and are meant to be read that way, as comprehensive narrative explanations of the beginning of life. The production of a new story of how the world and all that dwells in it came to be is an event, not to mention an enormous imaginative effort, as well as an act of some presumption. Ritchie acknowledges this, but explains that the will to create a new cosmological system stems not from some perceived societal lack but from his own need: "I'm trying to describe the universe as if it could be seen and understood by one person," he writes, "but I can only see through the blurry lens of my own life, so to help me animate my futile investigations, I embody the forces of the universe: energy and entropy, space and time, in the form of characters drawn from my own frame of reference."[10]

Since the beginning of his project, almost a decade ago, Ritchie has worked with a chart mapping the relationships among a roster of characters, colors, chemical elements, and attributes of each. Over the years his episodes have come together as a kind of epic serial adventure, owing much in spirit (though not in form) to comic strips (Ritchie particularly admires the superheroes the Fantastic Four) and Japanese *anime*. At first glance his drawings may seem to present a form of biomorphic abstraction, in the pastel palette of a nineteenth-century illustration for a British fairy story, but there are characters — some humanoid, some vegetal, some positively mineral — embedded in his complex, almost knotted compositions. Once we are familiar with the motifs that identify them we can trace their exploits, both through a sequence of drawings and through the entire oeuvre.

Ritchie started this enormous project, he has explained, with a challenge to himself to create what he calls "an integrated symbolic language" of visual art, one literalizing the then current notion that the elements of painting could be seen as a linguistic system. "It wasn't like I wanted to make a classical myth," recalls Ritchie, "but rather give people another language through which they can understand the interaction of a painting."[11] But what began as an exercise in the semiotics of artmaking has become a practice in which painting and drawing provide the paradigmatic set of rules for a full-blown "geo-biological heroic fantasy."[12] Armed with these rules, as well as with the notion that an act of individual creation is a model for the creation of a world, Ritchie, precise, profound, and a little clumsy, creates a new mythology that is available to all of us but is also all his own.

1. Friedrich von Schlegel, quoted in Gert Schiff, *German Masters of the Nineteenth Century: Paintings and Drawings from the Federal Republic of Germany*, exh. cat. (New York: The Metropolitan Museum of Art and Harry N. Abrams, 1981), p. 10.
2. Franz Ackermann, in an interview with the author, January 23, 2001.
3. Ibid.
4. Antonin Artaud, quoted in Axel Heil, "There Is a House: Fragments of Forgetting/Cup/Comin'," in *14 Fragments from Self-Portrait as a Building*, exh. cat. (Baden Baden: Staatliche Kunsthalle, 1998) n.p.
5. Ronald van de Sompel, "Notes on Self-Portrait as Building: A Floorplan of Desire," in *Mark Manders Shows Some Fragments of His Self-Portrait as a Building*, exh. cat. (Antwerp: MUHKA [Museum van Hedendaagse Kunst Antwerpen], 1994), n.p.
6. Mark Manders, quoted in Jan Brand, Catelijne de Muynck, and Valerie Smith, eds., *Sonsbeek 1993*, exh. cat. (Ghent: Snoeck-Ducaju & Zoon, 1993), p. 283.
7. I think, for example, of Kurt Schwitters and his lifelong project of the Merzbau, and more recently of Gregor Schneider, who re-creates secret cellars as full-scale models to be walked through.
8. Van de Sompel, "Notes on Self-Portrait as Building."
9. Matthew Ritchie, in an interview with the author, August 22, 2001.
10. Ritchie, *The Fast Set*, exh. cat. (Miami: Museum of Contemporary Art, 2000), p. 9.
11. Ritchie, quoted in Jennifer Berman, "Matthew Ritchie: An Interview," *Bomb*, Spring 1997, p. 61.
12. Ibid., p. 63.

54. Franz Ackermann
trans east west (tew) no. 1:
someone must fix it. 1999
Mixed media on paper,
6⅝₁₆ x 9⅞₁₆" (16 x 24 cm)

55. Franz Ackermann
trans east west (tew) no. 2:
the international carpet
center. 1999
Mixed media on paper,
6⅝₁₆ x 9⅞₁₆" (16 x 24 cm)

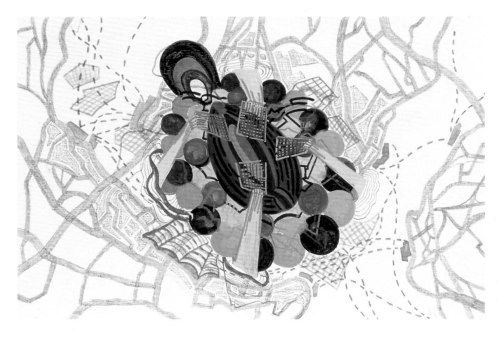

56. Franz Ackermann
trans east west (tew) no. 3:
the kasikçi stadium. 1999
Mixed media on paper,
6⅝₁₆ x 9⅞₁₆" (16 x 24 cm)

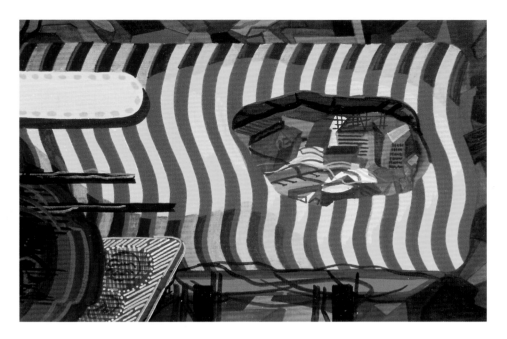

57. Franz Ackermann
trans east west (tew) no. 4:
instead of a message. 1999
Mixed media on paper,
6⅚₁₆ x 9⁷⁄₁₆" (16 x 24 cm)

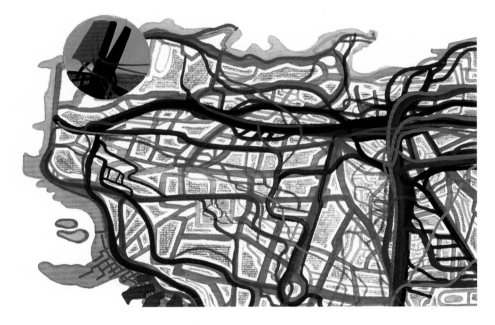

58. Franz Ackermann
trans east west (tew) no. 6:
rebuilding beirut. 1999
Mixed media on paper,
5⅛ x 7½" (13 x 19 cm)

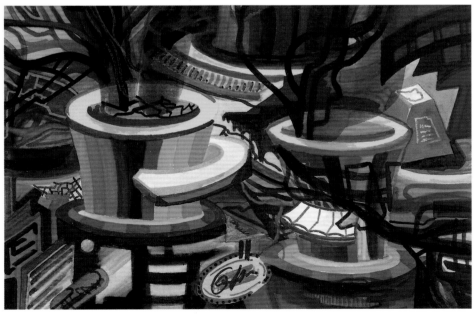

59. Franz Ackermann
trans east west (tew) no. 7:
bombing the power plant. 1999
Mixed media on paper,
5⅛ x 7½" (13 x 19 cm)

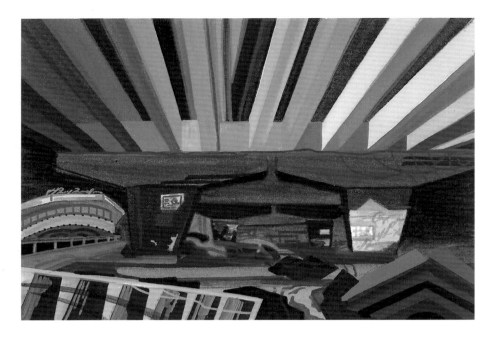

60. Franz Ackermann
trans east west (tew) no.8:
suddenly it was completely
dark (maybe because
I closed my eyes). 1999
Mixed media on paper,
5⅛ x 7½" (13 x 19 cm)

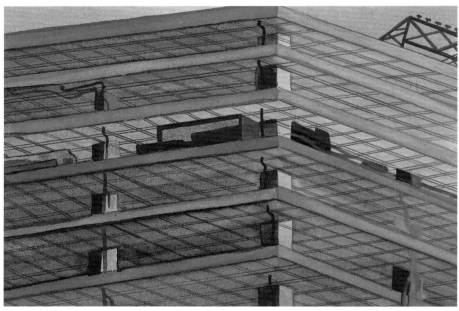

61. Franz Ackermann
trans east west (tew) no.9:
the "meridian" will have
a nice view. 1999
Mixed media on paper,
5⅛ x 7½" (13 x 19 cm)

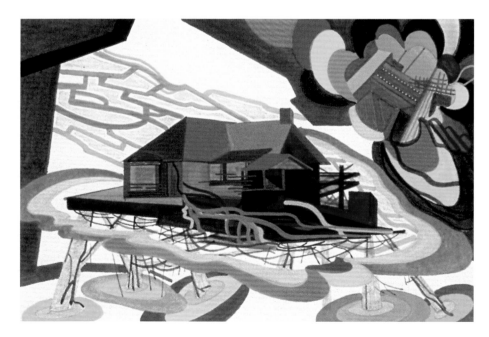

62. Franz Ackermann
trans east west (tew) no.21:
house with no windows. 1999
Mixed media on paper,
5 x 7½" (12.7 x 19 cm)

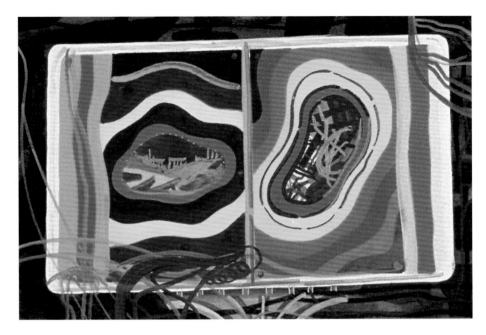

63. Franz Ackermann
trans east west (tew) no.23:
two ruins representing
one state. 1999
Mixed media on paper,
5 x 7½" (12.7 x 19 cm)

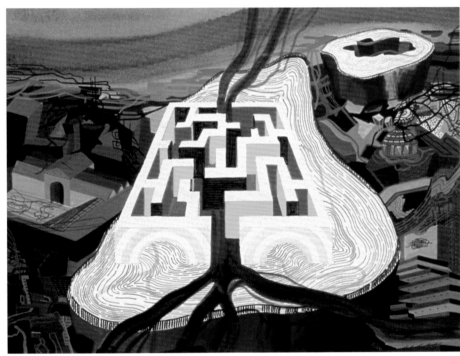

64. Franz Ackermann
trans east west (tew) no.30:
who's afraid of the outskirts
of damascus. 1999
Mixed media on paper,
12½ x 15½" (31.8 x 39.4 cm)

65. Far left: Franz Ackermann
*trans east west (tew) no.22:
changing money and
going out.* 1999
Mixed media on paper,
7½ x 5" (19 x 12.7 cm)

66. Near left: Franz Ackermann
*trans east west (tew) no.24:
enjoy your stay.* 1999
Mixed media on paper,
7½ x 5" (19 x 12.7 cm)

67. Franz Ackermann
trans east west (tew) no.29: former cinema. 1999
Mixed media on paper, 10 x 7½" (25.4 x 19 cm)

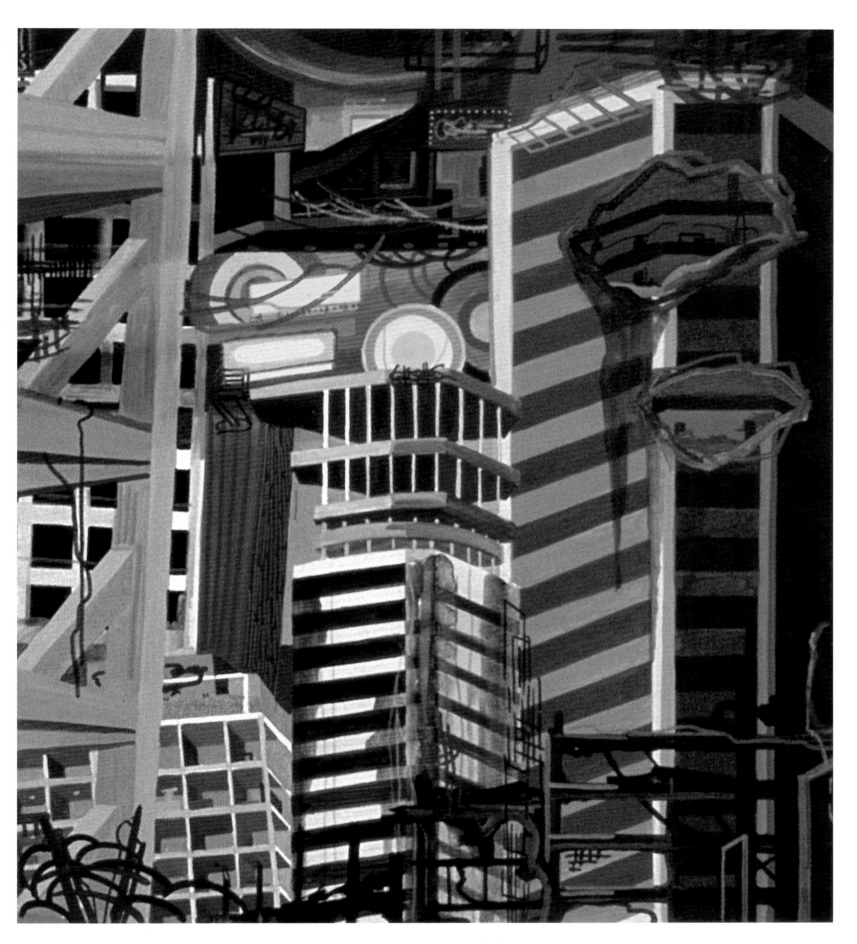

68. Franz Ackermann
trans east west (tew) no.33: former trade center. 1999
Mixed media on paper, 13 x 11½" (33 x 29.2 cm)

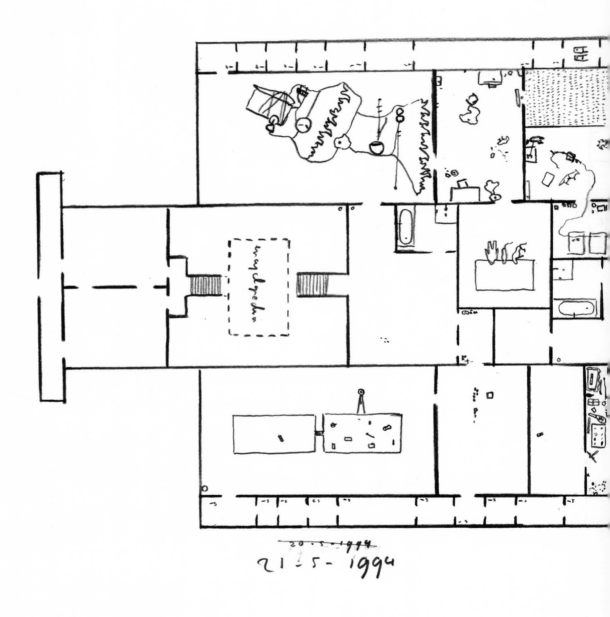

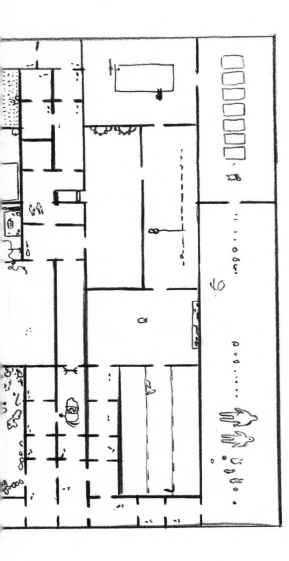

69. Mark Manders
Self-portrait as a building/
Provisional floor-plan. 1994
Graphite on paper,
16⁹⁄₁₆ x 23⁵⁄₁₆" (42.1 x 59.2 cm)

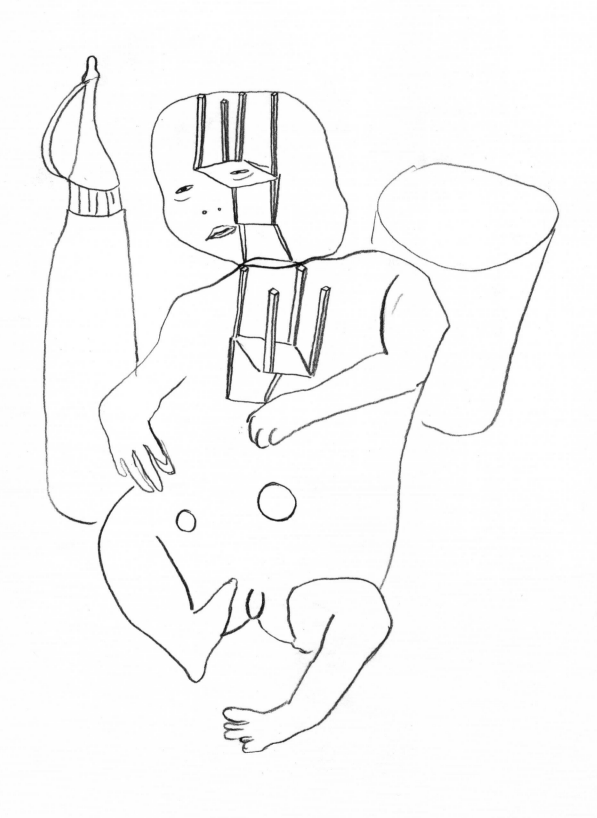

70. Mark Manders
Still-life. 1994
Graphite on paper,
16⁹⁄₁₆ x 11¹¹⁄₁₆"
(42.1 x 29.7 cm)

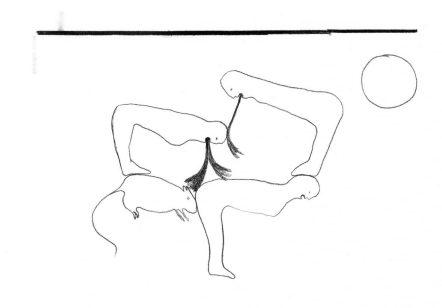

71. Mark Manders
Straight Cloud. 2001
Graphite on paper,
23⅝ x 19¹¹⁄₁₆" (60 x 50 cm)

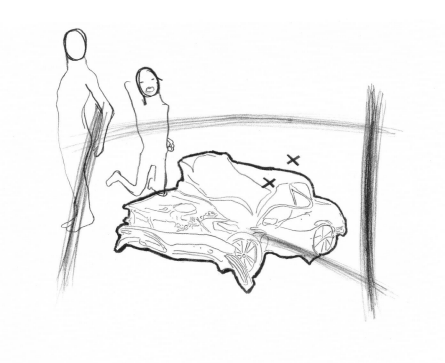

72. Mark Manders
Karin. 2000
Graphite on paper,
12¹¹⁄₁₆ x 17" (32.2 x 43.2 cm)

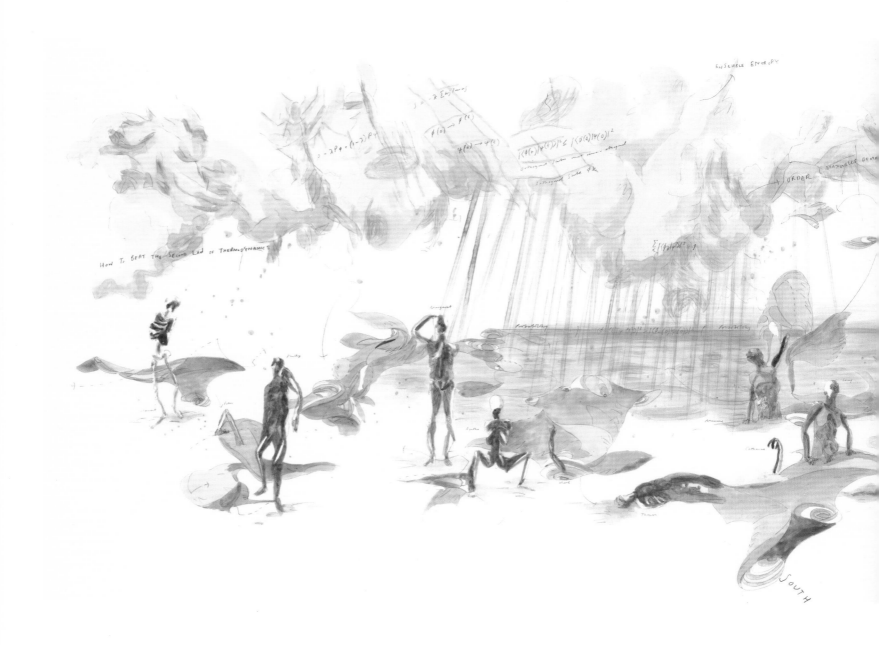

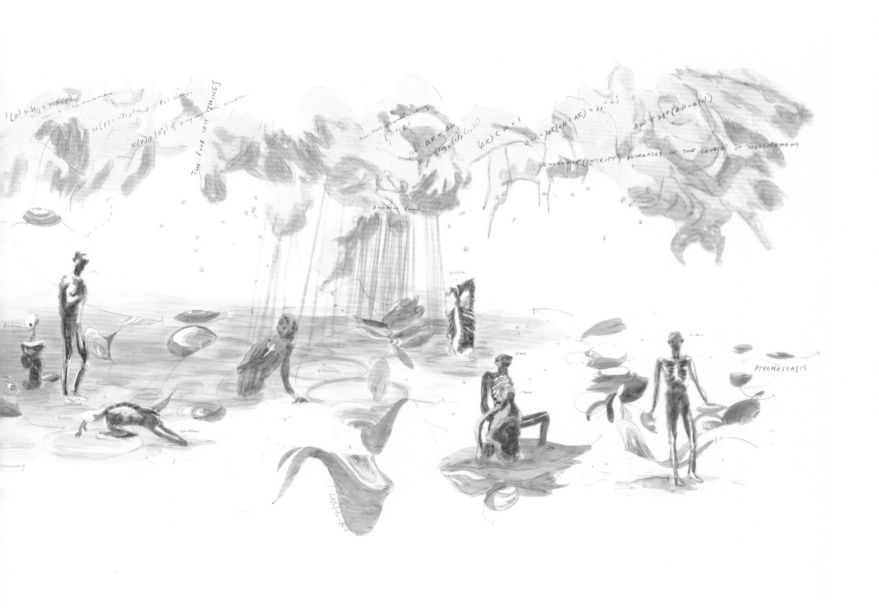

73. Matthew Ritchie
*Everyone Belongs to
Everyone Else.* 2000–2001
Ink and graphite on plastic
sheet, one from suite of
seven drawings, each 22 x 65"
(55.9 x 165.1 cm)

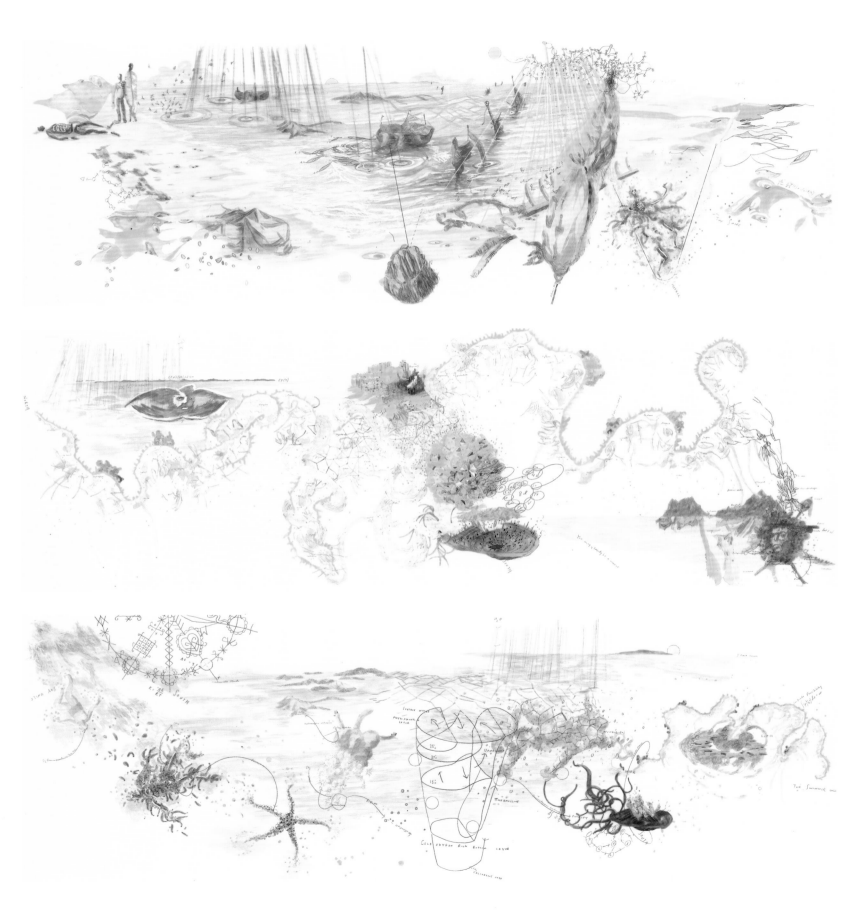

74–79. Matthew Ritchie
*Everyone Belongs to
Everyone Else.* 2000–2001
Ink and graphite on plastic
sheet, six from suite of seven
drawings, each 22 x 65"
(55.9 x 165.1 cm)

80, pp. 102–3.
Matthew Ritchie
*Everyone Belongs to
Everyone Else.* Detail of
plate 79

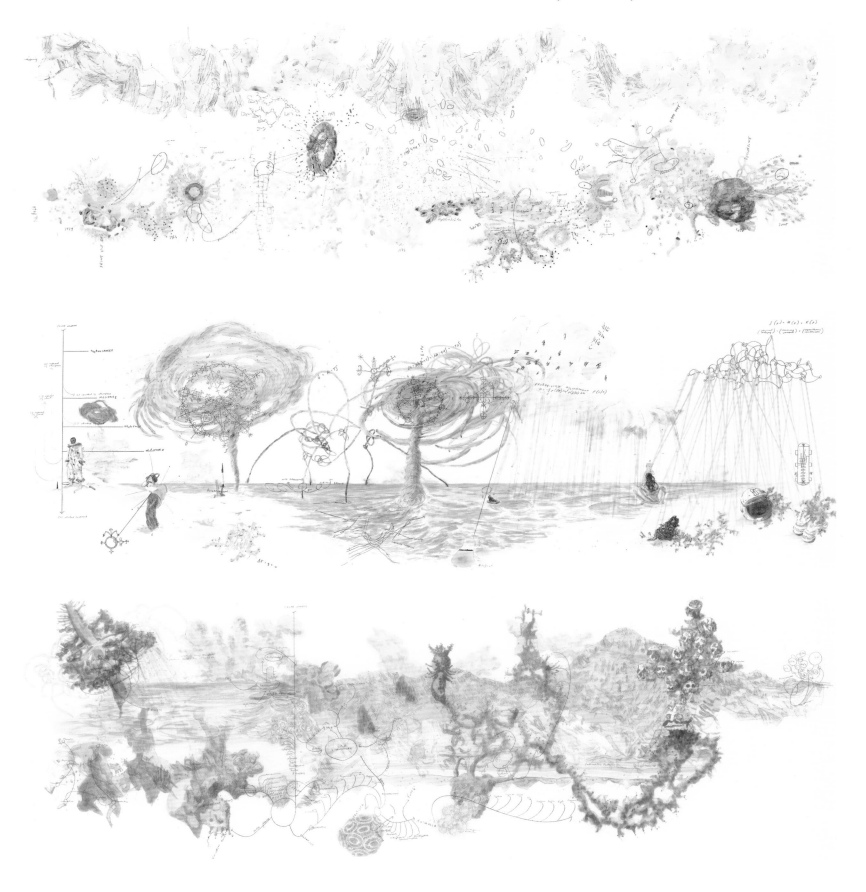

Oceanic
HydroThermal vents

Sulphur rede
bacteria.
chemobatho and
hyperthermof

CULT OF THE HEAD

C A T ANCESTOR G

Chlorobium

Cytophaga

Bacillus

Chloroplast

Thermus

Thermomicrobium

Aquifex

BACTERIA

BURIAL

CY
LITHOS

Methanobacterium

Thermococcus

Sulfolobus

Thermoproteus

Oxidation

Thermofilum

ARCHAEA

pJP 78

pJP 27

Pyrite

Physarum

OXYGEN

FeO2

Encephalitozoon

HOLOCAUST

Giardia

Hexamita

Trichomonas

BRANCH

CYTOSKELETON

EUKARYOTES

popular culture and national culture

kai althoff
kara walker
shahzia sikander
jockum nordström

1. Moritz von Schwind. *Rubezahl*.
1851–59. Oil on canvas,
25⅜ x 15¹¹⁄₁₆" (64.4 x 39.9 cm).
Schack-Galerie, Bayerische
Staatsgemäldesammlungen, Munich

The word "illustrative" has been somewhat derogatory in the context of art, because an illustration, as an image inspired by a text, implies an easy reliance on a source outside the artistic imagination[1]. Like the equally pejorative "decorative," "illustrative" also connotes a graphically lively, colorful kind of drawing produced for commercial purposes or entertainment. Above all, an illustration is readable, suggesting a lack of discursive complexity that has in the past sealed its banishment from the fine-art discourse. If the literary equivalent of the drawing might be the lyric poem, illustration finds its analogy in something closer to the ground: the narrative folktale, repository for the stock characters and the social and moral conventions of vernacular culture[2].

A surprising amount of contemporary figurative drawing adopts the styles of vernacular illustration, most interestingly as a means to examine cultural traditions and reignite old myths or fashion new ones. Adopting culture-specific imagery, naive styles, or traditional techniques in full awareness of their sometimes dangerous connotations, Kai Althoff, Kara Walker, Shahzia Sikander, and Jockum Nordström embrace them with purpose and without sarcasm.

An artist in many mediums, including painting, sculpture, and installation, Althoff has found inspiration in German folk illustration and mid-nineteenth-century folkloric paintings by artists such as Carl Spitzweg and Moritz von Schwind (fig. 1). Althoff's group of watercolors from the year 2000—intimate scenes of young men lounging in a field, gathering wood, or walking in a garden at sunset—bears a relationship to the middle-class sensibility

embodied by Spitzweg's and von Schwind's illustrative tableaux, even while its palette of purple blues, grays, and dusky pinks gives it a mysterious, even morbid air that is alien to nineteenth-century *Gemütlichkeit*. Althoff describes these works as "sad,"[3] but that is too mild; these sweet, blurry depictions exude a profound sense of loss of and longing for some past time and place where youth and poetry cohabited harmoniously—some "pleasure garden of the young race"[4] where Goethe, Schiller, and Fichte might roam the streets murmuring snatches of Novalis's poetry.

Althoff's earlier endeavors have included an album of classic German folk songs (if in heavy-metal interpretations), and it is tempting to see his drawings as expressing a subtle but insistent nostalgia for a specifically German past. But as their allusions to different German golden ages proliferate—they are Romantic in inspiration, somewhat Biedermeier in style, decidedly fin-de-siècle in tone, and suspiciously current in imagery—it becomes harder to see them as nostalgic for a particular era. Instead, in their depiction of brotherhood, nature, and village innocence, they seem less a lament for the past than a kind of hopeful prescription for the present.

Walker too mines history to comment on the present, but the past she retrieves is a shameful episode in history: the story of African enslavement in America. Working both in drawing and in room-scale installations of cut-paper silhouettes, and using imagery from sources as diverse as cartoons, minstrel shows, broadside advertising, and later soft-porn bodice-rippers about life on the old plantation, Walker

graphically depicts transgressive, sometimes horrific doings in an antic style that only emphasizes the disturbing nature of her subject.

"It took me a really long time to realize that what I like about art is pictures that tell stories that people can understand,"[5] says Walker, explaining her fascination with the silhouette, an eighteenth-century technique stereotypically known in the American visual-arts tradition as an antebellum ladies' pastime. Although Walker's silhouettes are her best-known work, she has also produced many drawings, in charcoal, ink, pencil, and gouache. Once mainly preparatory works for silhouettes, they now stand on their own, combining old master virtuosity with a feel for caricature worthy of George Cruikshank or Robert Crumb. Some of these works are gathered in an ongoing series called "Negress Notes" (begun in 1995)—a half dozen folios of notebook-sized pen-and-ink drawings, sometimes accompanied by snatches of dialogue or narrative related by one "Miss K. Walker, a Free Negress of Noteworthy Talent." The "Negress Notes," like the silhouettes, are inspired by vernacular material—what Sydney Jenkins has called "bits of nineteenth-century pop culture," like children's-book illustrations, sign painting, and woodcuts.[6] They have another nineteenth-century precedent in popular novelizations of the travails of slaves, supposedly told in the slave's "own voice" and published for white readers by antebellum abolitionists. Walker is interested, she says, in "truthful forms of historical fiction," and in using that "remove of history to access contemporary concerns."[7]

In "Negress Notes" and other projects Walker renarrates mythologized tales of slavery,

from the novel *Uncle Tom's Cabin* (1852) to the movie *Mandingo* (1975), reclaiming them by telling them as a victor, not a victim. Sikander, a Pakistani artist living in New York, is similarly involved in using traditional methods to retell old stories. As an art student in Lahore, Sikander stood out through her focus not on contemporary art but on traditional Asian miniature painting. Fascinated by their craft orientation and labor-intensiveness, she became adept at figure styles from the Persian, Mughal, Kangra, Deccan, and Rajput traditions. "The consensus was that miniature painting was a stylized and faded genre that had more to do with craft and technique than genuine expression. But, clearly, we have some relationship to the form even if it is just nostalgia," she has said.[8] Over the past several years, whether as a student at the Rhode Island School of Design or as an artist based in Houston and now in New York, Sikander retains the materials, techniques, styles, and even some of the characters of traditional Asian miniature painting but in a radically altered form. Addressing a "timeless" tradition in which rigorous rules govern everything from the preparation of the paper to the poses of the figures, Sikander creates altogether contemporary work not by breaking conventions but by inverting them.

In Sikander's miniatures, the figures of women have invaded an art that, in its Muslim incarnations, once depicted only men. Hindu goddesses peak shyly from behind transparent Muslim veils, and references to Western myths and folktales, from Rapunzel to Red Riding Hood, infiltrate scenes of Hindu deities. Sikander usually sticks close to the formal conventions of her chosen stylistic traditions, but in a striking

pair of delicate pencil drawings from 1997 she makes a definitive break with them as well. Detailed but lacking color or other decorative embellishment, the drawings would be considered unfinished according to the codes of miniature painting, but if these female figures on white grounds do seem in a way naked, they also seem liberated from the heavily decorated backgrounds that in other works give them context but also the aura of the past. Some dancing, some smiling, they fairly beam their sensuality, like the contemporary women they are.

Where many critics see a clash of cultures in Sikander's work, the historian Faisal Devji perceives complex dialogues among cultures and religions and the discovery of common ground through shared myths. Remarking that Sikander "neither combines Hindu and Muslim images into a homogenous national culture, nor arranges them side by side to conjure a liberal pluralism," Devji argues that she allows each image to remain exotic for its opposing viewer, in a kind of "exoticism of mutual intrusion." Far from illustrating difference, he writes, Sikander "is in fact stating...that the failure of translation, the failure to find a universal language, fuels desire."[9]

The notion that a foreign image, technique, or style might fuel desire rather than incite critique is illuminating in reference not only to Sikander but to many artists who insert elements of a vernacular or local tradition into fine-art production. Nordström's untutored-looking images could not look more different from Sikander's precise miniatures, but both oeuvres simultaneously exemplify a devotion to a traditional style and a rethinking of it in terms of hybridity, mystery, and desire. In addition to making art,

Nordström has been a successful children's-book illustrator in his native Sweden. Although his drawings and cut-paper collages only cursorily resemble his commercial work, their style illuminates his interest in art both for and by children.

In his collages Nordström consciously retains a clumsy pictographic style; the drawings are more finely detailed but similarly primitive. The imagery in both kinds of work — stylized trees, elfin figures — has the look of folk illustration, but what folk might that be? The collages could be construed as vaguely Nordic, but only through imaginative sympathy; no details argue for this placement, nor can we identify the iconography or recognize the characters. In fact Nordström seems to have created his own cast of folkloric characters, none of them corresponding to a known type. Arranged in poetically ambiguous or even bizarre or surreal tableaux bearing no resemblance to any folk tradition but one created by Nordström himself, these collages gleefully destroy just what is most treasured in the folktale: its familiarity.

1. See Kimerly Rorschach, *Blake to Beardsley: The Artist as Illustrator*, exh. cat. (Philadelphia: Rosenbach Museum and Library, 1988).
2. See David Blamires, *Happily Ever After: Fairytale Books through the Ages*, exh. cat. (Manchester: John Rylands University Library of Manchester, 1992).
3. Kai Althoff, in an interview with the author, June 2001.
4. Gert Schiff, *German Masters of the Nineteenth Century: Paintings and Drawings from the Federal Republic of Germany*, exh. cat. (New York: The Metropolitan Museum of Art and Harry N. Abrams, 1981), p. 10.
5. Kara Walker, quoted in Sydney Jenkins, "Slice of Hand: The Silhouette Art of Kara Walker," in *Look Away Look Away Look Away* (Annandale-on-Hudson: Center for Curatorial Studies, Bard College, 1995), p. 17.
6. See Jenkins, "Slice of Hand," pp. 25–26.
7. Walker, quoted in *Kara Walker: An Interview with Larry Rinder*, exh. brochure (San Francisco: California College of Arts and Crafts, 1998), n.p.
8. Shahzia Sikander, quoted in Homi Bhabha, "Chillava Klatch: Shahzia Sikander Interviewed by Homi Bhabha," in *Shahzia Sikander*, exh. cat. (Chicago: The Renaissance Society at the University of Chicago, 1998), p. 17.
9. Faisal Devji, "Translated Pleasures," in ibid., pp. 14, 15.

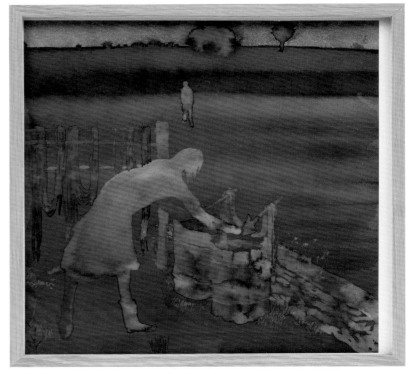

81. Kai Althoff
Untitled. 2000
Watercolor on paper,
11⅞ x 12⅝" (30 x 32 cm)

82. Kai Althoff
Untitled. 2000
Watercolor on paper,
11⅞ x 12⅝" (30 x 32 cm)

83. Kai Althoff
Untitled. 2000
Watercolor on paper,
11⅞ x 12⅝" (30 x 32 cm)

84. Kai Althoff
Untitled. 2000
Watercolor on paper,
11⅞ x 12⅝" (30 x 32 cm)

85. Kai Althoff
Untitled. 2000
Watercolor on paper,
11⅞ x 12⅝" (30 x 32 cm)

86. Kai Althoff
Untitled. 2000
Watercolor on paper,
11⅞ x 12⅝" (30 x 32 cm)

87. Kai Althoff
Untitled. 2000
Watercolor on paper,
11⅞ x 12⅝" (30 x 32 cm)

88. Kai Althoff
Untitled. 2000
Watercolor on paper,
11⅞ x 12⅝" (30 x 32 cm)

89. Kai Althoff
Untitled. 2000
Watercolor on paper,
11⅞ x 12⅝" (30 x 32 cm)

90. Kai Althoff
Untitled. 2000
Watercolor on paper,
11⅞ x 12⅝" (30 x 32 cm)

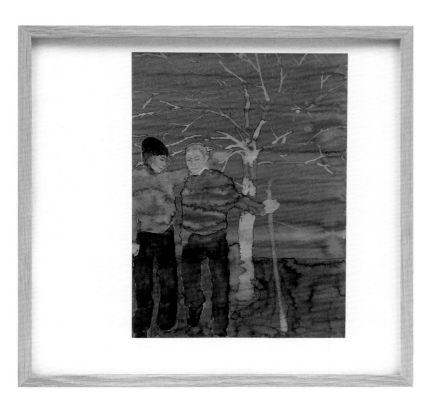

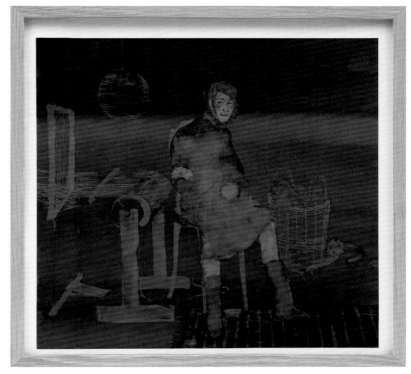

91. Kai Althoff
Untitled. 2000
Watercolor on paper,
11⅞ x 12⅝" (30 x 32 cm)

92. Kai Althoff
Untitled. 2000
Watercolor on paper,
11⅞ x 12⅝" (30 x 32 cm)

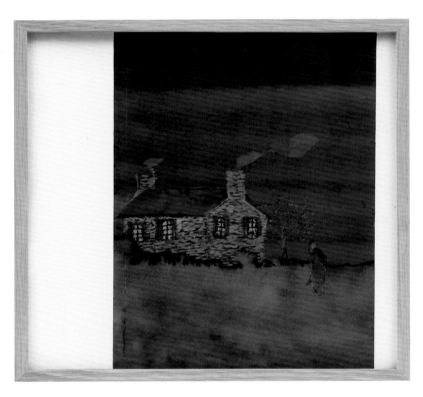

93. Kai Althoff
Untitled. 2000
Watercolor on paper,
11⅞ x 12⅝" (30 x 32 cm)

94. Kai Althoff
Untitled. 2000
Watercolor on paper,
11⅞ x 12⅝" (30 x 32 cm)

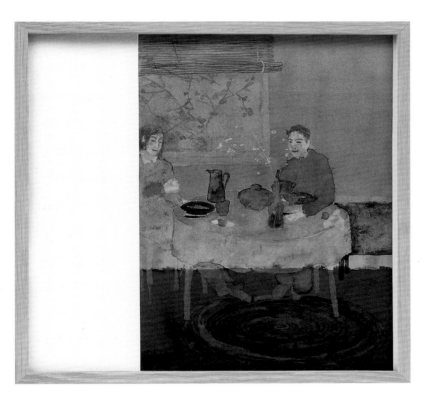

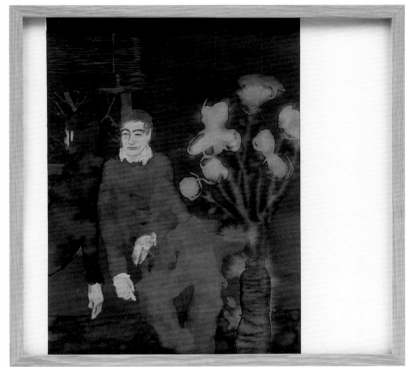

95. Kai Althoff
Untitled. 2000
Watercolor on paper,
11⅞ x 12⅝" (30 x 32 cm)

96. Kai Althoff
Untitled. 2000
Watercolor on paper,
11⅞ x 12⅝" (30 x 32 cm)

115

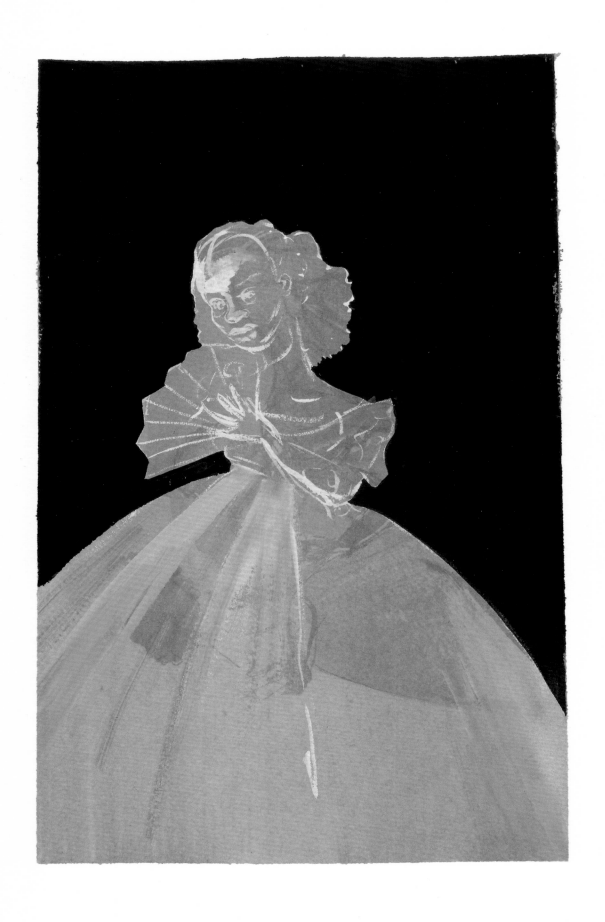

97. Kara Walker
Negress Notes. 1996
Watercolor on paper, one
of twenty-one sheets,
10¼ x 7" (26 x 17.8 cm)

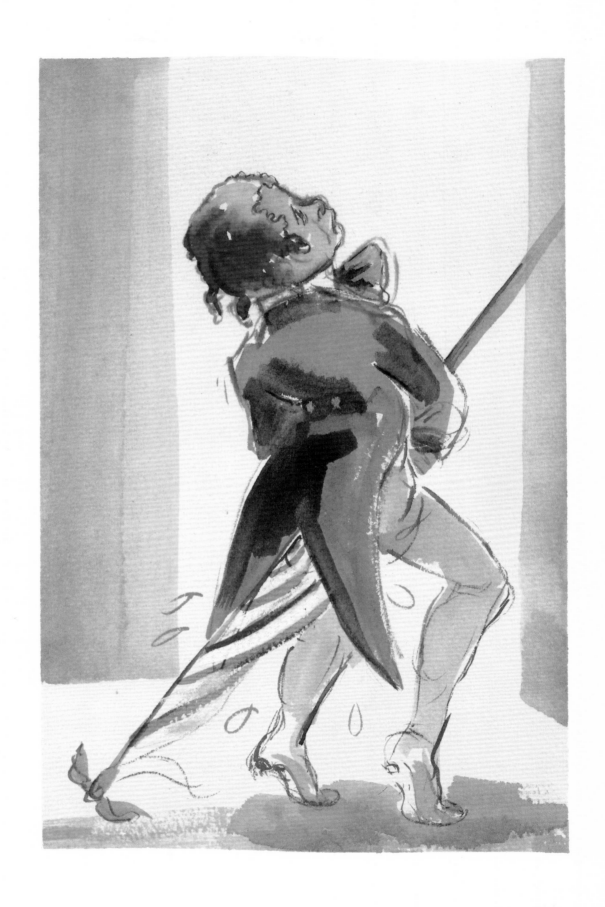

98. Kara Walker
Negress Notes. 1996
Watercolor on paper, one
of twenty-one sheets,
10¼ x 7" (26 x 17.8 cm)

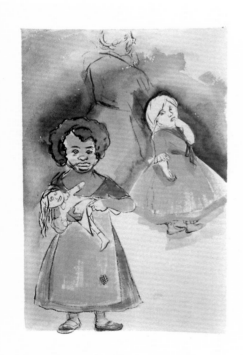
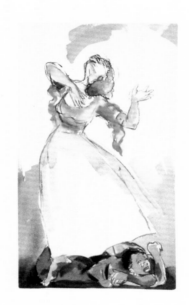
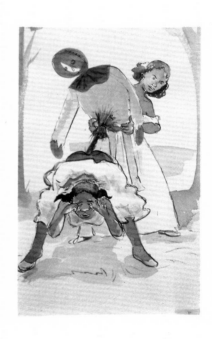

99–101. Kara Walker
Negress Notes. 1996
Watercolor on paper, three
of twenty-one sheets,
each 10¼ x 7" (26 x 17.8 cm)

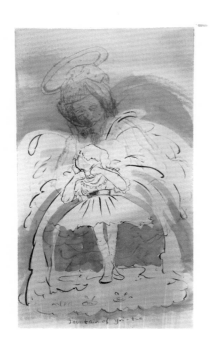

102–4. Kara Walker
Negress Notes. 1996
Watercolor on paper, three
of twenty-one sheets,
each 9 x 6" (22.9 x 15.2 cm)

105. Shahzia Sikander
*Where Lies the
Perfect Fit.* 1997
Pencil on paper,
10¾ x 7¾"
(27.2 x 19.7 cm)

106. Shahzia Sikander
*In Your Head and
Not on My Feet.* 1997
Pencil on paper,
10¾ x 9½"
(27.2 x 24.2 cm)

107. Shahzia Sikander
The Resurgence of Islam. 1999
Vegetable color, dry pigment,
watercolor, gold leaf, and tea
on hand-prepared "wasli" paper,
15¾ x 19¾" (40 x 50.2 cm)

108. Jockum Nordström
The Forest of Death. 2001
Mixed mediums and collage,
50¾ x 39⅝" (129 x 98 cm)

109. Jockum Nordström
The Judicature. 2001
Mixed mediums and collage,
43¹¹⁄₁₆ x 40¹⁵⁄₁₆" (111 x 104 cm)

110. Jockum Nordström
The Four Cardinal Points. 2001
Mixed mediums and collage,
48⅝ x 34¼" (123.5 x 87 cm)

111. Jockum Nordström
For Once Playing Guitar. 2001
Mixed mediums and collage,
35¹³⁄₁₆ x 28⅜" (90.8 x 72 cm)

112. Jockum Nordström
For Once Playing Guitar.
Detail, actual size

comics and other subcultures

barry mcgee
yoshitomo nara
takashi murakami

In my youth my ears were deafened
by a variety of skull cries,
Liberty, Progress, Science, Culture.

1. Raymond Pettibon. *No title (In My Youth).* 1994. Black and colored ink on paper, 22⅜ x 15⅛" (56.8 x 38.4 cm). The Museum of Modern Art, New York. Gift of the Friends of Contemporary Drawing

The most popular modern form of vernacular illustration is the comic strip. Its development was slow: historians of the genre date its beginnings to 1833, and the Swiss artist Rodolphe Töpffer's book *L'Histoire de M. Jabot*, but the first newspaper comic strip, Richard Felton Outcault's "Yellow Kid" in the *New York World*, did not run until 1895, and the first true comic book, *Funnies on Parade*, was published only in 1933. There followed, however, a fifty-year American golden age in which comics became a central part of the phenomenon of widespread visual literacy.[1]

The 1960s saw an explosion of underground comics, which differed from their commercial counterparts in that they grappled with social and political subject matter, with reality as well as fantasy. With the advent of small-press, noncommercial comic publishers like the San Francisco–based Zap, in 1968, a comics subculture merged with other subcultures, including those of art and popular music. Raymond Pettibon's work exemplifies the kinds of hybrids that were the result (fig. 1). In the late 1970s, Pettibon, a comics fan with close links to the Los Angeles punk scene, began making drawings in a black-and-white style inspired by American comics of the 1950s. Although first published as small-circulation comic books, Pettibon's works were not exactly comics, but neither were they the kind of appropriations of comics affected by older artists like Roy Lichtenstein, Andy Warhol, or Sigmar Polke. Pettibon's drawings are comic art in a mutated form, eschewing the defining element of sequential storytelling.

Precisely the dimension of comics that Pettibon ignores — that of extended narration —

has been embraced by artists of a slightly younger generation. In drawing comic narratives not on paper but on the cityscape itself, the San Francisco artist Barry McGee is pioneering a creative variant on the comic strip's sequential form. His chiaroscuro drawings of sad-sack characters owe much to the premier Zap artist Robert Crumb (fig. 2), but McGee is also a graffiti artist, or "tagger," who paints signature outdoor images of "hobos, job slaves and walking wounded" who loiter, pose, and die on backdrops ranging from delivery trucks to liquor bottles.[2] The draftsmanship of McGee's images, though, makes them unlike most other street art but for the most sophisticated. To explore a neighborhood where McGee has worked is to experience a comic narrative in space. That he can produce this level of detail under the pressured conditions that usually govern the making of street art is a measure of his work's allure, but also of his commitment to graphic narrative, however widespread his vignettes might be.

McGee has successfully translated his work into drawings and wall paintings that are exhibited in museums and galleries. Since his street work already demonstrates as much interest in the image made as in the action performed, the transfer of that image to the gallery was a logical step, but for McGee, the indoor and the outdoor work stand apart from one another. "What's done in the gallery," he states flatly, "is an entirely different thing."[3] The difference lies in the way he deploys his works for galleries, hanging them individually in frames as battered as their characters, and arranging them in mutating sequences that climb walls and continue around corners.

2. Robert Crumb. *Self Portrait with Banjo*. 1998. Pencil on paper, 8½ x 6" (21.6 x 15.2 cm). Courtesy Paul Morris Gallery, New York

Characters reappear within the matrix and narrative depending on the viewer's way of reading the work.

The critic Midori Matsui has discussed a "new notion of drawing created by young American and Japanese artists in the 1990s." "Sharing themes and styles with subcultures"[4] and "subcultural idioms" including vernacular and naive art, illustration, and animation,[5] Matsui writes, these artists have "reinvented drawing as a vehicle for developing a unique narrative space."[6] The Japanese artists who have done most to define that space are Yoshitomo Nara and Takashi Murakami, and they do so through the language of cartoons, comics, and animation.

In his influential essay "The Superflat Manifesto" (2000), Murakami argues that contemporary Japanese art, once isolated from Western popular culture, can now claim to be part of it. Japanese aesthetics, meanwhile, once divided into *geijutsu*, or arts and crafts, and *bijutsu*, or fine art, now collapses those distinctions to harbor a hybrid that combines high art and decoration, eccentric painting and animated cartoons. Superflat culture involves a vast horizontal panorama, stretching from Japanese decorative art to Japanese and Western comics and animation, from the ukiyo-e artist Katsushika Hokusai to the Pop artist Warhol. This panoramic view is also planar: Japan is seen as a surface, like a projection on glass. "No one has yet taken a serious look at the image resulting from the integration of layers of entertainment and art," says Murakami, "but the integration is already occurring."[7] Murakami and Nara have become the foremost practitioners of the superflat ideal.

Nara locates his artistic forebears not in the historical avant-gardes, whether Western or Japanese,[8] but in "ordinary pop culture" and specifically in *manga*, or Japanese popular comics.[9] The choice, he claims, does not reflect a rejection of Japanese art history; in fact his cartoonlike manner of drawing is as much a part of Japanese culture (in Japan's popular prints of leisure activities) as of the Western art (the work of Lichtenstein, Polke, and Warhol) that he studied at the Düsseldorf Kunstakademie in the early 1990s.[10] In keeping with this superflat stylistic mix, Nara's repertoire of characters includes sad-eyed doggies that flop sleepily, like stuffed animals, and a small army of sharp-eyed schoolgirls, their outsized heads balanced on blocky little bodies and their mischievous, sometimes downright evil deeds belying their doll-like aspect. These simplified drawings recall the Japanese comics and cartoons of Nara's 1960s childhood, like *Gigantor* and *Speed Racer*, more than contemporary *manga*.[11] They also evoke Ernie Bushmiller's great American comic strip *Nancy*, which is syndicated all over the globe.

In a group of drawings from 1999, Nara inserts his signature characters into well-known ukiyo-e prints. Ukiyo-e, or "floating world," is the genre of Japanese print that depicts secular pleasures and entertainments, from banquets to sexual assignations. These colorful works were easily available and extremely popular in Japan from the seventeenth to the mid-nineteenth century, much as *manga* are today. In fact it was Hokusai, one of the greatest ukiyo-e artists, who coined the term *manga*, to describe his own work.[12] Nara's little girls, their enormous heads emerging from sunset seas or blocking views of

Mount Fuji, do not blend easily with the floating world but make aggressive incursions into its voluptuous calm. The superflat notion need not connote integration; in Nara's version of ukiyo-e, cultural collisions and the delightful frictions they cause are as much a theme as cultural continuity. "The expressions born of the people, not of tradition," Nara has said, "retain their contact with life…they are powerful and real in any situation."[13] His ukiyo-e series is a test of that contention, a *manga a manga* matchup in which both forms of graphic narrative hold their own.

"*Otaku*" is a quasi-pejorative Japanese word for young people obsessed with pop culture, and in particular with *manga* and Japanese cartoon animation, or *anime*. Both Nara and Murakami proudly claim *otaku* status, and their devotion to the history of *manga* and *anime* goes beyond mere subversiveness. Unlike Nara, Murakami attended art school in Japan, where he drew from plaster casts of classical Greek and Roman statuary and studied *nihon-ga*, a fine-art hybrid of Eastern- and Western-style painting. He was fascinated by *manga* and *anime*, however, and in 1993 he created his own *manga* character, an asexual human-dog-mouse hybrid that he calls DOB. Murakami has put DOB through its paces in paintings, drawings, prints, sculptures, and inexpensive souvenirs such as stuffed toys, key chains, and computer screen-savers. For Murakami, *anime* is drawing in motion. Although he has never produced an animated film, some of his sculptures and drawings are inspired by models of *anime* characters that fans can build from commercially available kits. One group of drawings shows female superheroes — half women, half jet-fighter planes — on otherwise blank paper, and is brought to a degree of finish

unique in Murakami's works on paper, most of which are executed not by hand but on the computer.

Matsui tells us that the bias against the decorative and the illustrational exists in Japanese as well as Western aesthetics,[14] and Murakami's *anime* drawings directly test this presupposition. In that the drawings relate to sculptural figures, they suggest that this academically trained artist is making a bold analogy to the student copying of Greek and Roman statues. If a line can be drawn from the ukiyo-e print to *anime*,[15] so can one from the Apollo Belvedere to the *otaku* figurine.

1. See Will Eisner, *Graphic Storytelling* (Tamarac, Fla.: Poorhouse Press, 1996), p. 3.
2. Barry McGee, quoted in Susie Kalil, "Street Creed," in *Barry McGee: Hoss,* exh. cat. (Houston: Rice University Art Gallery, 1999), n.p.
3. McGee, quoted in Kalil, "Interview with Barry McGee," in ibid.
4. Midori Matsui, "Toward Fragmentation: The Drawing as Form," in Taro Amano, ed., *I Don't Mind if You Forget Me: Nara Yoshitomo,* exh. cat. (Yokohama: Yokohama Museum of Art and Nara Yoshitomo Exhibition Committee, 2001), pp. 163–64.
5. Matsui, "A Gaze from the Outside: Merits of the Minor in Yoshitomo Nara's Painting," in ibid., pp. 168–69.
6. Matsui, "Toward Fragmentation," pp. 163–64.
7. Takashi Murakami, "A Theory of Super Flat Japanese Art," *Superflat* (Tokyo: Madra Publishing Co., 2000), p. 25.
8. In "A Gaze from the Outside," p. 168, however, Matsui links Nara to the Japanese-American modernist Yasuo Kuniyoshi and the French painter Balthus.
9. See Matsui, "Toward Fragmentation," p. 164.
10. See Eric Nakamura, "Yoshitomo Nara: Kids, Dogs and Knives on Canvas," *Giant Robot* no. 20, *When Humans Attack* (Winter 2000): 26.
11. See ibid. It is important to note, as Nakamura does, that Nara does not appropriate characters from comics or other sources but creates characters of his own.
12. See Amada Cruz, "DOB in the Land of Otaku," in Cruz, Dana Friis-Hansen, and Matsui, *Takashi Murakami: The Meaning of the Nonsense of the Meaning,* exh. cat. (Annandale-on-Hudson: Center for Curatorial Studies, Bard College, 1999), p. 19. Interestingly, Nara omits Hokusai's best-known works from this series.
13. Nara, quoted in Matsui, "A Gaze from the Outside," p. 175.
14. See Matsui, "Toward a Definition of Tokyo Pop: The Classical Transgressions of Takashi Murakami," in *Takashi Murakami: The Meaning of the Nonsense of the Meaning,* p. 23.
15. Ibid., p. 29.

113. Barry McGee
Untitled. 1998–2002
Drawings, photographs, and found
objects, dimensions variable
Installation view, Deitch Projects,
New York, 2000

114, pp. 134–35. Barry McGee
Untitled (detail). 1998–2002
Drawings, photographs, and found
objects, dimensions variable
Installation view,
Fondazione Prada, Milan, 2002

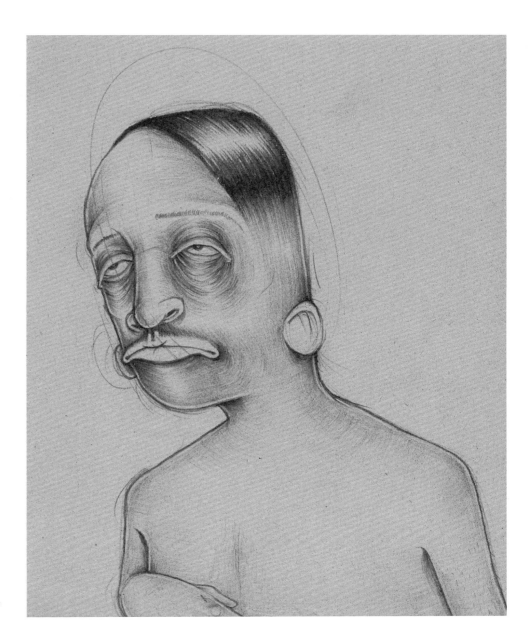

116. Barry McGee
Untitled. Detail

115. Barry McGee
Untitled (detail). 1998–2002
Drawings, photographs, and found
objects, dimensions variable
Installation view,
Fondazione Prada, Milan, 2002

117. Yoshitomo Nara
Time of My Life. 1992–2000
Colored pencil, magic marker,
ballpoint pen, graphite,
and acrylic on paper,
eighty-six sheets
Installation view, Santa Monica
Museum of Art, 2000

118. Yoshitomo Nara
Time of My Life. 1992–2000
Colored pencil, magic marker,
ballpoint pen, graphite,
and acrylic on paper, one
of eighty-six sheets,
10 x 7" (25.4 x 17.8 cm)

119. Yoshitomo Nara
Time of My Life. 1992–2000
Colored pencil, magic marker,
ballpoint pen, graphite,
and acrylic on paper, one
of eighty-six sheets,
5¾ x 3½" (14.6 x 8.9 cm)

120. Yoshitomo Nara
U-ki-yo-e. 1999
Oil on book pages,
one of sixteen parts,
13 x 16⅝" (33 x 42.1 cm)

121. Yoshitomo Nara
U-ki-yo-e. 1999
Oil on book pages,
one of sixteen parts,
16⅝ x 13" (42.1 x 33 cm)

阿波鳴門之風景 大判錦絵

102・103・104 安藤（歌川）重筆 阿波鳴門之風景

122. Takashi Murakami
Study for SMP Ko2. 1999
Watercolor on illustration board,
16⁹⁄₁₆ x 11¹¹⁄₁₆" (42.1 x 29.7 cm)

123. Takashi Murakami
Study for SMP Ko2. 1999
Watercolor on illustration board,
17 1/16 x 12 11/16" (43.3 x 32.2 cm)

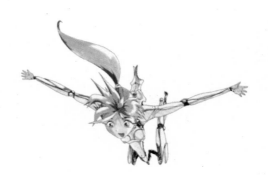

124–27. Takashi Murakami
Sakurako Jet Airplane
nos. *2*, *3*, *4*, and *6*. From the series
Sakurako Jet Airplane nos. 1–6. 1995
Watercolor on paper, four of six sheets,
each 18 x 141/2" (45.7 x 36.8 cm)

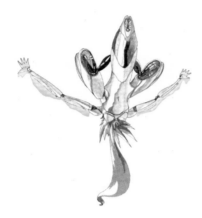

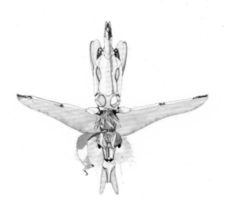

eight

fashion, likeness, and allegory

elizabeth peyton
graham little
john currin

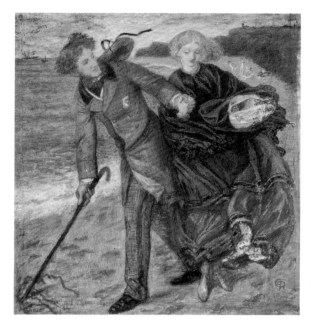

1. Dante Gabriel Rossetti.
Writing on the Sand. 1859.
Watercolor on paper,
10⅜ x 9½" (26.3 x 24.1 cm).
The British Museum, London

In 1848, the London painters Dante Gabriel Rossetti, William Holman Hunt, and John Everett Millais formed an association they called the Pre-Raphaelite Brotherhood. Emulating the anonymous artist-craftsmen who flourished before the Renaissance, the Pre-Raphaelites concentrated on art's capacity to edify, through the beauty and skill of decorative form as well as through allegorical subject matter often drawn from history, the Bible, folklore, and myth. Known for its detail, color, and sharp clarity, as well as for its faintly medieval aesthetic of fashion and beauty, this work balanced delicately on the line between illustration and history painting, between ornament and narrative.

Drawing was an important medium for Rossetti and Millais,[1] and Pre-Raphaelite drawings in general attained a high degree of finish and detail, reinforcing the connection to both graphic design and narrative illustration (fig. 1). Indeed these works on paper could often be read like stories.[2] Although briefly popular in the 1960s, the Pre-Raphaelite phenomenon has not weighed heavily in contemporary art discourse, but in the early twenty-first century the group's peculiar mixture of craft, fashion, and idealism is newly relevant to a number of artists striving for a similar integration between fine and commercial art. Over the last ten years the American artist Elizabeth Peyton has produced a large body of work that includes paintings, drawings, gouaches, and prints. She has concentrated on portraiture, at the beginning of her career producing small pictures of celebrities and other personal, popular, and historical heroes, rendered with a quick-brushed tenderness expressing the emotions more of a lover than of a fan. More recently she has limited her subjects to friends and fellow

artists. In either case, Peyton's winsome line and gorgeous color transform and aestheticize, turning her figures into graceful sylphs and hollow-cheeked dandies as colorful and graphic as the backgrounds in which they are embedded.

This practice of fictionalizing, even mythologizing contemporary subjects by rendering them in a decorative and vaguely nostalgic style seems directly inspired by the Pre-Raphaelites, but Peyton draws on another, more current source as well: contemporary fashion illustration. Gracefully arranged in attitudes familiar from magazines, the young and attractive people in Peyton's images often seem to be modeling rather than posing. These paintings and drawings are not only stylized but idealized. Although the works are portraits, the figures are rarely direct likenesses of their subjects; instead they sport identifying attributes or poses. Whether male or female, they also share certain generically attractive features—aquiline noses, almond eyes, and delicate, almost lanky bone-structures. In fact their identities are often only discernible through their clothes, their surroundings, or the works' titles. This conceit is part and parcel of the artist's idolization of her subjects, but it is also characteristic of the fashion illustrator, who, like Peyton, makes drawings about image, or, more accurately, draws portraits not merely of individuals but of current ideals of beauty.

Peyton is not the first artist to refer to fashion illustration in her drawing. Karen Kilimnik, for example, an American a decade older than Peyton, has produced works on paper that faithfully copy photographs of fashion models and celebrities since the 1980s. Coupled with

149

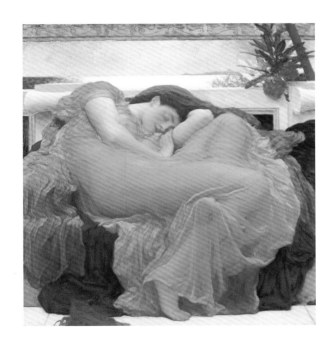

2. Frederic Leighton. *Flaming June.*
c. 1895. Oil on canvas, 46⅞ x 46⅞"
(119 x 199 cm). Museo de Arte de
Ponce, The Luis A. Ferré Foundation,
Inc., Ponce, Puerto Rico

handwritten captions—sometimes snatches of news stories, sometimes diaristic personal reminiscences—Kilimnik's images are ironic commentaries on the unreal, media-saturated lives of the rich and famous, and on the ways we can find ourselves living our own lives through them. Peyton's drawings lack both the pathos and the anger of Kilimnik's. Rather than mocking her sources, Peyton depicts her subjects with the eye of a fan, surrounding celebrities and friends alike with an aura of glamour. However modest her work's scale and however specific her subject matter, her purpose is both ambitious and daring: forging an unironic (and therefore all the more dangerous) partnership with fashion and fanzine pictures—sources outside fine art— Peyton wants her work to reach a world as wide as those images do but also to transcend their ephemerality and live on. "Fifteen-year-old kids who need a lot of hope get it from music, because it's so much more there for them in the media, magazines, movies, and so on. I think art can give people the same things but more," Peyton has said. "All really great art has to be of its time—fashionable—and outside of its time—timeless."[3]

Graham Little, a British artist half a generation younger than Peyton, takes her fashion allusions to their logical late-1990s conclusion, decking out his models in clothes that are easily identifiable as Armani, Gucci, Prada, and the like. The immediate subject of every portrait is not so much the anonymous people wearing these fashions as the fashions themselves, which lend the drawings their color, their texture, and to a great extent their composition. Many young artists today use fashion illustration as a model— Peyton may have opened a floodgate—but

Little's drawings stand out in their understanding of the qualities Peyton has extracted from nineteenth-century British Romanticism. Using colored pencils to suffuse his subjects in chromatically saturated atmospheres, he manages to connect his generic mannequins of the latest fashion to the venerable tradition of the female allegorical figure: clad in costumes and posed evocatively, Graham's runway models can be seen as contemporary embodiments of the classical humors, the virtues, or even the seasons. If Peyton's work seems to emulate that of the Pre-Raphaelites, Little's drawings can be more easily connected to slightly later models: the artists of the Aesthetic movement, particularly the portraitist Frederic, Lord Leighton, whose *Flaming June* (1895; fig. 2), a depiction of sultry summer heat in the guise of a sleeping female figure, has become an icon and a staple of calendar illustration. Little's untitled half-length portrait of a model sporting an orange windbreaker makes reference to Leighton's masterpiece;[4] he re-creates the heated glow and heavy, static atmosphere of that painting by surrounding his pouting model with a cloud of deep mandarin orange—the color that swathes the older work's somnolent figure.

Leighton's sensuous portraits, with their gorgeous color, polished surfaces, and scrupulous detail, were influenced by the work of the Pre-Raphaelites and by their German examples, the Nazarenes.[5] His real place, however, was among painters like J. A. M. Whistler, Edward Burne-Jones, and Rossetti (both of the latter had once been Pre-Raphaelites), who gathered around London's Grosvenor Gallery. Established in 1877, the Grosvenor attracted intellectuals like Oscar Wilde, and also its fair share of contro-

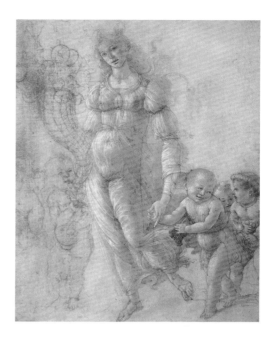

3. Sandro Botticelli. *Abundance.* 1475–78. Ink and wash over chalk on paper, tinted pink, heightened with white, 12½ x 9¹⁵⁄₁₆" (31.7 x 25.3 cm). The British Museum, London

versy: some Londoners referred to it sneeringly as "the greenery-yallery Grosvenor Gallery," and critics attributed an effeteness to the work it exhibited, as well as a shallow sensuality and a lack of formal rigor.[6] Interestingly, a similar criticism surrounds Little's practice, which has been characterized as "art for fashion-label queens."[7] Like nineteenth-century criticism of the Aesthetic movement, the twenty-first-century commentary refuses to focus on the daring of such an intense intertwining of fashion and art. Like Peyton's paintings and drawings, Little's project, which in addition to drawings includes sculpture decorated with lively surface patterns cribbed from contemporary designer clothes, plays on the appeal of fashionable society to society at large. His drawings also aim for something bigger: the moment when color, atmosphere, physical beauty, and graphic skill lift a timely picture into one that, like *Flaming June*, will outlast the fashion that it depicts.

Fashion, popular illustration, art-historical reference, and allegory merge in John Currin's works on paper, which run the technical and representational gamut from caricature to cartoons to straight portraits to traditional nudes to highly finished contemporary Floras, Ceres, and Dianas executed in pen and ink on a paper resembling the Renaissance *carta tinta*. Although most of Currin's works on paper feature a single figure, his inclusion in a chapter on likeness is somewhat arbitrary, because types rather than likenesses are this artist's bailiwick.[8] Tellingly, Currin has described himself as "the author" of his paintings and drawings, implying that each work is the repository for a story—of the anonymity of middle age (*The Moved Over Lady*, 1991), of the desire of the unfamous for

a moment of celebrity (*Charlie Rose Guest*, 1998), of the presence of death behind every visage (*The Exwife*, 2001).[9] Moving effortlessly from the modern illustrator's colored pencils to a Leonardo-esque sepia and wash, colored chalks recalling Watteau and Fragonard, and pastels in icy colors like Boucher's, Currin can return the seductively curved *Cosmopolitan* cover girl to her Botticellian roots as the personification of spring (fig. 3), then can rudely update figures from antiquity and myth, finding Flora in a shopping mall, Venus in a Victoria's Secret advertisement. His likenesses of playboys, or of women of a certain age, are pathetic and at the same time noble, neatly making the connection between the archetype and the stereotype.

1. The Pre-Raphaelite emphasis on works on paper has been attributed to the popularity of book illustration in mid-nineteenth-century England. See J. A. Gere, *Pre-Raphaelite Drawing in the British Museum* (London: British Museum Press, 1994), p. 9.
2. See Anne Carlisle, *English Drawings XIX Century* (New York, London, and Paris: Hyperion Press, 1951), p. 12.
3. Elizabeth Peyton, quoted in Linda Pilgrim, "An Interview with a Painter," *Parkett* 53 (1998): 61.
4. Graham Little, in an interview with the author, January 29, 2001.
5. Frederic, Lord Leighton studied in Germany in 1850–52.
6. The phrase "greenery-yallery, Grosvenor Gallery" derives from the Gilbert and Sullivan opera *Patience* (1881), which satirizes the Aesthetic movement. "Greenery-yallery"—green and yellow or gold—were colors associated with the movement. On criticism of the movement see Frederic Leighton Leighton of Stretton, ed., *Frederic, Lord Leighton: Eminent Victorian Artist* (New York: Harry N. Abrams, with the Royal Academy of Arts, London, 1996).
7. Alex Coles, "Graham Little," *Artext*, May–July 2001, p. 78.
8. John Currin has often claimed that all of his works, including his portraits of 1970s television matrons such as Bea Arthur and Nancy Walker, are self-portraits, but by this one would assume he is implying an allegorical relationship that speaks of his adolescent desires, fears, foibles, and prejudices. See Keith Seward, "John Currin: The Weirdest of the Weird," *Flash Art* no. 185 (November–December 1995): 78.
9. Currin, quoted in ibid.

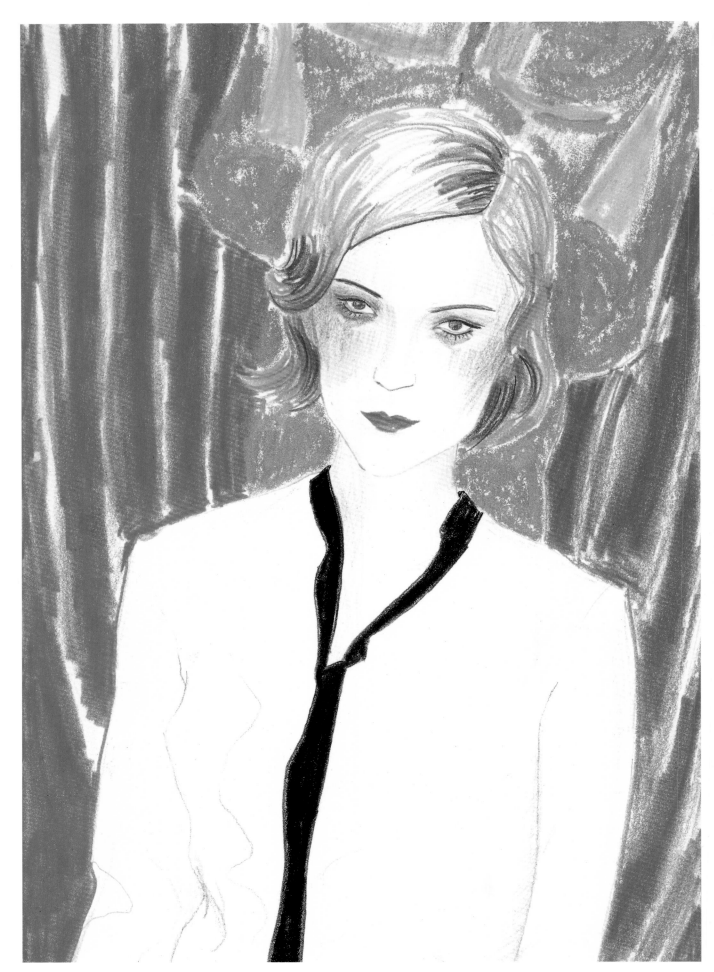

128. Elizabeth Peyton
Chloe (Gold). 2001
Colored pencil on paper,
8⅝ x 6" (22 x 15.2 cm)

129. Elizabeth Peyton
Chloe. 2000
Colored pencil on paper,
8¾ x 6" (22.2 x 15.2 cm)

130. Elizabeth Peyton
Chloe. 2001
Colored pencil on paper,
8⅝ x 6" (22 x 15.2 cm)

131. Elizabeth Peyton
Scott Walker. 1996
Watercolor on paper,
10 x 7" (25.4 x 17.8 cm)

132. Elizabeth Peyton
Spencer. 1999
Colored pencil on paper,
8¾ x 6" (22.2 x 15.2 cm)

134. Elizabeth Peyton
Daniel, Berlin. 1999
Watercolor on paper,
40 x 28¾" (101.6 x 73 cm)

133. Elizabeth Peyton
Daniel, Berlin.
Detail, actual size

135. Graham Little
Untitled. 2000
Acrylic and colored pencil
on paper,
14 x 15" (36 x 37 cm)

136. Graham Little
Untitled. 2000
Colored pencil on paper,
19 x 17" (48.5 x 43 cm)

137. Graham Little
Untitled. 2000
Colored pencil on paper,
24 x 23" (61 x 59 cm)

138. Graham Little
Untitled. 2001
Colored pencil on paper,
16⁷⁄₁₆ x 11¹³⁄₁₆" (42 x 30 cm)

139. John Currin
Hobo. 2001. Sepia ink on paper,
11½ x 9" (29.2 x 22.9 cm)

140. John Currin
Hobo. 2001. Sepia ink on paper,
11½ x 9" (29.2 x 22.9 cm)

141. John Currin
Hobo. 2001. Sepia ink on paper,
11½ x 9" (29.2 x 22.9 cm)

142. John Currin
Hobo. 2001. Ink on paper,
11½ x 9" (29.2 x 22.9 cm)

143. John Currin
Hobo. 2001. Pencil on paper,
11½ x 9" (29.2 x 22.9 cm)

144. John Currin
The Moved Over Lady. 1991
Pencil on paper,
17¾ x 15" (45.5 x 38 cm)

145. John Currin
The Clairvoyant. 2001
Gouache on prepared paper,
11⅝ x 8⅜" (29.5 x 21.3 cm)

conclusion:

the emancipation of drawing

A little while ago the critic Benjamin Buchloh somewhat fearfully described the resurgence of drawing in the 1990s as "an incessant and ever-expanding deployment of draughtsmanship."[1] This tsunami of drawing has included virtually all types of the form, from the connotative to the denotative, from the performative to the narrative. Drawing now can be work done on paper with charcoal, pencil, gouache, paint, a dirty thumb, even a small insect dipped in ink but still sufficiently alive to scuttle and leave its mark.[2]

Amidst all this work a form of drawing has arisen that has not been at the center of art discourse since arguably the mid-nineteenth century, although it never fully disappeared: the kind of autonomous drawing that is attached less to process than to finished product, that describes a specific object or state of mind, that maps a specific experience, that tells a particular story. This kind of drawing has borrowed from other types of drawing not necessarily welcome until now within the precincts of fine art, including scientific and architectural drafting, ornamental design, vernacular illustration, comics, animation, and fashion illustration. If painting, sculpture, video, film, and performance have burst the boundaries of their traditional definitions, first gradually, then all in a rush, so too has drawing, which can no longer be characterized by old criteria having to do with form, finish, and manner of execution, or by the designation of fine or avant-garde art. "The emancipation of drawing hasn't happened," Franz Ackermann has complained, "That would only happen when you don't need anything more than the drawing."[3] But Ackermann may be wrong: the work of artists emancipated *by* drawing over the past decade is evidence that drawing is all you need.

1. Benjamin H. D. Buchloh, "Raymond Pettibon: Return to Disorder and Disfiguration," *October* 92 (Spring 2000): 38.
2. The Japanese artist Yukinori Yanagi dips insects in ink and lets them run on paper. Yanagi uses the resulting patterns in drawings and prints.
3. Franz Ackermann, in an interview with the author, January 23, 2001.

Franz Ackermann

German, born 1963

trans east west (tew) no. 1: someone must fix it. 1999 (plate 54)
Mixed media on paper, 6⁵⁄₁₆ x 9⁷⁄₁₆" (16 x 24 cm)
MORA Foundation, London. Courtesy Mark Fletcher/Art Management

trans east west (tew) no. 2: the international carpet center. 1999
(plate 55)
Mixed media on paper, 6⁵⁄₁₆ x 9⁷⁄₁₆" (16 x 24 cm)
MORA Foundation, London. Courtesy Mark Fletcher/Art Management

trans east west (tew) no. 3: the kasikçi stadium. 1999 (plate 56)
Mixed media on paper, 6⁵⁄₁₆ x 9⁷⁄₁₆" (16 x 24 cm)
MORA Foundation, London. Courtesy Mark Fletcher/Art Management

trans east west (tew) no. 4: instead of a message. 1999 (plate 57)
Mixed media on paper, 6⁵⁄₁₆ x 9⁷⁄₁₆" (16 x 24 cm)
MORA Foundation, London. Courtesy Mark Fletcher/Art Management

*trans east west (tew) no. 5: the attack of the embassy
(reconstruction).* 1999
Mixed media on paper, 5⅛ x 7½" (13 x 19 cm)
Carnegie Museum of Art, Pittsburgh. Second Century Acquisition Fund

trans east west (tew) no. 6: rebuilding beirut. 1999 (plate 58)
Mixed media on paper, 5⅛ x 7½" (13 x 19 cm)
Carnegie Museum of Art, Pittsburgh. Second Century Acquisition Fund

trans east west (tew) no. 7: bombing the power plant.
1999 (plate 59)
Mixed media on paper, 5⅛ x 7½" (13 x 19 cm)
Carnegie Museum of Art, Pittsburgh. Second Century Acquisition Fund

*trans east west (tew) no. 8: suddenly it was completely dark
(maybe because I closed my eyes).* 1999 (plate 60)
Mixed media on paper, 5⅛ x 7½" (13 x 19 cm)
Carnegie Museum of Art, Pittsburgh. Second Century Acquisition Fund

trans east west (tew) no. 9: the "meridian" will have a nice view.
1999 (plate 61)
Mixed media on paper, 5⅛ x 7½" (13 x 19 cm)
Carnegie Museum of Art, Pittsburgh. Second Century Acquisition Fund

trans east west (tew) no. 10: to the people of damascus. 1999
Mixed media on paper, 5⅛ x 7½" (13 x 19 cm)
Carnegie Museum of Art, Pittsburgh. Second Century Acquisition Fund

trans east west (tew) no. 11: former restaurant. 1999
Mixed media on paper, 5⅛ x 7½" (13 x 19 cm)
Carnegie Museum of Art, Pittsburgh. Second Century Acquisition Fund

trans east west (tew) no. 12: the neighbors. 1999
Mixed media on paper, 5⅛ x 7½" (13 x 19 cm)
Carnegie Museum of Art, Pittsburgh. Second Century Acquisition Fund

trans east west (tew) no. 13: the president. 1999
Mixed media on paper, 5⅛ x 7½" (13 x 19 cm)
Carnegie Museum of Art, Pittsburgh. Second Century Acquisition Fund

trans east west (tew) no. 14: to the people of damascus. 1999
Mixed media on paper, 5⅛ x 7½" (13 x 19 cm)
Carnegie Museum of Art, Pittsburgh. Second Century Acquisition Fund

trans east west (tew) no. 15: cinema beirut. 1999
Mixed media on paper, 5⅛ x 7½" (13 x 19 cm)
Carnegie Museum of Art, Pittsburgh. Second Century Acquisition Fund

*trans east west (tew) no. 16: secret excavations in
pigman's land.* 1999
Mixed media on paper, 5⅛ x 7½" (13 x 19 cm)
Carnegie Museum of Art, Pittsburgh. Second Century Acquisition Fund

trans east west (tew) no. 21: house with no windows.
1999 (plate 62)
Mixed media on paper, 5 x 7½" (12.7 x 19 cm)
Collection Samuel and Shanit Schwartz, Beverly Hills

trans east west (tew) no. 22: changing money and going out.
1999 (plate 65)
Mixed media on paper, 7½ x 5" (19 x 12.7 cm)
Courtesy works on paper, inc., Los Angeles

trans east west (tew) no. 23: two ruins representing one state.
1999 (plate 63)
Mixed media on paper, 5 x 7½" (12.7 x 19 cm)
Collection Meredith Palmer, New York

trans east west (tew) no. 24: enjoy your stay. 1999 (plate 66)
Mixed media on paper, 7½ x 5" (19 x 12.7 cm)
Collection Michael Benevento

trans east west (tew) no. 25: the big performance. 1999
Mixed media on paper, 6½ x 9½" (16.5 x 24.1 cm)
Collection Candace A. Younger

trans east west (tew) no. 26: unknown international airport. 1999
Mixed media on paper, 5⅛ x 7½" (13 x 19 cm)
Collection Matt Aberle, Los Angeles

*trans east west (tew) no. 27: everybody hates an
emergency case.* 1999
Mixed media on paper, 17½ x 20" (44.5 x 50.9 cm)
Collection Marcia Goldenfeld Maiten and Barry Maiten, Los Angeles

*trans east west (tew) no. 28: thanks for helping with city plan-
ning.* 1999
Mixed media on paper, 17½ x 18½" (44.5 x 47 cm)
Private collection, Los Angeles

trans east west (tew) no. 29: former cinema. 1999 (plate 67)
Mixed media on paper, 10 x 7½" (25.4 x 19 cm)
Collection Tom Peters, Los Angeles

*trans east west (tew) no. 30: who's afraid of the outskirts
of damascus.* 1999 (plate 64)
Mixed media on paper, 12½ x 15½" (31.8 x 39.4 cm)
Schimmel Collection

trans east west (tew) no. 33: former trade center. 1999 (plate 68)
Mixed media on paper, 13 x 11½" (33 x 29.2 cm)
Collection Tom Peters, Los Angeles

trans east west (tew) no. 34: the next sixth month. 1999
Mixed media on paper, 22 x 29½" (55.9 x 74.9 cm)
Collection Brian D. Butler, Santa Monica

Kai Althoff

German, born 1966

Untitled. 2000 (plate 81)
Watercolor on paper, 11⅞ x 12⅝" (30 x 32 cm)
Goetz Collection, Munich

Untitled. 2000
Watercolor on paper, 11⅞ x 12⅝" (30 x 32 cm)
Private collection

Untitled. 2000 (plate 82)
Watercolor on paper, 11⅞ x 12⅝" (30 x 32 cm)
Private collection

Untitled. 2000
Watercolor on paper, 11⅞ x 12⅝" (30 x 32 cm)
Collection Barbara Gladstone

Untitled. 2000 (plate 83)
Watercolor on paper, 11⅞ x 12⅝" (30 x 32 cm)
Private collection

Untitled. 2000
Pencil and watercolor on paper, 11⅞ x 12⅝" (30 x 32 cm)
Goetz Collection, Munich

Untitled. 2000 (plate 84)
Pencil and watercolor on paper, 11⅞ x 12⅝" (30 x 32 cm)
Collection Markus Nöthen, Cologne

Untitled. 2000
Pencil and watercolor on paper, 11⅞ x 12⅝" (30 x 32 cm)
Collection Yilmaz Dziewior

Untitled. 2000 (plate 85)
Watercolor on paper, 11⅞ x 12⅝" (30 x 32 cm)
Collection Susanne Nöthen, Cologne

Untitled. 2000
Watercolor on paper, 11⅞ x 12⅝" (30 x 32 cm)
Goetz Collection, Munich

Untitled. 2000
Watercolor on paper, 11⅞ x 12⅝" (30 x 32 cm)
Collection Schröder

Untitled. 2000 (plate 86)
Watercolor on paper, 11⅞ x 12⅝" (30 x 32 cm)
Private collection

Untitled. 2000
Watercolor on paper, 11⅞ x 12⅝" (30 x 32 cm)
Collection Barbara Gladstone

Untitled. 2000
Watercolor on paper, 11⅞ x 12⅝" (30 x 32 cm)
Private collection

Untitled. 2000
Watercolor on paper, 11⅞ x 12⅝" (30 x 32 cm)
Collection Schröder

Untitled. 2000
Watercolor on paper, 11⅞ x 12⅝" (30 x 32 cm)
Goetz Collection, Munich

Untitled. 2000
Watercolor on paper, 11⅞ x 12⅝" (30 x 32 cm)
Collection Susan and Michael Hort

Untitled. 2000 (plate 87)
Watercolor on paper, 11⅞ x 12⅝" (30 x 32 cm)
Collection Schröder

Untitled. 2000 (plate 88)
Watercolor on paper, 11⅞ x 12⅝" (30 x 32 cm)
Collection Schröder

Untitled. 2000
Watercolor on paper, 11⅞ x 12⅝" (30 x 32 cm)
Collection Barbara Gladstone

Untitled. 2000
Watercolor on paper, 11⅞ x 12⅝" (30 x 32 cm)
Collection Daniel Buchholz and Christopher Mueller, Cologne

Untitled. 2000 (plate 89)
Watercolor on paper, 11⅞ x 12⅝" (30 x 32 cm)
Collection Mima and Cesar Reyes, San Juan, Puerto Rico

Untitled. 2000 (plate 90)
Watercolor on paper, 11⅞ x 12⅝" (30 x 32 cm)
Goetz Collection, Munich

Untitled. 2000
Watercolor on paper, 11⅞ x 12⅝" (30 x 32 cm)
Collection Dumont-Schutte

Untitled. 2000 (plate 91)
Watercolor on paper, 11⅞ x 12⅝" (30 x 32 cm)
Goetz Collection, Munich

Untitled. 2000 (plate 92)
Watercolor on paper, 11⅞ x 12⅝" (30 x 32 cm)
Goetz Collection, Munich

Untitled. 2000
Watercolor on paper, 11⅞ x 12⅝" (30 x 32 cm)
Courtesy Marc Jancou Fine Art, New York

Untitled. 2000 (plate 93)
Watercolor on paper, 11⅞ x 12⅝" (30 x 32 cm)
Private collection

Untitled. 2000 (plate 94)
Watercolor on paper, 11⅞ x 12⅝" (30 x 32 cm)
Collection Schröder

Untitled. 2000 (plate 95)
Watercolor on paper, 11⅞ x 12⅝" (30 x 32 cm)
Collection Susan and Michael Hort

Untitled. 2000 (plate 96)
Watercolor on paper, 11⅞ x 12⅝" (30 x 32 cm)
Collection Dumont-Schutte

Untitled. 2000
Watercolor, vellum, and cut paper, diam. 31⅞" (81 cm)
Collection Karola Grässlin, Cologne

Untitled. 2000
Watercolor on paper, 11⅞ x 12⅝" (30 x 32 cm)
Private collection, Berlin

Untitled. 2000
Watercolor on paper, 11⅞ x 12⅝" (30 x 32 cm)
Courtesy Marc Jancou Fine Art, New York

Kevin Appel

American, born 1967

Light Model: Northwest View (2). 2002 (plate 28; not in the exhibition)
Liquid acrylic and pencil on paper, 22½ x 30" (57.2 x 76.2 cm)
Courtesy Angles Gallery, Santa Monica

Light Model: Southeast View. 2002 (plate 29; not in the exhibition)
Liquid acrylic and pencil on paper, 22½ x 30" (57.2 x 76.2 cm)
Courtesy Angles Gallery, Santa Monica

Light Model: Northwest View. 2002 (plate 30; not in the exhibition)
Liquid acrylic and pencil on paper, 22½ x 30" (57.2 x 76.2 cm)
Courtesy Angles Gallery, Santa Monica

Light Model: West View. 2002 (plate 31; not in the exhibition)
Liquid acrylic and pencil on paper, 22½ x 30" (57.2 x 76.2 cm)
Courtesy Angles Gallery, Santa Monica

Untitled. 2002
Pencil and acrylic on paper, 29 x 41" (73.7 x 104.1 cm)
Courtesy the artist and Angles Gallery, Santa Monica

Untitled. 2002
Pencil and acrylic on paper, 29 x 41" (73.7 x 104.1 cm)
Courtesy the artist and Angles Gallery, Santa Monica

Untitled. 2002
Pencil and acrylic on paper, 29 x 41" (73.7 x 104.1 cm)
Courtesy the artist and Angles Gallery, Santa Monica

Untitled. 2002
Pencil and acrylic on paper, 29 x 41" (73.7 x 104.1 cm)
Courtesy the artist and Angles Gallery, Santa Monica

Untitled. 2002
Pencil and acrylic on paper, 29 x 41" (73.7 x 104.1 cm)
Courtesy the artist and Angles Gallery, Santa Monica

Untitled. 2002
Pencil and acrylic on paper, 29 x 41" (73.7 x 104.1 cm)
Courtesy the artist and Angles Gallery, Santa Monica

Untitled. 2002
Pencil and acrylic on paper, 29 x 41" (73.7 x 104.1 cm)
Courtesy the artist and Angles Gallery, Santa Monica

Untitled. 2002
Pencil and acrylic on paper, 29 x 41" (73.7 x 104.1 cm)
Courtesy the artist and Angles Gallery, Santa Monica

Los Carpinteros

Dagoberto Rodriguez, Cuban, born 1969
Marco Castillo, Cuban, born 1971
Alexandre Arrechea, Cuban, born 1970

Proyecto de Acumulación de Materiales (Project of accumulation of materials). 1999 (plate 39; not in the exhibition)
Watercolor and pencil on paper, 46¼" x 11' 7⅞" (117.5 x 355.3 cm)
The Museum of Modern Art, New York. Purchased with funds provided by Sylvia de Cuevas, Leila and Melville Straus, and The Contemporary Arts Council

Site-specific wall drawing. 2002
Based on *Cárcel* (Prison). 2001 (plate 40)
Mixed mediums on paper, 64" x 8' (162.6 x 243.8 cm)
Collection the artists

Russell Crotty

American, born 1956

Plaid Shirt and Tubing Off-Shore Filth. 1991
Ink and pencil on paper, six panels, each c. 6' 10¼" x 35½"
(208.9 x 90.2 cm), overall 13' 8¼" x 18' 5⅝" (417 x 563 cm)
Courtesy the artist and Shoshana Wayne Gallery, Santa Monica

Five Nocturnes. 1996 (plates 10, 11)
Ink on paper in bound book, closed: 62 x 31½ x 2"
(157.5 x 80 x 5.1 cm), open: 62" x 9' 9" (157.5 x 297.2 cm)
The Museum of Modern Art, New York. Acquired through the generosity of The Junior Associates of The Museum of Modern Art

Jupiter Strip Sketch Book. 1996
Ink on paper in bound book, closed: 21 x 21" (53.3 x 53.3 cm),
open: 21 x 42" (53.3 x 106.7 cm)
Courtesy the artist and Shoshana Wayne Gallery, Santa Monica

Small Atlas of Lunar Drawings. 1999
Ink on paper in bound book, closed: 14 x 9½" (35.5 x 24.1 cm),
open: 14 x 18⅜" (35.5 x 46.7 cm)
Courtesy the artist and Shoshana Wayne Gallery, Santa Monica

Annals of the Solstice Peak Observatory Volume 1. 1999–2000
Ink on paper in bound book, closed: 23 x 15" (58.4 x 38.1 cm),
open: 23 x 30" (58.4 x 76.2 cm)
Collection Kenneth L. Freed, Boston

*Favorite Terminology from the Desk of the Principal
Investigator*. 2000
Ink and pencil on paper in bound book, closed: 23½ x 16"
(59.7 x 40.6 cm), open: 23½ x 32" (59.7 x 81.3 cm)
Courtesy the artist and CRG Gallery, New York

John Currin

American, born 1962

The Moved Over Lady. 1991 (plate 144)
Pencil on paper, 17¾ x 15" (45.5 x 38 cm)
Private collection

Nancy Walker. 1992
Watercolor on paper, 11⅝ x 10¼" (29.6 x 25.6 cm)
Collection Marvin and Alice Kosmin, New York

Ramona. 1992
Pencil on paper, 11¼ x 9⅜" (28.5 x 23.8 cm)
Private collection, New York

Substitute. 1992
Watercolor on paper, 10 x 8½" (25.3 x 21.6 cm)
Ann and Mel Schaffer Family Collection

Bearded Man. 1993
Gouache on paper, 13½ x 11" (34.3 x 28 cm)
Private collection, New York

Autumn Lovers. 1994
Watercolor and wash on paper, 12 x 8" (30.5 x 20.3 cm)
Collection Stefan Edlis

Happy Couple. 1994
Watercolor on paper, 11½ x 9" (29.2 x 22.9 cm)
Collection Jennifer and David Stockman

Blue Nude. 1995
Conté crayon and charcoal on paper, 15 x 11" (38.1 x 27.9 cm)
Collection Susan and Michael Hort

Charlie Rose Guest. 1998
Gouache on paper, 12 x 8⅛" (30.5 x 20.3 cm)
The Museum of Modern Art, New York. Fractional and promised
gift of Stafford Broumand

Three Friends. 1998
Gouache on chipboard, 12 x 8" (30.5 x 20.2 cm)
Collection Dianne Wallace, New York

Veiled Figure. 1998
Gouache on brown paper, 12 x 8" (30.5 x 20.2 cm)
Collection Nina and Frank Moore

Untitled. 1998
Pencil and gouache on brown paper, 12 x 8³⁄₁₆" (30.5 x 20.8 cm)
Collection Nina and Frank Moore

Untitled. 1999
Gouache on brown paper, 13³⁄₁₆ x 8⅛" (33.5 x 20.6 cm)
Collection Patricia and Morris Orden, New York

Untitled. 1999
Ink on paper, 11⅝ x 7¹³⁄₁₆" (29.3 x 19.8 cm)
Collection Steven and Heather Mnuchin, New York

Wedges. 2000
Gouache on paper, 10 x 8" (25.4 x 20.2 cm)
Collection Sadie Coles, London

The Clairvoyant. 2001 (plate 145)
Gouache on prepared paper, 11⅝ x 8⅜" (29.5 x 21.3 cm)
The Museum of Modern Art, New York. Fractional and promised
gift of Nina and Frank Moore in memory of Elaine Dannheisser

The Exwife. 2001
Gouache on prepared paper, 14 x 11¼" (35.6 x 28.6 cm)
The Museum of Modern Art, New York. Gift of Oliver Kamm,
Linda Kamm, and Lisa Kamm

Hobo. 2001 (plate 139)
Sepia ink on paper, 11½ x 9" (29.2 x 22.9 cm)
The Museum of Modern Art, New York. Fractional and promised
gift of Barry Blumberg

Hobo. 2001 (plate 140)
Sepia ink on paper, 11½ x 9" (29.2 x 22.9 cm)
The Museum of Modern Art, New York. Fractional and promised
gift of Jennifer Stockman

Hobo. 2001 (plate 141)
Sepia ink on paper, 11½ x 9" (29.2 x 22.9 cm)
The Museum of Modern Art, New York. Fractional and promised
gift of Dean Valentine

Hobo. 2001 (plate 142; not in the exhibition)
Ink on paper, 11½ x 9" (29.2 x 22.9 cm)
The Museum of Modern Art, New York. Fractional and promised
gift of Sam Schwartz

Hobo. 2001 (plate 143; not in the exhibition)
Pencil on paper, 11½ x 9" (29.2 x 22.9 cm)
The Museum of Modern Art, New York. Fractional and promised
gift of Adam Sender

Lady on the Fence. 2001
Gouache and ink on prepared paper, 11⅛ x 8⅛" (28.3 x 20.6 cm)
The Museum of Modern Art, New York. Fractional and promised
gift of Dianne Wallace

Toba Khedoori

Australian, born 1964

Untitled (House). 1995
Oil and wax on paper, 11 x 16' (335.2 x 487.6 cm)
Sammlung Hauser und Wirth, St. Gall

Untitled (Doors). 1999 (plate 32)
Oil and wax on paper, 11' 6" x 15' 11½" (350.5 x 486.4 cm)
Private collection, New York

Untitled (Window). 1999
Oil and wax on paper, 12 x 20' (366 x 610 cm)
Emanuel Hoffman Foundation, permanent loan to the
Kupferstichkabinett, Öffentliche Kunstsammlung, Basel

Untitled (Rooms). 2001 (plate 33)
Oil and wax on paper, 12 x 12' (366 x 366 cm)
San Francisco Museum of Modern Art. Accessions Committee
Fund purchase

Graham Little

British, born 1972

Untitled. 2000
Colored pencil, watercolor, and gesso on paper, 27 x 22"
(68.5 x 55.8 cm)
Collection Kenneth L. Freed, Boston

Untitled. 2000 (plate 135)
Acrylic and colored pencil on paper, 14 x 15" (36 x 37 cm)
Private collection, London

Untitled. 2000 (plate 136)
Colored pencil on paper, 19 x 17" (48.5 x 43 cm)
Private collection, London

Untitled. 2000 (plate 137)
Colored pencil on paper, 24 x 23" (61 x 59 cm)
Collection Susan and Michael Hort

Untitled. 2001
Colored pencil on paper, 14 x 12⅜" (35.5 x 31.5 cm)
Collection Weiler, Frankfurt am Main

Untitled. 2001
Colored pencil on paper, 13⅜ x 10" (34 x 25.5 cm)
Collection Kenneth L. Freed, Boston

Untitled. 2001 (plate 138)
Colored pencil on paper, 16⁷⁄₁₆ x 11¹³⁄₁₆" (42 x 30 cm)
Private collection, London

Untitled. 2001
Colored pencil and gouache on paper, 19⅛ x 16⅛" (48.5 x 41 cm)
Collection Susan and Michael Hort

Untitled. 2001
Colored pencil on paper, 33 x 27" (83 x 69.5 cm)
Schorr Family Collection

Untitled. 2001
Colored pencil and watercolor on paper, 19 x 14" (50 x 35 cm)
Collection Chris Gorell Barnes, London

Untitled. 2001
Colored pencil and watercolor on paper, 17 x 20" (43 x 51.5 cm)
Collection Dianne Wallace, New York

Untitled. 2001
Colored pencil on paper, 26 x 17¼" (66 x 43.8 cm)
Private collection, New York. Courtesy asprey jacques, London

Mark Manders

Dutch, born 1968

Self-portrait as a building/Provisional floor-plan. 1994 (plate 69)
Graphite on paper, 16⁹⁄₁₆ x 23⁵⁄₁₆" (42.1 x 59.2 cm)
The Over Holland Collection

Still-life. 1994 (plate 70)
Graphite on paper, 16⁹⁄₁₆ x 11¹¹⁄₁₆" (42.1 x 29.7 cm)
The Over Holland Collection

Sunday Night Trick. 1994
Graphite on paper, 23⅝ x 16½" (60 x 42 cm)
The Over Holland Collection

Untitled. 1994
Charcoal on paper, 19¹¹⁄₁₆ x 25⁹⁄₁₆" (50 x 65 cm)
The Over Holland Collection

Spit and Stare. 1997
Graphite on paper, 22½ x 16¹⁵⁄₁₆" (57 x 45 cm)
The Over Holland Collection

Drawing with singing sailors. 1998
Pencil on paper, 8¼ x 11¹¹⁄₁₆" (21 x 29.7 cm)
Private collection, New York

Drawing with Vanishing Point. 1998
Pencil on paper, 11¹¹⁄₁₆ x 16½" (29.7 x 42 cm)
Private collection, New York

Substratum Trick. 1998
Graphite on paper, 8 x 11" (20.3 x 27.9 cm)
Courtesy Greene Naftali, New York

Drawing with isolated landscape. 1999
Pencil on paper, 11⁵⁄₁₆ x 8¼" (28.7 x 21 cm)
Courtesy Zeno X Gallery, Antwerp

Snare drum drawing. 1999
Pencil on paper, 16½ x 11¹¹⁄₁₆" (42 x 29.7 cm)
Courtesy Zeno X Gallery, Antwerp

Undated Letter/Invisible Branch. 1999
Charcoal on paper, 8¼ x 11½" (21 x 29.2 cm)
The Marieluise Hessel Collection

Untitled. 1999
Pencil on paper, 16½ x 11⅝" (42 x 29.5 cm)
Courtesy Zeno X Gallery, Antwerp

Drawing with Cemetery Horses. 2000
Graphite on paper, 16½ x 11¹¹⁄₁₆" (42 x 29.7 cm)
The Over Holland Collection

Karin. 2000 (plate 72)
Graphite on paper, 12¹¹⁄₁₆ x 17" (32.2 x 43.2 cm)
The Over Holland Collection

Pervert. 2000
Pencil on paper, 16½ x 11¹¹⁄₁₆" (42 x 29.7 cm)
Courtesy Zeno X Gallery, Antwerp

Untitled. 2000
Pencil on paper, 11¹¹⁄₁₆ x 8¼" (29.7 x 21 cm)
Courtesy Zeno X Gallery, Antwerp

Untitled. 2000
Pencil on paper, 11¹¹⁄₁₆ x 8¼" (29.7 x 21 cm)
Courtesy Zeno X Gallery, Antwerp

Yellow bathtub/three touched. 2000
Pencil on paper, 26 x 20½" (66 x 52 cm)
Courtesy Zeno X Gallery, Antwerp

Draft with bones. 2001
Graphite and colored pencil on paper, 22½ x 16¹⁵⁄₁₆" (57 x 45 cm)
The Over Holland Collection

Fragment of Longing. 2001
Graphite on paper, 23⅝ x 16½" (60 x 42 cm)
The Over Holland Collection

Straight Cloud. 2001 (plate 71)
Graphite on paper, 23⅝ x 19¹¹⁄₁₆" (60 x 50 cm)
The Over Holland Collection

Barry McGee

American, born 1966

Untitled. 1998–2002 (plates 113–16)
Drawings, photographs, and found objects, dimensions variable
Collection Jeffrey Deitch

Julie Mehretu

American, born in Addis Ababa, Ethiopia, 1970

Untitled. 2000 (plate 34)
Ink, colored pencil, and cut paper on Mylar, 18 x 24" (45.7 x 61 cm)
Private collection

Untitled. 2000 (plate 35)
Ink, colored pencil, and cut paper on Mylar, 18 x 24" (45.7 x 61 cm)
Courtesy The Greenberg Rohatyn Collection

Untitled. 2000 (plate 36)
Ink, colored pencil, and cut paper on Mylar, 18 x 24" (45.7 x 61 cm)
Courtesy The Greenberg Rohatyn Collection

Untitled. 2000 (plates 37, 38)
Ink, colored pencil, and cut paper on Mylar, 18 x 24" (45.7 x 61 cm)
Collection the artist, New York

Untitled. 2000
Ink, colored pencil, and cut paper on Mylar, 18 x 24" (45.7 x 61 cm)
Collection Martin and Rebecca Eisenberg

Untitled. 2000
Ink, colored pencil, and cut paper on Mylar, 18 x 24" (45.7 x 61 cm)
Collection Martin and Rebecca Eisenberg

Untitled. 2000
Ink, colored pencil, and cut paper on Mylar, 18 x 24" (45.7 x 61 cm)
Collection Alvin Hall, New York

Untitled. 2000
Ink, colored pencil, and cut paper on Mylar, 18 x 24" (45.7 x 61 cm)
Collection Alvin Hall, New York

Untitled. 2000
Ink, colored pencil, and cut paper on Mylar, 18 x 24" (45.7 x 61 cm)
New Museum of Contemporary Art, New York. Altoids Curiously
Strong Collection

Untitled. 2000
Ink, colored pencil, and cut paper on Mylar, 18 x 24" (45.7 x 61 cm)
Collection Christophe Van de Weghe, New York

Site-specific wall drawing. 2002

Takashi Murakami

Japanese, born 1962

Sakurako Jet Airplane nos. 1–6. 1995 (plates 124–27)
Watercolor on paper, six sheets, each 18 x 14½" (45.7 x 36.8 cm)
Collection Kenneth L. Freed, Boston

Project Ko2 (study). 1996
Ink and watercolor on paper, 17⅜ x 12⅜" (44.1 x 31.4 cm)
Collection Martin and Rebecca Eisenberg

Study for SMPKo2. 1998
Pencil on tracing paper, 11¹¹⁄₁₆ x 8¼" (29.7 x 21 cm)
Collection the artist. Courtesy Kaikai Kiki and Blum & Poe,
Santa Monica

Study for SMPKo2. 1998
Pencil on tracing paper, 11¹¹⁄₁₆ x 8¼" (29.7 x 21 cm)
Collection the artist. Courtesy Kaikai Kiki and Blum & Poe,
Santa Monica

Study for SMPKo2. 1998
Pencil on tracing paper, 8¼ x 11¹¹⁄₁₆" (21 x 29.7 cm)
Collection the artist. Courtesy Kaikai Kiki and Blum & Poe,
Santa Monica

Transformation Part B. 1998
Watercolor on board, 11 x 8½" (27.9 x 21.6 cm)
Private collection. Courtesy Blum & Poe, Santa Monica

Study for SMPKo2. 1999
Watercolor on illustration board, 19 x 13¹¹⁄₁₆" (48.3 x 34.8 cm)
Collection the artist. Courtesy Kaikai Kiki and Blum & Poe,
Santa Monica

Study for SMPKo2. 1999 (plate 122)
Watercolor on illustration board, 16⁹⁄₁₆ x 11¹¹⁄₁₆" (42.1 x 29.7 cm)
Collection the artist. Courtesy Kaikai Kiki and Blum & Poe,
Santa Monica

Study for SMPKo2. 1999 (plate 123)
Watercolor on illustration board, 17¹⁄₁₆ x 12¹¹⁄₁₆" (43.3 x 32.2 cm)
Collection the artist. Courtesy Kaikai Kiki and Blum & Poe,
Santa Monica

Yoshitomo Nara

Japanese, born 1959

Time of My Life. 1992–2000
Colored pencil, magic marker, ballpoint pen, graphite, and acrylic
on paper, forty-eight sheets ranging from 2⅜ x 5⅞" (6 x 14.9 cm)
to 11¾ x 8¼" (29.9 x 21 cm)
Collection David Teiger

Time of My Life. 1992–2000 (plates 117–19)
Colored pencil, magic marker, ballpoint pen, graphite, and acrylic
on paper, eighty-six sheets ranging from 1¾ x 2¼" (4.5 x 5.7 cm)
to 12 x 9" (30.5 x 22.9 cm)
Collection David Teiger

U-ki-yo-e. 1999 (plates 120, 121)
Oil on book pages, sixteen parts, twelve sheets each 16⅝ x 13"
(42.1 x 33 cm), four sheets each 13 x 16⅝" (33 x 42.1 cm)
Collection Eileen and Peter Norton, Santa Monica

Paul Noble

British, born 1963

Nobslum. 1997–98
Pencil on paper, 59" x 6' 6¾" (150 x 200 cm)
Collection Mark Hubbard

Nobspital. 1997–98 (plates 42, 43)
Pencil on paper, 8' 2½" x 59" (250 x 150 cm)
Courtesy Mitchell-Innes & Nash, New York

Nobson Central. 1998–99 (plate 41)
Pencil on paper, 9' 10" x 13' 1¾" (299.7 x 400.7 cm)
Courtesy Mitchell-Innes & Nash, New York

Mall. 2001–2
Pencil on paper, 13' 1½" x 9' 10⅛" (400 x 300 cm)
Courtesy Maureen Paley Interim Art, London

Jockum Nordström

Swedish, born 1963

Dala Sex. 2001
Mixed mediums and collage, 27½ x 39" (70 x 99 cm)
Collection John A. Smith and Vicky Hughes, London

For Once Playing Guitar. 2001 (plates 111, 112)
Mixed mediums and collage, 35¹³⁄₁₆ x 28⅜" (90.8 x 72 cm)
Collection Dianne Wallace, New York. Courtesy David Zwirner,
New York

The Architects. 2001
Mixed mediums and collage, 19¹¹⁄₁₆ x 27⁹⁄₁₆" (50 x 70 cm)
Private collection, New York

The Forest of Death. 2001 (plate 108)
Mixed mediums and collage, 50¾ x 39⅝" (129 x 98 cm)
Private collection. Courtesy Gallery Magnus Karlsson, Stockholm

The Four Cardinal Points. 2001 (plate 110)
Mixed mediums and collage, 48⅝ x 34¼" (123.5 x 87 cm)
Collection Christian Larsen. Courtesy Gallery Magnus Karlsson,
Stockholm

The Judicature. 2001 (plate 109; not in the exhibition)
Mixed mediums and collage, 43¹¹⁄₁₆ x 40¹⁵⁄₁₆" (111 x 104 cm)
Private collection. Courtesy Gallery Magnus Karlsson, Stockholm

There Is a Mischief Brewing. 2001
Mixed mediums and collage, 39⅜ x 27¹⁵⁄₁₆" (100 x 71 cm)
Collection Raymond Learsy and Melva Bucksbaum.
Courtesy David Zwirner, New York

Chris Ofili

British, born 1968

Afro daze. 1997
Pencil on paper, 22¼ x 30" (56.5 x 76.2 cm)
Goetz Collection, Munich

Afrofilia. 1997
Pencil on paper, 29¹⁵⁄₁₆ x 22¹⁄₁₆" (76 x 56 cm)
Collection Warren and Victoria Miro

Afro Twist. 1997
Pencil on paper, 22¼ x 29¹¹⁄₁₆" (56.5 x 75.4 cm)
Goetz Collection, Munich

Albinos and Bros with Fros. 1999 (plate 22)
Pencil on paper, 22¼ x 29¾" (56.5 x 75.6 cm)
Collection Raymond Learsy and Melva Bucksbaum

D'Afro. 1999 (plate 21)
Pencil on paper, 20 x 30" (50.8 x 76.2 cm)
Private collection, London

Prince among Thieves with Flowers. 1999 (plates 19, 20)
Pencil on paper, 29¾ x 22¼" (75.5 x 56.5 cm)
The Museum of Modern Art, New York. Gift of David Teiger
and the Friends of Contemporary Drawing

Afro Love and Support. 2000
Pencil on paper, 22¼ x 29¾" (56.5 x 75.5 cm)
Collection Laura Steinberg and B. Nadal-Ginard, Chestnut Hill, Mass.

Afrofantazia. 2000
Pencil on paper, 29¹⁵⁄₁₆ x 22¹⁄₁₆" (76 x 56 cm)
Collection Warren and Victoria Miro

Enough. 2000
Pencil on paper, 29¹⁵⁄₁₆ x 22¹⁄₁₆" (76 x 56 cm)
Magasin 3 Stockholm Konsthall, Stockholm

Untitled (Woman). 2000 (plate 23)
Pencil on paper, 30 x 22" (76.2 x 56 cm)
Collection Dianne Wallace, New York

Laura Owens

American, born 1970

Untitled. 1998
Watercolor and crayon on paper, 7 x 10¼" (17.7 x 26 cm)
Collection Norman Dubrow

Untitled. 1998
Acrylic, pencil, and watercolor on paper, 10¾ x 7¾" (27.3 x 19.7 cm)
Collection Joel Wachs

Untitled. 1998
Watercolor, pencil, and pen on paper, 10½ x 7⅛" (26.7 x 18.1 cm)
Collection Oliver Barker, London

Untitled. 1999
Acrylic and watercolor on paper, 29¹⁵⁄₁₆ x 22¼" (76 x 56.5 cm)
Collection Carel Balth

Untitled. 1999
Acrylic and pencil on paper, 49½ x 38" (125.7 x 96.5 cm)
Collection Matt Aberle, Los Angeles

Untitled. 2000 (plate 15)
Cut and pasted colored papers, watercolor, acrylic, and pencil on paper, 39⅛ x 27⅝" (99.4 x 70.2 cm)
The Museum of Modern Art, New York. Purchased with funds provided by the Friends of Contemporary Drawing

Untitled. 2000
Watercolor, collage, and pencil on paper, 12¼ x 9" (31.1 x 22.9 cm)
Collection Arthur and Jeanne Cohen, Beverly Hills

Untitled. 2000
Collage with watercolor and acrylic on paper, 24 x 18⅛" (61 x 46 cm)
Private collection, New York. Courtesy Sadie Coles HQ, London

Untitled. 2000
Photograph, colored paper, acrylic, and pencil on paper, 16 x 12" (40.6 x 30.4 cm)
Private collection, New York

Untitled. 2000
Acrylic, pencil, spray paint, enamel, and glimmer on paper, 14¼ x 12⅛" (36.2 x 30.8 cm)
Goetz Collection, Munich

Untitled. 2000
Pencil, enamel, glimmer, acrylic, and spray paint on paper, 41 x 26" (104.1 x 66 cm)
Goetz Collection, Munich

Untitled. 2001
Watercolor, pencil, and collage on paper, 10³⁄₁₆ x 7¹⁄₁₆" (25.9 x 17.9 cm)
Collection Ninah and Michael Lynne

Untitled. 2001 (plate 16)
Photograph, watercolor, colored pencil, and collage on paper, 14 x 10" (35.6 x 25.4 cm)
Collection Mario Testino. Courtesy Gavin Brown's enterprise, New York

Untitled. 2001 (plate 17)
Pencil and watercolor on paper, 30 x 22½" (76.2 x 57.2 cm)
Collection Ella Venet, New York

Untitled. 2001 (plate 18)
Watercolor and pencil on paper, 44 x 30¼" (111.8 x 76.8 cm)
Collection Martin and Rebecca Eisenberg

Untitled. 2001
Watercolor, felt, and photograph on paper, 12 x 9½" (30.5 x 24.1 cm)
Collection Mr. and Mrs. Jeffrey R. Winter

Jennifer Pastor

American, born 1966

Untitled. 1994
Pencil on two sheets of paper, 13 x 16" (33 x 40.5 cm) and 13 x 20" (33 x 50.8 cm) respectively
Collection Eileen and Peter Norton, Santa Monica

Study for *Fall.* 1995 (plate 2)
Ink on paper, 24 x 16" (60.9 x 40.6 cm)
Collection Richard Telles and Robert Lade

Study for *Spring.* 1996 (plate 1)
Ink and pencil on paper, 18 x 12½" (45.7 x 31.8 cm)
Collection Joel Wachs

Equal Volumes, Equally Extracted. 1998
Pencil on paper, 19 x 24" (48.3 x 61 cm)
Collection Anthony W. Ganz

Equal Volumes, Equally Extracted. 1998
Pencil on paper, 19 x 24" (48.3 x 61 cm)
Collection Anthony W. Ganz

Three States. 1998
Pencil on paper, 30 x 40" (76.2 x 101.6 cm)
Collection Anthony W. Ganz

Flow Chart for the "Perfect Ride" Animation. 1999–2000 (plates 3–9)
Pencil on paper, seven sheets, each 13½ x 17" (34.3 x 43.2 cm)
Collection Dean Valentine and Amy Adelson, Los Angeles

Elizabeth Peyton

American, born 1965

Craig. 1996
Watercolor on paper, 9 x 12" (22.8 x 30.5 cm)
Collection Nina and Frank Moore

Jarvis. 1996
Watercolor on paper, 10¼ x 7¹⁄₁₆" (26 x 18 cm)
Sammlung Hauser und Wirth, St. Gall

Scott Walker. 1996 (plate 131)
Watercolor on paper, 10 x 7" (25.4 x 17.8 cm)
Collection Susan and Michael Hort

Craig. 1997
Watercolor on paper, 10½ x 7" (26.6 x 17.8 cm)
Private collection, Paris

David Hockney. 1997
Watercolor and colored pencil on paper, 14¼ x 10¼" (36.2 x 26 cm)
Collection Muffy and Xavier Flouret

Daniel, Berlin. 1999 (plates 133, 134)
Watercolor on paper, 40 x 28¾" (101.6 x 73 cm)
The Museum of Modern Art, New York. Fractional and promised gift of Patricia and Morris Orden

Savoy (self-portrait). 1999
Colored pencil on paper, 8¼ x 5¾" (21 x 14.6 cm)
Private collection, Berlin. Courtesy neugerriemschneider, Berlin

Spencer. 1999 (plate 132)
Colored pencil on paper, 8¾ x 6" (22.2 x 15.2 cm)
The Museum of Modern Art, New York. Fractional and promised gift of David Teiger

Tony Napoleon. 1999
Pencil on paper, 8¾ x 5¼" (22.3 x 13 cm)
Collection the artist

Tony Sleeping. 1999
Colored pencil on paper, 7½ x 6" (19 x 15.2 cm)
Collection Alexander Lasarenko

Birthday, Dec. 20, 1999. 2000
Charcoal on paper, 13½ x 11" (34.3 x 28 cm)
Collection Tony Just and Elizabeth Peyton

Chloe. 2000 (plate 129)
Colored pencil on paper, 8¾ x 6" (22.2 x 15.2 cm)
Collection Martin and Rebecca Eisenberg

Leonard Cohen. 2000
Pencil on paper, 8½ x 6" (21.5 x 15.2 cm)
Private collection, Berlin. Courtesy neugerriemschneider, Berlin

November (Tony). 2000
Colored pencil on paper, 8¾ x 6" (22.2 x 15.2 cm)
Collection the artist

Chloe (Gold). 2001 (plate 128)
Colored pencil on paper, 8⅝ x 6" (22 x 15.2 cm)
Collection Martin and Rebecca Eisenberg

Chloe. 2001 (plate 130)
Colored pencil on paper, 8⅝ x 6" (22 x 15.2 cm)
Collection Martin and Rebecca Eisenberg

Poo (Rirkrit Sleeping). 2001
Colored pencil on paper, 15¹⁵⁄₁₆ x 8⅝" (13.5 x 22 cm)
Courtesy the artist and Gavin Brown's enterprise, New York

Sarah on Her Birthday. 2001
Colored pencil on paper, 11⅝ x 8¹⁵⁄₁₆" (29.5 x 22.8 cm)
Private collection. Courtesy Regen Projects, Los Angeles

Neo Rauch

German, born 1960

Messe. 1999 (plate 45)
Oil on paper, 31⅞ x 60¼" (81 x 153 cm)
Collection Kaufmann, Berlin. Courtesy Galerie EIGEN + ART, Leipzig and Berlin

Moder. 1999
Oil on paper, 31⅞ x 60¼" (81 x 153 cm)
Kunstmuseum Wolfsburg

Warner. 1999 (plate 44)
Oil on paper, 31⅞ x 60¼" (81 x 153 cm)
Private collection, Hamburg. Courtesy Galerie EIGEN + ART, Leipzig and Berlin

Weiche. 1999 (plates 47, 48)
Oil on paper, 7'⅝" x 6' 2¹³⁄₁₆" (215 x 190 cm)
Sammlung Deutsche Bank, Frankfurt. Courtesy Galerie EIGEN + ART, Leipzig and Berlin

Busch. 2001 (plate 46)
Oil on paper, 6' 6¾" x 6' 6¾" (200 x 200 cm)
Collection David Teiger. Courtesy Galerie EIGEN + ART, Leipzig and Berlin

Matthew Ritchie

American, born 1964

Everyone Belongs to Everyone Else. 2000–2001 (plates 73–80)
Ink and graphite on Mylar, suite of seven drawings,
each 22 x 65" (55.9 x 165.1 cm)
The Museum of Modern Art, New York. Purchase

Ugo Rondinone

Swiss, born 1963

No. 135 VIERTERJUNINEUNZEHNHUNDERTNEUNUNDNEUNZIG
(No. 135 Fourthofjuninenineteenninetynine). 1999 (plate 12)
Ink on paper, 6' 7" x 9' 10" (200.6 x 299.7 cm)
Private collection, New York

No. 249 EINUNDZWANZIGSTERSEPTEMBERZWEITAUSENDUNDEINS
(No. 249 Twentyfirstofseptembertwothousandandone). 2001
(plates 13, 14)
Ink on paper, 6' 7½" x 9' 10" (201.9 x 299.7 cm)
Courtesy Matthew Marks Gallery, New York

Shahzia Sikander

Pakistani, born 1969

Apparatus of Power. 1995
Vegetable color, watercolor, dry pigment, and tea on "wasli" paper,
9 x 5⅞" (22.9 x 14.9 cm)
Collection Carol and M. George Craford, Los Altos

Separate Working Things I. 1995
Vegetable color, dry pigment, watercolor, and tea on hand-prepared
"wasli" paper, 9½ x 6½" (24.1 x 16.5 cm)
Private collection

Uprooted. 1995
Watercolor and dry pigment on "wasli" paper, 8½ x 7¼"
(21.6 x 18.4 cm)
Collection Aliya Hasan, M.D.

Collective Experiences. 1997
Vegetable color and watercolor on clay on paper, 28 x 22"
(71.1 x 55.9 cm)
Collection Lois Plehn

Eye-I-ing Those Armorial Bearings, Series I. 1997
Vegetable color and watercolor on "wasli" paper, 8½ x 5¾"
(21.6 x 14.6 cm)
Collection Carol and Arthur Goldberg, New York

Eye-I-ing Those Armorial Bearings, Series III. 1997
Vegetable color and watercolor on "wasli" paper, 9 x 7"
(22.9 x 17.8 cm)
Collection Dean Valentine and Amy Adelson, Los Angeles

Eye-I-ing Those Armorial Bearings, Series IV. 1997
Vegetable color and watercolor on "wasli" paper, 9 x 7"
(22.9 x 17.8 cm)
Collection James Casebere

In Your Head and Not on My Feet. 1997 (plate 106)
Pencil on paper, 10¾ x 9½" (27.2 x 24.2 cm)
Collection Susan and Lewis Manilow

Perilous Order I. 1997
Vegetable color and watercolor on clay on paper, 28 x 22"
(71.1 x 55.9 cm)
Collection Tina Max

Ready to Leave Series II. 1997
Vegetable color and watercolor on "wasli" paper, 7¾ x 6¼"
(19.7 x 15.9 cm)
Collection Lois Plehn

Reinventing the Dislocation. 1997
Vegetable color, dry pigment, watercolor, and tea on hand-prepared
"wasli" paper, 13 x 9½" (33 x 24.1 cm)
Whitney Museum of American Art, New York. Purchase, with
funds from the Drawing Committee

Uprooted Order I. 1997
Vegetable color, dry pigment, watercolor, tea, and collage on
hand-prepared "wasli" paper, 17½ x 12" (44.5 x 30.5 cm)
Collection A. G. Rosen

Uprooted Order II. 1997
Vegetable color, dry pigment, watercolor, tea, and collage on
hand-prepared "wasli" paper, 17½ x 12" (44.5 x 30.5 cm)
Collection A. G. Rosen

Where Lies the Perfect Fit. 1997 (plate 105)
Pencil on paper, 10¾ x 7¾" (27.2 x 19.7 cm)
Collection Susan and Lewis Manilow

Untitled. 1998
Collage, watercolor, and gouache on paper, 10½ x 15" (26.7 x 38.1 cm)
Collection Martin and Rebecca Eisenberg

The Resurgence of Islam. 1999 (plate 107)
Vegetable color, dry pigment, watercolor, gold leaf, and tea on
hand-prepared "wasli" paper, 15¾ x 19¾" (40 x 50.2 cm)
Commissioned by the *New York Times Magazine* for the
Millennium Issue, September 1999
Collection the artist, New York

Maligned Monsters. 2001
Dry pigment, watercolor, and ink on hand-prepared "wasli" paper,
6⅞ x 3⅜" (17.5 x 8.6 cm)
Collection Salman Khokhar

Negotiations I. 2002.
Graphite, ink, and wash on "wasli" paper, 12 x 9" (30.5 x 22.9 cm)
Collection the artist, New York

Negotiations II. 2002.
Graphite, ink, and wash on "wasli" paper, 12 x 9" (30.5 x 22.9 cm)
Collection the artist, New York

Negotiations III. 2002.
Graphite, ink, and wash on "wasli" paper, 12 x 9" (30.5 x 22.9 cm)
Collection the artist, New York

Negotiations IV. 2002.
Graphite, ink, and wash on "wasli" paper, 12 x 9" (30.5 x 22.9 cm)
Collection the artist, New York

Negotiations V. 2002.
Graphite, ink, and wash on "wasli" paper, 12 x 9" (30.5 x 22.9 cm)
Collection the artist, New York

Negotiations VI. 2002.
Graphite, ink, and wash on "wasli" paper, 12 x 9" (30.5 x 22.9 cm)
Collection the artist, New York

David Thorpe

British, born 1972

*Out from the Night, the Day Is Beautiful and We Are Filled
with Joy*. 1999 (plate 53)
Paper collage, 31⅞ x 27¹⁵⁄₁₆" (81 x 71 cm)
Private collection, London

Pilgrims. 1999 (plate 51)
Paper collage, 46¼ x 68" (117.5 x 173 cm)
Collection Laura Steinberg and B. Nadal-Ginard, Chestnut Hill, Mass.

We Are Majestic in the Wilderness. 1999 (plate 50)
Paper collage, 70⅞ x 57¹⁄₁₆" (180 x 145 cm)
Rubell Family Collection

House for Auto-Destiny, Imaginative Research. 2000 (plate 52)
Paper collage, 23¾ x 39½" (60 x 100 cm)
Collection Laura Steinberg and B. Nadal-Ginard, Chestnut Hill, Mass.

Life Is Splendid. 2000
Paper collage, 32 x 21¼" (81 x 54 cm)
Collection Laura Steinberg and B. Nadal-Ginard, Chestnut Hill, Mass.

Evolution Now. 2000–2001 (plate 49)
Paper collage, 43¼ x 27½" (110 x 70 cm)
Michael and Judy Ovitz Collection

Kara Walker

American, born 1969

Negress Notes. 1996 (plates 97–104)
Watercolor on paper, twenty-one sheets, fourteen sheets each
10¼ x 7" (26 x 17.8 cm), seven sheets each 9 x 6" (22.9 x 15.2 cm)
Collection Susan and Lewis Manilow

Black Joke. 2000
Gouache and watercolor on paper, 24 x 18" (61 x 45.7 cm)
Collection Susan and Lewis Manilow

Perished under Its Own Weight. 2000
Gouache and watercolor on paper, 24 x 18" (61 x 45.7 cm)
Collection Susan and Lewis Manilow

Sublime. 2000
Gouache and watercolor on paper, 18 x 24" (45.7 x 61 cm)
Courtesy Brent Sikkema, New York

The Captain's Girl. 2000
Gouache and watercolor on paper, 24 x 18" (61 x 45.7 cm)
Collection Susan and Lewis Manilow

Richard Wright

British, born 1960

Untitled. 1999 (plate 27; not in the exhibition)
Gouache on wall. Installation view,
The Drawing Center, New York

Untitled. 2000 (plates 24, 25; not in the exhibition)
Gouache on wall
Courtesy Gagosian Gallery, New York

Method. 2000 (plate 26; not in the exhibition)
Gouache and gold leaf on wall. Installation view,
Talbot Rice Art Centre, Edinburgh

Site-specific wall drawing. 2002

Franz Ackermann

Born 1963 in Neumarkt St. Veit, Germany. Lives and works in Berlin

Solo Exhibitions
1990 Galerie Fischer, Hamburg
1991 Art Acker, Berlin
1994 Belgisches Haus, Cologne. *Ackermanns Wörterbuch der Tatigkeiten*
neugerriemschneider, Berlin. *condominium*
1995 Gavin Brown's enterprise, New York
Thomas Solomon's Garage, Los Angeles
1996 neugerriemschneider, Berlin. *Das weiche Zimmer*
1997 Gio' Marconi, Milan
Portikus, Frankfurt am Main
Städtische Galerie Nordhorn. *Unerwartet.*
Traveled: Gavin Brown's enterprise, New York
1998 Neuer Aachener Kunstverein, Aachen. *Songline*
neugerriemschneider, Berlin
White Cube, London. *Pacific*
2000 Castello di Rivoli, Turin
Galeria Camargo Vilaça, São Paulo
2001 Gavin Brown's enterprise, New York
Gio' Marconi, Milan
2002 Kunsthalle Basel. *Eine Nacht in den Tropen*

Group Exhibitions
1995 Akademie der bildenden Künste, Vienna. *En passant: Stadtansichten in der zeitgenössischen Kunst*
1996 Hamburger Kunstverein, Hamburg. *Wunderbar.* Traveled: Kunstraum, Vienna
1999 Bildmuseet, Umea. *Mirror's Edge.* Traveled: Vancouver Art Gallery; Castello di Rivoli, Turin; Tramway, Glasgow; et al.
Carnegie Museum of Art, Pittsburgh. Carnegie International 1999/2000
2001 Castello di Rivoli, Turin. *Form Follows Fiction*
Walker Art Center, Minneapolis. *Painting at the Edge of the World*

Bibliography
Ackermann, Franz. "Junge Touristen." *Texte zur Kunst* no. 16 (1994): 197–98
———. "Wish You Were Here." *Frieze*, February 1999, pp. 37–38
Beccaria, Marcella. *Franz Ackermann: B.I.T.* Exh. cat. Turin: Castello di Rivoli, 2000
Cotter, Holland. "Franz Ackermann 'Unexpected.'" *New York Times*, January 2, 1998
Decter, Joshua. Review. *Artforum*, November 1995
Denk, Andreas. "Franz Ackermann, Songline." *Kunstforum* no. 140 (April/June 1998): 390–92
Enwezor, Okwui. *Mirror's Edge.* Exh. cat. Umea: Bildmuseet, 1999
Fogle, Douglas, et al. *Painting at the Edge of the World.* Exh. cat. Minneapolis: Walker Art Center, 2001
Franz Ackermann. Exh. cat. Basel: Kunsthalle Basel, 2002
Fricke, Harald. *Franz Ackermann: Mental Maps.* Exh. cat. Frankfurt am Main: Portikus, 1997
Meneguzzo, Marco. "Franz Ackermann." *Artforum*, April 2001
Meschede, Friedrich. "Franz Ackermann. All the Places I've Never Been." *Kunstforum International*, June/August 1997, pp. 64–69
Ritchie, Matthew. "The New City." *Art/Text* 65 (1999): 74–79
Saltz, Jerry. "Franz Ackermann." *Time Out New York*, January 1998, p. 50
Spiegel, Andreas. *En passant: Stadtansichten in der zeitgenössischen Kunst.* Exh. cat. Vienna: Akademie der bildenden Künste, 1995, p. 2
Stange, Raimar. "Franz Ackermann." *Art: Das Kunstmagazin* 4 (1997): 40–43
———. "Street Drawing Man." *Kunst-Bulletin*, March 3, 1997, pp. 6–11
Unerwartet. Exh. cat. Nordhorn: Städtische Galerie Nordhorn, 1997

Kai Althoff

Born 1966 in Cologne, West Germany. Lives and works in Cologne

Solo Exhibitions
1993 Galerie Lukas & Hoffmann, Berlin
1994 Galerie Lukas & Hoffmann, Berlin. *Uwe: auf guten Rat folgt Missetat*
Galerie Nicolai Wallner, Copenhagen. *Zu ewigen Lampe*
1995 Galerie Christian Nagel, Cologne. *Kirsche-Jade-Block*
Galerie Daniel Buchholz, Cologne. *Modern wird lahmgelegt*
Künstlerhaus Stuttgart. *Hast du heute Zeit—Ich aber nicht*
1996 Galerie Christian Nagel, Cologne. *Hakelhug*
1997 Anton Kern Gallery, New York. *Hilfen und Recht der äusseren Wand (an mich)*
Robert Prime Gallery, London. *In Search of Eulenkippstadt*
1998 Galerie Daniel Buchholz, Cologne. *Bezirk der Widerrede*
Galerie Neu, Berlin. *Reflux Lux*
1999 Galerie Christian Nagel, Cologne
2000 Acme, Los Angeles
Galerie Ascan Crone, Hamburg. *Stigmata aus Grossmannssucht*
Galerie Neu, Berlin. *Hau ab, du Scheusal*
2001 Anton Kern Gallery, New York
Galerie Daniel Buchholz, Cologne. *Aus dir*
Galerie Neu, Berlin

Group Exhibitions
1993 Künstlerhaus Bethanien, Berlin. *E*
Venice Biennale. *Aperto 93*
1995 Stedelijk Museum, Amsterdam. *Wild Walls.* Traveled: Institute of Contemporary Arts, London
1997 Deichtorhallen Hamburg. *Home Sweet Home*
Kunsthalle Nürnberg, Nuremberg. *Time Out*
1998 Portikus, Frankfurt am Main. *Ars Viva 98/99—Installationen.* Traveled: Brandenburgische Kunstsammlungen, Cottbus; Kunstverein Braunschweig
2001 Frankfurter Kunstverein, Frankfurt am Main. *Neue Welt*
2002 Centre national d'art et de culture Georges Pompidou, Paris. *Cher peintre: Peintures figuratives depuis l'ultime Picabia.* Traveled: Kunsthalle Wein, Vienna; Schirn Kunsthalle, Frankfurt am Main

Bibliography
Coomer, Martin. "Kai Althoff." *Time Out London*, April 9–16, 1997
Diedrichsen, Diedrich. "House Style." *Art International* no. 3 (November 1996): 32–33
Dziewior, Yilmaz. "Das Beste aller Seiten." *Texte zur Kunst* no. 25 (March 1997): 136–39
———. "Kai Althoff. Verwobene Fictionen." *Neue bildende Kunst*, April/May 1998
———. Review. *Artforum*, May 2000, pp. 186–87
Graw, Isabelle. "Nichts geht verloren." *Berliner Tageszeitung*, December 29, 1999
Heiser, Jorg. "Bohemian Rhapsody." *Frieze*, November/December 1997, pp. 66–69
Hunt, Ian. "Kai Althoff." *Art Monthly*, May 1997, pp. 38–39
Roos, Renate. "Kai Althoff. Ein noch zu weiches Gewese der 'Urain Bündne.'" *Kunstforum International*, January/March 2000, p. 308

Kevin Appel

Born 1967 in Los Angeles, California. Lives and works in Los Angeles

Solo Exhibitions
1994 Food House, Santa Monica
1995 Spanish Box, Santa Barbara
1998 Angles Gallery, Santa Monica
1999 Angles Gallery, Santa Monica
Museum of Contemporary Art, Los Angeles
2001 Marianne Boesky Gallery, New York
2002 Angles Gallery, Santa Monica

Group Exhibitions
1996 L.A.C.E., Los Angeles. *Interiors*
1997 Long Beach Museum of Art. *Inhabited Spaces: Artists' Depictions*

1998 Contemporary Arts Museum, Houston. *Abstract Painting Once Removed*. Traveled: Kemper Museum of Contemporary Art, Kansas City, Mo.
Deitch Projects, New York. *Painting from Another Planet: New Painting from Los Angeles*
1999 Duke University Museum of Art, Durham, N.C. *The Perfect Life: Artifice in L.A.*
South London Gallery. *Drive-By: New Art from L.A.*
2000 UC Berkeley Art Museum. *2x2: Architectural Collaborations*
Henry Art Gallery, University of Washington, Seattle. *Shifting Ground: Transformed Views of the American Landscape*
Institute of Contemporary Art, University of Pennsylvania, Philadelphia. *Against Design*. Traveled: Palm Beach Institute of Contemporary Art, Lake Worth, Fla.; Kemper Museum of Contemporary Art, Kansas City, Mo.; et al.
2001 The Museum of Modern Art, New York. *New to the Modern: Recent Acquisitions*
San Francisco Museum of Modern Art. *010101: Art in Technological Times*
Walker Art Center, Minneapolis. *Painting at the Edge of the World*

Bibliography
Chung, Karen. "Appel Core." *Wallpaper*, July/August 1999, p. 58
Colpitt, Frances. Review. *Art in America* 88, no. 2 (February 2000): 137
Darling, Michael. "Kevin Appel." *Frieze* 41 (June/August 1998): 88
Fogle, Douglas, et al. *Painting at the Edge of the World*. Exh. cat. Minneapolis: Walker Art Center, 2001
Friis-Hansen, Dana. *Abstract Painting Once Removed*. Exh. cat. Houston: Contemporary Arts Museum, 1998, pp. 44–45
Johnson, Ken. Review. *New York Times*, October 26, 2001, p. E33
Pagel, David. "Fresh Outlook." *Los Angeles Times*, February 13, 1998, p. F23
———. "Home Vision." *Los Angeles Times*, June 4, 1999, p. F17
The Perfect Life: Artifice in L.A. Exh. cat. Durham, N.C.: Duke University Museum of Art, 1999
Relyea, Lane. "Virtually Formal." *Artforum* 37, no. 1 (September 1998): 126–33, 173
Robins, Mark, and Stephen Beyer. *Against Design*. Exh. cat. Philadelphia: Institute of Contemporary Art, University of Pennsylvania, 2000
Ross, David A., et al. *010101: Art in Technological Times*. Exh. cat. San Francisco: San Francisco Museum of Modern Art, 2001
Schimmel, Paul, Jeremy Strick, and Jan Tumlir. *Kevin Appel*. Exh. cat. Los Angeles: Museum of Contemporary Art, 1999
Sullivan, John J. "Art for Architecture's Sake." *Metropolis*, 1999, pp. 66–71

Los Carpinteros

Dagoberto Rodriguez, born 1969 in Caibarien, Las Villas, Cuba.
Marco Castillo, born 1971 in Camagüey, Cuba.
Alexandre Arrechea, born 1970 in Trinidad, Las Villas, Cuba.
Los Carpinteros live and work in Havana

Solo Exhibitions
1991 Fábrica de Tabacos Partagás, Havana. *Para Usted*
1992 Casa del Joven Criador, Havana. *Arte-Sano*
Centro de Arte 23 y 12, Havana. *Pintura de caballete*
Galería Arte 7, Complejo Cultural Cinematográfico Yara, Havana. *No sitios pintados*
1995 Galería Angel Romero, Madrid
Galería Habana, Havana. *Ingeniería civil*
1996 Castillo de los Tres Reyes del Morro, Havana. *Todo fue reducido al metal originál*
1997 Convento San Francio de Asís, Havana. *Viejos métodos para nuevas dudas*
Galería Angel Romero, Madrid. *Construimos el puente para que cruce la gente, construimos paredes para que el sol no llegue*
1998 Galería Habana, Havana. *Mecánica popular*
Iturralde Gallery, Los Angeles
Ludwig Forum für Internationale Kunst, Aachen. Traveled: Kunsthalle, Berlin

2000 Grant Selwyn Fine Art, Los Angeles
2001 Galeria Camargo Vilaça, São Paulo
Grant Selwyn Fine Art, Los Angeles
Los Angeles County Museum of Art
Palacio de Abrahante, Salamanca. *Tuneles populares*
P.S.1 Contemporary Art Center, Long Island City, New York. *Ciudad transportable*. Traveled: Contemporary Art Museum of Hawaii, Honolulu

Group Exhibitions
1993 Centro de Desarrollo de las Artes Visuales, Havana. *Las metáforas del templo*
1994 Centro Wifredo Lam, Havana. *Subasta*
Galería Municipal de Arte, Valparaíso. Valparaíso Bienal
Havana Bienal
1995 Haus der Kulturen der Welt, Berlin. *Havanna/São Paulo. Junge Kunst aus Lateinamerika*
Whitechapel Art Gallery, London. *New Art from Cuba*. Traveled: Tullie House Museum and Art Gallery, Carlisle
1996 Casa de América, Madrid. *Mundo soñado. Joven plástica cubana*
1997 Centro Wifredo Lam, Havana. *El arte que no cesa*
Haus der Kulturen der Welt, Berlin. *The Rest of the World*
Johannesburg Biennale. *Trade Routes. Africus 97*
Morris and Helen Belkin Art Gallery, Vancouver. *New Art from Cuba: Utopian Territories*
1998 Arizona State University Art Museum, Tempe. *Contemporary Art from Cuba: Irony and Survival on the Utopian Island*. Traveled: Yerba Buena Center for the Arts, San Francisco
The New Museum of Contemporary Art, New York
Stadthaus, Zurich. *La dirección de la mirada: Arte actual de Cuba*. Traveled: Musée des Beaux-Arts, La Chaux-de-Fonds
World Health Organization, Geneva. *The Edge of Awareness*. Traveled: P.S.1 Contemporary Art Center, Long Island City, New York; SESC de Pompeia, São Paulo; et al.
2001 The Museum of Modern Art, New York. *New to the Modern: Recent Acquisitions*
2002 Galeria "El Pasilló," Instituto Superior de Arte, Havana. *Bienalisa*. (collateral to Havana Bienal)
São Paulo Bienal

Bibliography
Anselmi, Inés. "Entrevista con los Carpinteros." *La dirección de la mirada: Arte actual de Cuba*. Exh. cat. Zurich: Stadthaus, 1998
Becker, Wolfgang. *Los Carpinteros. Provisorische Utopien*. Exh. cat. Aachen: Ludwig Forum für Internationale Kunst, 1998
Castaño, Adolfo. "Los tres carpinteros." *ABC Cultural* (Madrid) no. 177 (March 24, 1995): 28
E. V. "Los Carpinteros." *Arte y Parte* (Madrid) no. 8 (April/May 1997): 132
Fernandez Rodriguez, Antonio Eligio. "Los Carpinteros." *New Art from Cuba*. Exh. brochure. London: Whitechapel Art Gallery, 1995
Fortes, Márcia. Review. *Frieze* no. 42 (1998): 101–2
Garrels, Gary. *New to the Modern: Recent Acquisitions* Exh. brochure. New York: The Museum of Modern Art, 2001
"Los Carpinteros: Manos sabias." *Tribuna Hispana* (Madrid), March 1997, p. 23
"Los Carpinteros: Mecánica popular." *Arte Cubano* (Havana) no. 2 (1998): 68–69
Mena, Abelardo. "Mecánica popular: exposición de Los Carpinteros." *Noticias de Arte* (New York) no. 264 (Summer 1998): 22–23
Mosquera Fernandez, Gerardo. "Los hijos de Guillermo Tell." *Poliester* no. 4 (Winter 1993): 18–27
Muchnic, Suzanne. "Los Carpinteros." *Artnews*, January 1999
Ollmann, Leah. "Los Carpinteros Collaborate on Witty Works." *Los Angeles Times*, November 6, 1998
Revolución y Cultura (Havana) no. 3 (1994): 10–18, 53–60
Sirmans, Franklin. "A Mythical Metropolis Materializes in Queens." *New York Times*, May 20, 2001
"Trabajo de Carpinteros." *ABC Cultural* (Madrid), March 28, 1997, p. 24
West, Judy. "Los Carpinteros." *Artnews*, January 1999, p. 132

Russell Crotty

Born 1956 in San Rafael, California. Lives and works in Malibu

Solo Exhibitions
1991 Bess Cutler Gallery, Los Angeles. *Drawings*
1992 Dorothy Goldeen Gallery, Los Angeles. *Drawings*
1993 Cabinet Gallery, London. *Coastal Diatribes*
1994 Dan Bernier Gallery, Santa Monica. *Planetary Drawings*
 Gallery 210, University of Missouri, St. Louis
1996 Cabinet Gallery, London. *Atlases*
 Dan Bernier Gallery, Los Angeles. *Three Large Atlases*
1997 Transmission Gallery, Glasgow. *Atlases*
1998 Dan Bernier Gallery, Los Angeles. *Hiding Out on Solstice Peak*
2000 CRG Gallery, New York
 Shoshana Wayne Gallery, Santa Monica
2001 Art Center College of Design, Pasadena. *The Universe from
 My Back Yard*
2002 CRG Gallery, New York
 Hosfelt Gallery, San Francisco

Group Exhibitions
1990 L.A.C.E., Los Angeles. *Frontier Tales*
1996 Museum of Contemporary Art, Los Angeles. *The Power
 of Suggestion, Notation and Narrative in Contemporary
 Drawing*
1997 Gesellschaft für aktuelle Kunst, Bremen. *Die Arbeit
 des Zeichnens*
1998 South London Gallery. *Lovecraft*
2000 Beaver College Art Gallery, Glenside, Pa. *The Sea and
 the Sky*. Traveled: Royal Hibernian Academy, Dublin
 Los Angeles County Museum of Art. *Made in California
 1900–2000*

Bibliography
Belloli, Jay, ed. *The Universe: A Convergence of Art, Music
 and Science*. Pasadena: Armory Center for the Arts, 2001
Butler, Cornelia. *The Power of Suggestion, Notation and Narrative
 in Contemporary Drawing*. Exh. cat. Los Angeles: Museum
 of Contemporary Art, 1996
Cooper, Jacqueline. Review. *New Art Examiner*, March 2001, p. 55
Darling, Michael. Review. *Frieze*, February 1999
Duncan, Michael. Review. *Art in America*, May 1997
Duncan, Michael, and Bruce Davis. "Russell Crotty: Two Views."
 Art Issues, November/December 1991
Escalante, Greg and Kristian. Review. *Surfer's Journal* no. 2
 (April 1992)
Frick, Thomas. Review. *Art in America*, June 1992
Higgs, Matthew. *Seven Wonders of the World*. London:
 BookWorks, 1999
Hughes, Robert. "A Flawed Ex-Paradise." *Time*, December 11, 2000
Kandel, Susan. Review. *Los Angeles Times*, November 24, 1994
Love in the Ruins. Exh. cat. Long Beach: Long Beach Museum
 of Art, 1994
Pagel, David. Review. *Los Angeles Times*, September 27, 1991
Princenthal, Nancy. Review. *Art in America*, December 2000, p. 120
Russell Crotty. Exh. cat. St. Louis: University of Missouri, 1994
Stewart, Susan, Patrick Murphy, and Richard Torchia.
 The Sea and the Sky. Exh. cat. Glenside, Pa.: Beaver College
 Art Gallery, 2000

John Currin

Born 1962 in Boulder, Colorado. Lives and works in New York

Solo Exhibitions
1992 Andrea Rosen Gallery, New York
1993 Galerie Monika Sprüth, Cologne
1994 Andrea Rosen Gallery, New York
 Galerie Jennifer Flay, Paris
1995 Andrea Rosen Gallery, New York
 Institute of Contemporary Arts, London
1996 Regen Projects, Los Angeles
1997 Andrea Rosen Gallery, New York
 Sadie Coles HQ, London
1999 Andrea Rosen Gallery, New York
 Regen Projects, Los Angeles
2000 Galerie Monika Sprüth, Cologne
 Sadie Coles HQ, London
2001 Andrea Rosen Gallery, New York
2002 Regen Projects, Los Angeles

Group Exhibitions
1993 Venice Biennale. *Aperto 93: After the Event*
1995 Stedelijk Museum, Amsterdam. *Wild Walls*. Traveled:
 Institute of Contemporary Arts, London
1996 Center for Curatorial Studies, Bard College, Annandale-on-
 Hudson, N.Y. *a/drift: Scenes from the Penetrable Culture*
1997 The Museum of Modern Art, New York. *Projects 60:
 John Currin, Elizabeth Peyton, Luc Tuymans*
1998 The Aldrich Museum of Contemporary Art, Ridgefield, Conn.
 Pop Surrealism
 The Saatchi Gallery, London. *Young Americans 2*
1999 Carnegie Museum of Art, Pittsburgh. Carnegie International
 1999/2000
 MUHKA, Antwerp. *Trouble Spot: Painting*
 Whitechapel Art Gallery, London. *Examining Pictures:
 Exhibiting Paintings*. Traveled: Museum of Contemporary
 Art, Chicago; UCLA Hammer Museum, Los Angeles
2000 Whitney Museum of American Art, New York. Whitney
 Biennial
2001 The Museum of Modern Art, New York. *New to the Modern:
 Recent Acquisitions*
2002 Centre national d'art et de culture Georges Pompidou, Paris.
 Cher peintre: Peintures figuratives depuis l'ultime Picabia.
 Traveled: Kunsthalle Wien, Vienna; Schirn Kunsthalle,
 Frankfurt am Main

Bibliography
Adams, Brooks, and Lisa Liebmann. *Young Americans 2*. Exh. cat.
 London: The Saatchi Gallery, 1998
Bonami, Francesco, and Judith Nesbitt. *Examining Pictures*.
 Exh. cat. London: Whitechapel Art Gallery, and Manchester:
 Cornerhouse Publications, 1999
Cotter, Holland. "Fervidly Drafting the Self and Sex." *New York
 Times*, October 10, 1997
———. "The Gift of Art Ready to be Opened." *New York Times*,
 December 21, 2001, pp. E41, 43
D'Amato, Brian. "Spotlight: John Currin." *Flash Art*,
 Summer 1992, p. 105
Decter, Joshua. Review. *Artforum*, May 1994, pp. 100–101
Doran, Anne. "Projects 60: John Currin, Elizabeth Peyton, Luc
 Tuymans." *Time Out New York*, August 21–28, 1997, p. 39
Hoptman, Laura. *Projects 60: John Currin, Elizabeth Peyton, Luc
 Tuymans*. Exh. brochure. New York: The Museum of
 Modern Art, 1997
Januszczak, Waldemar. "Goya of the Golden Girls." *Sunday Times*,
 January 21, 1996, pp. 14–15
Kandel, Susan. "Posturing in a Most Unusual Fashion." *Los Angeles
 Times*, June 20, 1996, p. F6
Kimmelman, Michael. "John Currin." *New York Times*,
 November 12, 1999, p. E42
Leffingwell, Edward. Review. *Art in America*, February 2000,
 pp. 124–25
Morgan, Stuart. "A Can of Worms." *Frieze* no. 27
 (March/April 1996): 48–51
Rosenblum, Robert. "John Currin." *Bomb*, Spring 2000, pp. 72–78
Saltz, Jerry. "The Redemption of a Breast Man: Sanctify My Love."
 Village Voice, November 17–23, 1999, p. 77
Schjeldahl, Peter. "The Daub Also Rises." *Village Voice*,
 July 29, 1997, p. 85
———. "The Elegant Scavenger." *New Yorker*,
 February 22–March 1, 1999, pp. 174–76
Schwabsky, Barry. Review. *Artforum*, May 1999, pp. 182–83
Seward, Keith. "Boomerang." *John Currin Oeuvres/Works
 1989–1995*. Exh. cat. Limousin: Fonds regional d'art
 contemporain, 1995
Smith, Roberta. "Realism Reconsidered from Three Angles."
 New York Times, August 1, 1997, p. C25
———. Review. *New York Times*, November 17, 1995, p. C30
Zizek, Slavoj. "The Lesbian Session." *lacanian ink*, 1997, pp. 58–69

Toba Khedoori

Born 1964 in Sydney, Australia. Lives and works in Los Angeles

Bibliography
Ayerzy, Josefina. *lacanian ink*, Fall/Winter 1999, pp. 6, 7, 37, 38
Bonami, Francesco, and Judith Nesbitt. *Examining Pictures*.
 Exh. cat. London: Whitechapel Art Gallery, and Manchester:
 Cornerhouse Publications, 1999
Calame, Ingrid. "Toba Khedoori." *Art Issues* no. 37
 (March/April 1995): 42
Darling, Michael. "Marshaled Fields." *L.A. Weekly*,
 April 25–May 9, 1997, p. 55
Deitch, Jeffrey, and Stuart Morgan. *Everything That's Interesting
 Is New: The Dakis Joannou Collection*. Exh. cat. Athens:
 Deste Foundation, and Stuttgart: Cantz, 1995
Directions: Toba Khedoori. Exh. cat. Washington, D.C.: Hirshhorn
 Museum and Sculpture Garden, Smithsonian Institution, 1998
Johnson, Ken. Review. *Art in America*, November 1996, p. 108
Kandel, Susan. "Khedoori Explores Being, Nothingness."
 Los Angeles Times, January 6, 1995
Kertess, Klaus, John Ashbery, et al. *1995 Whitney Biennial*.
 Exh. cat. New York: Whitney Museum of American Art, 1995
Knight, Christopher. "Khedoori's Inviting Exhibition."
 Los Angeles Times, April 9, 1997, pp. F1, 4
Lowry, Glenn. "Feminin Masculin. L'Art Puisssance 4."
 Connaissance des Arts, May 2001, pp. 62–65
Relyea, Lane. Review. *Artforum*, Summer 1997, p. 131
Relyea, Lane, and Hans Rudolf Reust. *Toba Khedoori: Gezeichnete
 Bilder*. Exh. cat. Basel: Museum für Gegenwartskunst, 2001
Schorr, Collier. *Toba Khedoori*. Exh. cat. New York: David Zwirner,
 and Overland Park, Kansas: Johnson County Community
 College, 1995
Schumacher, Rainald, ed. *The Mystery of Painting*. Exh. cat.
 Munich: Sammlung Goetz, 2001
Singerman, Howard, ed. *Public Offerings*. Exh. cat. Los Angeles:
 Museum of Contemporary Art, 2001
Smith, Elizabeth, and Anthony Vidler. *Toba Khedoori*. Exh. cat.
 Los Angeles: Museum of Contemporary Art, 1997
Vidler, Anthony. *Warped Space: Art, Architecture, and Anxiety
 in Modern Culture*. Cambridge, Mass.: The MIT Press, 2000,
 pp. 151–58
Vine, Richard. Review. *Art in America*, October 1994
Wakefield, Neville. "Openings." *Artforum*, October 1995, pp. 94–95

Graham Little

Born 1972 in Dundee, Scotland. Lives and works in London

Bibliography
Barrett, David. *dumbpop*. London: Jerwood Gallery, 1998
Buck, Louisa. *Art Newspaper* no. 109 (December 2000)
Burrows, David. "New Contemporaries 98." *Art Monthly*,
 September 1998
Coles, Alex. "Graham Little." *Artext*, May/July 2001
"Exit Poll—Dumbpop." *Independent*, December 12, 1998
Feaver, William. "New Contemporaries 98." *Observer*, July 12, 1998
Jevons, Richard. "dumbpop." *Flux* no. 11 (February/March 1999)
Kent, Sarah. "Dumb and Dumber." *Time Out London*,
 December 9–16, 1998
———. "Sweetie." *Time Out London*, June 1998
Packer, William. "Dumb by Name but Not by Nature."
 Financial Times, January 12, 1999
Ratnam, Niru S. "Stealing Beauty." *Face*, December 2000
Shave, Stuart. "This Season's Colours." *i-D Magazine* no. 193
 (December 1999)
Taylor, John Russel. "The Big Show: Dumbpop." *Metro*,
 January 2–8, 1998
Williams, Gilda. "Heart and Soul." *Art Monthly*, September 1999

Mark Manders

Born 1968 in Volkel, The Netherlands. Lives and works in Arnhem

1995 Galerie Erika + Otto Friedrich, Bern
1997 De Appel, Amsterdam. Traveled: Douglas Hyde Gallery, Dublin
 Zeno X Gallery, Antwerp
1998 Staatliche Kunsthalle, Baden-Baden. *Yet on the Other Hand,
 Part 1*
1999 Galerie Erika + Otto Friedrich, Bern
2000 The Drawing Center, New York. *Room with Several Night
 Drawings and One Reduced Night Scene*
 Greene Naftali Gallery, New York. *Reduced November Room
 (Fragment from Self-Portrait as a Building, Reduced
 to 88%)*
 Kabinet Overholland in het Stedelijk, Amsterdam.
 Nachttekeningen uit Zelfportret als Gebouw
2002 Rijksmuseum Kröller-Müller, Otterlo

Group Exhibitions
1993 Sonsbeek, Arnhem
 Venice Biennale
1994 Musée d'Art Moderne de la Ville de Paris. *Du concept à
 l'image: Art pays-bas XXe siècle*
 Museum van Hedendaagse Kunst, Gent. *This Is the Show
 and the Show Is Many Things*
1995 National Museum of Modern Art, Jakarta.
 Orientasi/Oriëntatie. Traveled: Stedelijk Museum
 de Lakenhal, Leiden
1997 Fondazione Sandretto Re Rebaudengo, Turin
 Institute of Contemporary Arts, London. *Belladonna*
1998 São Paulo Bienal. *Self-Portrait in a Surrounding Area*
 Stedelijk Van Abbemuseum, Eindhoven. *Entr'acte*
1999 Bonner Kunstverein, Bonn. *Transmitter*
2000 Kabinet Overholland in het Stedelijk, Amsterdam. *Dutch Glory*
 Kabinet Overholland in het Stedelijk, Amsterdam. *Face to Face*
 Museum voor Moderne Kunst, Ostend
2001 Sonsbeek, Arnhem. *Locus Focus*
 Venice Biennale. *Plateau of Humankind and Post-Nature:
 Nine Dutch Artists*
2002 Documenta 11, Kassel

Bibliography
Brand, Jan, Catelijne de Muynck, and Valerie Smith, eds. *Sonsbeek
 93.* Exh. cat. Gent: Snoeck-Ducaju & Zoo, 1993, pp. 281–92
Brehm, Margrit. "14 Fragments from Self-Portrait as a Building."
 Yet on the Other Hand, Part 1. Exh. cat. Baden-Baden:
 Staatliche Kunsthalle, 1998
Breidenbach, Tom. Review. *Artforum*, November 2000, pp. 156–57
de Baere, Bart. "Mark Manders—'Momentenmachine.'" *Kunst Nu*,
 May 1996, p. 3
de Baere, Bart, Ronald van de Sompel, and Dirk Pultau.
 This Is the Show and the Show Is Many Things. Exh. cat.
 Gent: Museum van Hedendaagse Kunst, 1994
Du concept à l'image: Art pays-bas XXe siècle. Exh. cat. Paris:
 Musée d'Art Moderne de la Ville de Paris, 1994, pp. 103–9
Fragments from Self-Portrait as a Building. Exh. cat. Amsterdam:
 De Appel, and Dublin: Douglas Hyde Gallery, 1997
Guldemond, Jaap, Marente Bloemheuvel, et al. *Post-Nature:
 Nine Dutch Artists.* Exh. cat. Eindhoven: Stedelijk
 Van Abbemuseum, and Rotterdam: NAI Publishers, 2001
Reust, Hans Rudolf. "Mark Manders." *Artforum*, September 1995,
 pp. 98–99
van de Sompel, Ronald. "A Floor Plan of Desire. Notes on the
 Self-Portrait as a Building." In *De afwezigheid van
 Mark Manders.* Exh. cat. Antwerp: MUHKA, 1994
van der Plas, Els. "Mark Manders." In *Orientasi/Orientatie.*
 Exh. cat. Jakarta: Cemeti Art Foundation, and Amsterdam:
 Gate Foundation, 1995
Zes projecten. Exh. cat. Eindhoven: Stedelijk Van Abbemuseum,
 1994, pp. 59–67

Barry McGee

Born 1966 in San Francisco, California. Lives and works in
San Francisco

Solo Exhibitions
1993 Museum Laser Segall, São Paulo
1994 Yerba Buena Center for the Arts, San Francisco
1998 Walker Art Center, Minneapolis. *Regards*
1999 Deitch Projects, New York. *The Buddy System*
 Rice University Art Gallery, Houston. *Hoss*
2000 UCLA Hammer Museum, Los Angeles
2002 Gallery Paule Anglim, San Francisco
 Prada Foundation, Milan

Group Exhibitions
1991 Southern Exposure, San Francisco. *3/Play*
 Southern Exposure, San Francisco. *Wet Paint*
 University of California, Berkeley. *Wall of Resistance,
 Wall of Shame*
1993 Berkeley Art Center. *Texture of Nature*
1995 New Langton Arts, San Francisco. *The Library*
1996 The Drawing Center, New York. *Wall Drawings*
1997 San Francisco Museum of Modern Art. *Drawing Today*
2000 Institute of Contemporary Art, University of Pennsylvania,
 Philadelphia. *Indelible Market*
2001 Deste Foundation, Athens. *Holdfast*
 Fondation Cartier pour l'Art Contemporain, Paris.
 Un Art populaire

Bibliography
Baker, Alex. *Indelible Market.* Exh. cat. Philadelphia: Institute of
 Contemporary Art, University of Pennsylvania, 2000
Birnbaum, Daniel. "More Is Less." *Artforum*, September 2001
Blake, Nayland. *Interview*, February 1999
The Buddy System. New York: Deitch Projects, 1999
Cohen, Michael. Review. *Flash Art*, January/February 2001
Heartney, Eleanor. "Speaking for Themselves." *Art in America*,
 February 2002
Leffingwell, Edward. Review. *Art in America*, 1999
McCormick, Carlo. "Barry McGee's Twist of Faith." *Paper*, 1999
Street Market. Tokyo: Little More Publishers, 2000
Valdez, Sarah. Review. *Art in America*, December 2000
Yablonsky, Linda. Review. *Time Out New York*, November 2–9, 2000

Julie Mehretu

Born 1970 in Addis Ababa, Ethiopia. Lives and works in New York

Solo Exhibitions
1995 Archive Gallery, New York. *Ancestral Reflections.* Traveled:
 Hampshire College Gallery, Amherst
1996 Sol Koffler Gallery, Providence
1998 Barbara Davis Gallery, Houston
1999 Project Row Houses, Houston. *Module*
2001 ArtPace, San Antonio
 The Project, New York
2002 White Cube, London

Group Exhibitions
1995 Brooklyn Public Library, New York. *Yewenshet: Three
 Ethiopian Painters*
1998 Glassel School of Art, The Museum of Fine Arts, Houston.
 Core 1998
 University Galleries, Illinois State University, Normal.
 *Text and Territory: Navigating through Immigration
 and Dislocation*
1999 Contemporary Arts Museum, Houston. *Texas Draws*
 Glassel School of Art, The Museum of Fine Arts, Houston.
 Core 1999
 Jones Center for Contemporary Art, Austin. *Material,
 Process, Memory*
 Weatherspoon Art Gallery, University of North Carolina,
 Greensboro. *Hot Spots: Houston, Miami and Los Angeles*

2000 Center for Curatorial Studies, Bard College,
Annandale-on-Hudson, N.Y.
Museo de la Ciudad de Mexico, Mexico City.
Cinco continentes y una ciudad
P.S.1 Contemporary Art Center, Long Island City, New York.
Greater New York
The Project, New York
2001 Barbican Gallery, London. *The Americans: New Art*
The Studio Museum in Harlem, New York. *Freestyle*
Walker Art Center, Minneapolis. *Painting at the Edge of
the World*
2002 Baltic Triennale, Vilnius. *Center of Attraction*
Musée d'Art Moderne de la Ville de Paris. *Urgent Painting*
The New Museum of Contemporary Art, New York. *Out of Site*
Pusan Biennale

Bibliography
Cotter, Holland. Review. *New York Times*, June 23, 2000
Dumbadze, Alexander. "Julie Mehretu and Amy Brock." *New Art
Examiner*, September 1999
Fogle, Douglas, et al. *Painting at the Edge of the World.* Exh. cat.
Minneapolis: Walker Art Center, 2001
Griffin, Tim. "Exploded View." *Time Out New York*,
December 6–13, 2001
———. "Race Matters." *Time Out New York*, May 24–31, 2001
Hainley, Bruce, Katy Siegel, Bennett Simpson, et al. *The Americans:
New Art.* Exh. cat. London: Booth-Clibborn Editions, 2001
Hoptman, Laura. "Crosstown Traffic." *Frieze*, September 2000
Hunt, David, et al. *Freestyle.* Exh. cat. New York: The Studio
Museum in Harlem, 2001
Saltz, Jerry. "Greater Expectations." *Village Voice*, March 7–13, 2000
Sirmans, Franklin. "Mapping a New, and Urgent, History of the
World." *New York Times*, December 9, 2001

Takashi Murakami

Born 1962 in Tokyo, Japan. Lives and works in Tokyo and New York

Solo Exhibitions
1993 Hiroshima City Museum of Contemporary Art. *A Very Merry
Unbirthday!*
1994 SCAI The Bathhouse, Tokyo. *Which Is Tomorrow?—Fall in Love*
1995 Emmanuel Perrotin, Paris
SCAI The Bathhouse, Tokyo. *Crazy Z*
1996 Feature, New York
Gavin Brown's enterprise, New York
Ginza Komatsu, Tokyo. *A Very Merry Unbirthday, to You, to Me!*
1997 Blum & Poe, Santa Monica
Emmanuel Perrotin, Paris
1998 Blum & Poe, Santa Monica. *Back Beat*
Feature, New York
Tomio Koyama Gallery, Tokyo. *Superflat, Back Beat 2*
1999 Center for Curatorial Studies Museum, Bard College,
Annandale-on-Hudson, N.Y. *Takashi Murakami:
The Meaning of the Nonsense of the Meaning*
Marianne Boesky Gallery, New York. *Superflat*
Parco Gallery, Tokyo and Nagoya. *DOB in the Strange Forest*
2000 Blum & Poe, Santa Monica. *727*
P.S.1 Contemporary Art Center, Long Island City, New York.
Takashi Murakami: SMP Ko2
2001 Emmanuel Perrotin, Paris. *Kaikai Kiki*
Marianne Boesky Gallery, New York. *Mushroom*
Museum of Fine Arts, Boston
2002 Blum & Poe, Santa Monica

Group Exhibitions
1995 Louisiana Museum of Modern Art, Humlebaek. *Japan Today.*
Traveled: Kunstnernes Hus, Oslo; Liljevalchs Konsthall,
Stockholm; et al.
Venice Biennale. *Transculture.* Traveled: Benesse House,
Naoshima; Contemporary Art Museum, Kagawa
1996 Asia-Pacific Triennial of Contemporary Art, Brisbane
1997 Wiener Secession, Vienna. *Cities on the Move.* Traveled: capc
Musée d'art contemporain, Bordeaux; P.S.1 Contemporary
Art Center, Long Island City, New York; et al.

1998 Contemporary Arts Museum, Houston. *Abstract Painting
Once Removed.* Traveled: Kemper Museum of
Contemporary Art, Kansas City, Mo.
1999 Carnegie Museum of Art, Pittsburgh. Carnegie International
1999/2000
2000 Parco Gallery, Tokyo. *Superflat.* Traveled: Parco Gallery,
Nagoya
2001 Barbican Gallery, London. *JAM: Tokyo London*
Des Moines Art Center. *My Reality: Contemporary Art and
the Culture of Japanese Animation.* Traveled: Brooklyn
Museum of Art, New York; The Contemporary Arts
Center, Cincinnati
Museum of Contemporary Art, Los Angeles. *Superflat.*
Traveled: Walker Art Center, Minneapolis; Henry Art
Gallery, University of Washington, Seattle
Site Santa Fe. *Beau Monde: Toward a Redeemed
Cosmopolitanism*
Walker Art Center, Minneapolis. *Painting at the Edge of
the World*

Bibliography
Cruz, Amada, Midori Matsui, and Dana Friis-Hansen. *Takashi
Murakami: The Meaning of the Nonsense of the Meaning.*
Exh. cat. Annandale-on-Hudson, N.Y.: Center for Curatorial
Studies Museum, Bard College
Fleming, Jeff, et al. *My Reality: Contemporary Art and the Culture
of Japanese Animation.* Exh. cat. New York: ICI, 2001
Fogle, Douglas, et al. *Painting at the Edge of the World.* Exh. cat.
Minneapolis: Walker Art Center, 2001
Friis-Hansen, Dana. *Abstract Painting Once Removed.* Exh. cat.
Houston: Contemporary Arts Museum, 1998
———. "Takashi Murakami." *Grand Street* 65 (1998): 216–21
Itoi, Kay. "The Wizard of DOB." *Artnews*, March 2001, pp. 134–37
Knight, Christopher. "Flat-Out Profound." *Los Angeles Times*,
January 16, 2001, pp. F1, 7
Matsui, Midori. "Japanese Innovators." *Flash Art*,
January/February 2000, pp. 90–91
Murakami, Takashi. *Superflat.* Tokyo: Madra Publishing and
Takashi Murakami, 2000, pp. 4–5, 8–25
Nakamura, Eric. "Superfly." *Giant Robot* no. 21 (2001): 24–28
———. "The Year Otaku Broke." *Artext* no. 73 (May/July 2001): 36–39
Pagel, David. "Takashi Murakami: Meet Japan's Pop Art Samurai."
Interview, March 2001, pp. 188–91
Rimanelli, David. Review. *Artforum*, November 1999, pp. 134–35
Rubinstein, Raphael. "In the Realm of the Superflat." *Art in
America*, 2001, pp. 110–15
Smith, Roberta. Review. *New York Times*, February 5, 1999, p. B35
———. Review. *New York Times*, April 6, 2001, p. B36

Yoshitomo Nara

Born 1959 in Aomori Prefecture, Japan. Lives and works in Tokyo

Solo Exhibitions
1984 Gallery Space to Space, Nagoya. *Wonder Room*
1988 Galerie Humanite, Nagoya and Tokyo. *Innocent Being*
Goethe Institut, Düsseldorf
1990 Galerie d'Eendt, Amsterdam
1991 Galerie d'Eendt, Amsterdam
Galerie Humanite, Nagoya. *Cogitationes Cordium*
1993 Galerie Humanite, Nagoya and Tokyo. *Be Happy*
Johnen & Schöttle, Cologne
1994 Hakutosha, Nagoya. *Lonesome Babies*
1995 Blum & Poe, Santa Monica. *Pacific Babies*
Galerie Humanite, Nagoya. *Oil on Canvas*
Galerie Humanite, Tokyo. *Nothing Gets Me Down*
Museum of Contemporary Art, Nagoya. *Cup Kids*
SCAI The Bathhouse, Tokyo. *In the Deepest Puddle*
1996 Hakutosha, Nagoya. *Hothouse Fresh*
Tomio Koyama Gallery, Tokyo. *Lonesome Puppy.* Traveled:
Hakutosha, Nagoya
1997 Blum & Poe, Santa Monica
Hakutosha, Nagoya. *Drawing Days*
Tomio Koyama Gallery, Tokyo. *Screen Memory*

1999 Blum & Poe, Santa Monica
Institut für moderne Kunst Nürnberg, Nuremberg
Marianne Boesky Gallery, New York. *Pave Your Dreams*
Parco Gallery, Nagoya. *Done Did*
Tomio Koyama Gallery, Tokyo. *No, They Didn't*
2000 Johnen & Schöttle, Cologne. *In the Empty Fortress*
Museum of Contemporary Art, Chicago. *Walk On*
Santa Monica Museum of Art. *Lullaby Supermarket*
Stephen Friedman Gallery, London
2001 Blum & Poe, Santa Monica. *In the White Room*
Yokohama Museum of Art. *I Don't Mind if You Forget Me.*
Traveled: Hiroshima Museum of Contemporary Art;
Ashiya City Museum of Art; et al.

Group Exhibitions

1995 Osaka Contemporary Art Center. *The Future of Paintings*
SCAI The Bathhouse, Tokyo. *Endless Happiness*
1998 Museum of Contemporary Art Tokyo. *The Manga Age*
1999 Des Moines Art Center. *Almost Warm and Fuzzy: Childhood
and Contemporary Art.* Traveled: Tacoma Art Museum;
P.S.1 Contemporary Art Center, Long Island City,
New York; et al.
2000 Parco Gallery, Tokyo. *Superflat.* Traveled: Parco Gallery,
Nagoya
2001 Barbican Gallery, London. *JAM: Tokyo London*
Des Moines Art Center. *My Reality: Contemporary Art and
the Culture of Japanese Animation.* Traveled: Brooklyn
Museum of Art, New York; The Contemporary Arts
Center, Cincinnati
Museum of Contemporary Art, Los Angeles. *Superflat.*
Traveled: Walker Art Center, Minneapolis; Henry Art
Gallery, University of Washington, Seattle

Bibliography

Darling, Michael. "Yoshitomo Nara." *Frieze*,
November/December 1997, p. 85
Fleming, Jeff, et al. *My Reality: Contemporary Art and the Culture
of Japanese Animation.* Exh. cat. New York: ICI, 2001
Fujitsu, Ryota. "Superflat: Battle of America." *Bijutsu Techo* 53,
no. 803 (April 2001): 179–90
"Interview." *Bijutsu Techo* no. 709 (July 1995): 34–37
Itoi, Kay. "Star Track: The Next Generation. Yoshitomo Nara."
Artnews, May 1998, p. 153
Joynes, Les. Review. *Art in America*, July 1999, p. 106
Knight, Christopher. "Flat-Out Profound." *Los Angeles Times*,
January 16, 2001, pp. F1, 7
Matsui, Midori. "The Container for the Open Spirit." *Bijutsu Techo*,
April 2000
Nagoya, Satoru. "Ouverture: Yoshitomo Nara." *Flash Art*,
May/June 1998, p. 91
Nakamura, Eric. "Punk Art." *Giant Robot* no. 20 (2001): 24–28
———. "The Year Otaku Broke." *Artext* no. 73 (May/July 2001): 36–39
Nara, Yoshitomo. *In the Deepest Puddle.* Tokyo: Kadokawa
Shoten, 1998
Pagel, David. "Lullaby: Just the Right Cup of Tea." *Los Angeles Times*,
April 10, 2000, pp. F1, 10
Smith, Roberta. Review. *New York Times*, November 5, 1999, p. B39
"Special Feature: Yoshitomo Nara." *Bijutsu Techo* 52, no. 790
(July 2000): 11–147
Yoshimoto, Banana. *Yoshitomo Nara: Lullaby Supermarket.*
Nuremberg: Verlag für moderne Kunst Nürnberg, and Tokyo:
Kadokawa Shoten, 2001

Paul Noble

Born 1963 in Northumberland, England. Lives and works in London

Solo Exhibitions

1990 City Racing, London
1995 Cubitt Gallery, London. *Ye Olde Worke*
1996 Interim Art, London. *Doley*
1999 Chapman Fine Arts, London
Chisenhale Gallery, London. *NOBSON*
Maureen Paley/Interim Art, London
2000 Gorney Bravin + Lee, New York. *Nobson Newtown*
2001 MAMCO, Geneva.
2002 Albright-Knox Art Gallery, Buffalo
Maureen Paley/Interim Art, London

Group Exhibitions

1994 Laure Genillard, London. *Supastore Boutique*
1995 Maureen Paley/Interim Art, London
1996 Portikus, Frankfurt am Main. *Semikolon*
South London Gallery. *Popocultural*
1999 Bricks and Kicks, Vienna. *It Took Ages*
City Racing, London. *The Last Show*
Institute of Contemporary Arts, London. *Belladonna*
Institute of Contemporary Arts, London. *Surfacing:
Contemporary Drawing*
Tate Gallery, London. *Abracadabra*
2000 Manifesta, Ljubljana
Thread Waxing Space, New York. *Death Race 2000*
2001 Institute of Contemporary Arts, London. *City Racing
1988–1998: A Partial Account*
2002 Sydney Biennale. *(The World May Be) Fantastic*

Bibliography

Archer, Michael. "Paul Noble." *Artforum*, Summer 1998, p. 143
Beech, David. "Paul Noble." *Art Monthly* no. 215 (April 1998): 24–25
Bishop, Claire. Review. *Flash Art* 33, no. 206 (May/June 1999)
Brown, Neal. "Paul Noble." *Frieze*, Summer 1998, p. 89
Buck, Louisa. "Artist Q & A: Paul Noble." *Art Newspaper* 10, no. 88
(January 1999)
Currah, Mark. *Time Out London*, October 11–18, 1995
Davies, Peter. "Paul Noble." *Flash Art*, November/December 1996,
pp. 107–8
Hubbard, Sue. "Paul Noble." *Time Out London*,
May 22–29, 1996, p. 51
Jones, Jonathan. "Art: Paul Noble." *Observer*, December 20, 1998
Kino, Carol. Review. *Art in America*, October 2000, pp. 169–70
Kuni, Verena. "Semikolon." *Kunst-Bulletin*, November 1996
Lillington, David. "Comic Art." *Art Monthly* no. 266 (May 1998)
Schwabsky, Barry. "Drawing on the New Town: Chad McCail and
Paul Noble." *Art on Paper*, July/August 2000, pp. 34–39
Slyce, John. "Paul Noble: Nobwaste." *Flash Art*, March–April 2001
Williams, Gilda. Review. *Art Monthly* no. 252
(December 2001–January 2002)

Jockum Nordström

Born 1963 in Stockholm, Sweden. Lives and works in Stockholm

Solo Exhibitions

1988 Uddevalla Konsthall, Uddevalla
1989 Galleri Arton A, Stockholm
1991 Galleri Arton A, Stockholm
1992 Villa Val Lemme, Turin
1993 Olle Olsson-huset, Solna
1994 Galleri St. Olof, Norrköping
1995 Galleri 1, Gothenburg
1997 Galleri Kavaletten, Stockholm
Galleri Magnus Karlsson, Västerås
1998 Galleri Dialog, Stockholm
Galleri Magnus Karlsson, Stockholm
1999 Galleri 1, Gothenburg
Wetterling Gallery, Stockholm
2000 David Zwirner, New York
2001 Galleri Magnus Karlsson, Stockholm
2002 David Zwirner, New York

Group Exhibitions

2001 The Museum of Modern Art, New York. *New to the Modern:
Recent Acquisitions*

Bibliography

Diamond, Karen. "Jockum Nordström." *Flash Art*,
January/February 2002, pp. 100–101
Johnson, Ken. Review. *New York Times*, March 15, 2002

Rasmusson, Ludvig. "Jockum Nordström." *10.000 gulddollar till den som gifter sig med snön*, 1998, pp. 2–3
Shaw, Lytle. *Time Out New York*, October 5–12, 2000
Smith, Roberta. Review. *New York Times*, September 29, 2000
Spears, Dorothy. "Jockum Nordström." *Art on Paper*, January/February 2001, pp. 91–92

Chris Ofili

Born 1968 in Manchester, England. Lives and works in London

Solo Exhibitions
1991 Kepler Gallery, London. *Paintings and Drawings*
1995 Gavin Brown's enterprise, New York
1996 Victoria Miro Gallery, London. *Affrodizzia*
1998 Southampton City Art Gallery. Traveled: Serpentine Gallery, London
1999 Gavin Brown's enterprise, New York. *Afrobiotics*
2000 Victoria Miro Gallery, London. *Chris Ofili Drawings*
2001 Gallery Side 2, Tokyo. *Watercolours*

Group Exhibitions
1992 Bulawayo Art Gallery, Bulawayo. *Pachipamwe International*
1993 Cornerhouse Gallery, Manchester. *BT New Contemporaries*. Traveled: Orchard Gallery, Derry; Mappin Art Gallery, Sheffield; et al.
1995 Walker Art Center, Minneapolis. *Brilliant! New Art from London*. Traveled: Museum of Contemporary Art, Houston
Walker Art Gallery, Liverpool. *John Moores Exhibition of Contemporary Painting*
1996 Louisiana Museum of Modern Art, Humlebaek. *NowHere*
Museum of Modern Art, Oxford. About Vision: *New British Painting in the 1990s*. Traveled: Christchurch Mansion, Ipswich; Fruitmarket Gallery, Edinburgh; et al.
South London Gallery, London. *Popocultural*
1997 Institute of Contemporary Arts, London. *Belladonna*
Royal Academy of Arts, London. *Sensation: Young British Artists from the Saatchi Collection*. Traveled: Hamburger Bahnhof, Berlin; Brooklyn Museum of Art, New York
Stedelijk Museum, Amsterdam. *Mothership Connection*
Walker Art Gallery, Liverpool. *John Moores Exhibition of Contemporary Painting*
1998 Tate Gallery, London. *The Turner Prize Exhibition*
1999 Carnegie Museum of Art, Pittsburgh. Carnegie International 1999/2000
Istanbul Biennial
MUHKA, Antwerp. *Trouble Spot: Painting*
2000 Sydney Biennial
2001 Castello di Rivoli, Turin. *Form Follows Fiction*
Museum of Contemporary Art, Los Angeles. *Public Offerings*
Sammlung Goetz, Munich. *The Mystery of Painting*
Walker Art Center, Minneapolis. *Painting at the Edge of the World*

Bibliography
Adams, Brooks, Lisa Jardine, Martin Maloney, et al. *Sensation: Young British Artists from the Saatchi Collection*. Exh. cat. London: Royal Academy of Arts, in association with Thames & Hudson, 1997
Buck, Louisa. "Openings: Chris Ofili." *Artforum*, September 1996
Cork, Richard. "The Name to Droppings." *Times*, October 6, 1998
Eshun, Kodwo. "An Ofili Big Adventure." *Arena*, October 1998, pp. 138–40
Fogle, Douglas, et al. *Painting at the Edge of the World*. Exh. cat. Minneapolis: Walker Art Center, 2001
Januszczak, Waldemar. "Ordure of no Merit." *Sunday Times*, October 4, 1998
MacRitchie, Lynn. "Ofili's Glittering Icons." *Art in America*, January 2000, pp. 96–101
Morgan, Stuart. "The Elephant Man." *Frieze* no. 15 (1994)
Myers, Terry R. "Chris Ofili, Power Man." *Art/Text* no. 58 (August–October 1996)
Schumacher, Rainald, ed. *The Mystery of Painting*. Exh. cat. Munich: Sammlung Goetz, 2001

Singerman, Howard, ed. *Public Offerings*. Exh. cat. Los Angeles: Museum of Contemporary Art, 2001
Smith, Roberta. Review. *New York Times*, October 29, 1999
———. Review. *New York Times*, December 2, 1995
Worsdale, Godfrey, Lisa Corrin, and Kodwo Eshun. *Chris Ofili*. Exh. cat. Southampton: Southampton City Art Gallery, and London: Serpentine Gallery, 1998

Laura Owens

Born 1970 in Euclid, Ohio. Lives and works in Los Angeles

Solo Exhibitions
1995 Rosamund Felsen Gallery, Santa Monica
1996 Gavin Brown's enterprise, New York
Künstlerhaus Bethanien, Berlin. *Studio 246*
1997 Sadie Coles HQ, London
1998 Acme, Los Angeles
Gavin Brown's enterprise, New York
1999 Galerie Gisela Capitain, Cologne
Sadie Coles HQ, London
2000 Inverleith House, Royal Botanic Garden, Edinburgh
Studio Guenzani, Milan
2001 Acme, Los Angeles
Isabella Stewart Gardner Museum, Boston

Group Exhibitions
1996 Hamburger Kunstverein, Hamburg. *Wunderbar*. Traveled: Kunstraum, Vienna
1997 P.S.1 Contemporary Art Center, Long Island City, New York. *Vertical Painting Show*
1998 The Saatchi Gallery, London. *Young Americans 2*
Studio Guenzani, Milan
1999 Carnegie Museum of Art, Pittsburgh. Carnegie International 1999/2000
Kunsthalle Basel. *Nach-Bild*
San Francisco Museum of Modern Art. *New Work: Painting Today*
Whitechapel Art Gallery, London. *Examining Pictures: Exhibiting Paintings*. Traveled: Museum of Contemporary Art, Chicago; UCLA Hammer Museum, Los Angeles
2001 Museum of Contemporary Art, Los Angeles. *Public Offerings*
Sammlung Goetz, Munich. *The Mystery of Painting*
Walker Art Center, Minneapolis. *Painting at the Edge of the World*
2002 Kunstmuseum and Museum für Gegenwartskunst, Basel. *Painting on the Move*
Musée d'Art Moderne de la Ville de Paris. *Urgent Painting*
Santa Monica Museum of Art. *Cavepainting*

Bibliography
Adams, Brooks, and Lisa Liebmann. *Young Americans 2*. Exh. cat. London: The Saatchi Gallery, 1998
Avgikos, Jan. Review. *Artforum*, January 1999, pp. 118–19
Bonami, Francesco, and Judith Nesbitt. *Examining Pictures*. Exh. cat. London: Whitechapel Art Gallery, and Manchester: Cornerhouse Publications, 1999
Cavalchini, Pieranna, ed. *Laura Owens*. Milan: Charta, 2001, for the Isabella Stewart Gardner Museum, Boston
Fogle, Douglas, et al. *Painting at the Edge of the World*. Exh. cat. Minneapolis: Walker Art Center, 2001
Fresh Cream. London: Phaidon Press, 2000
Grynsztejn, Madeleine, ed. *Carnegie International 1999/2000*. Exh. cat. Pittsburgh: Carnegie Museum of Art, 1999
Iannaccone, Carmine. "Entertainment Complex." *Frieze*, November/December 1999, pp. 81–91
Morgan, Susan. "A Thousand Words: Laura Owens Talks about Her New Work." *Artforum*, Summer 1999, pp. 130–31
Morgan, Susan, and Henry Noltie. *New Work by Laura Owens (1999) and John Hutton Balfour's Botanical Teaching Diagrams (1840–1879)*. Exh. cat. Edinburgh: Inverleith House, Royal Botanic Garden, 2000
Pagel, David. "New Sophistication in Owens's Landscapes." *Los Angeles Times*, October 1998, p. F26

Princenthal, Nancy. "Laura Owens." *Art in America*,
February 1999, p. 115
Relyea, Lane. "Virtually Formal." *Artforum* 37, no. 1
(September 1998): 126–33, 173
Saltz, Jerry. "Regular, No Sugar." *Time Out New York*,
February 27, 1997
Schumacher, Rainald, ed. *The Mystery of Painting*. Exh. cat.
Munich: Sammlung Goetz, 2001
Singerman, Howard, ed. *Public Offerings*. Exh. cat. Los Angeles:
Museum of Contemporary Art, 2001
Smith, Roberta. Review. *New York Times*, February 2, 1996, p. C26
Stark, Frances. *Nach-Bild*. Exh. cat. Basel: Kunsthalle Basel, 1999,
pp. 84–92
Weissman, Benjamin. "Openings: Laura Owens." *Artforum*,
November 1995

Jennifer Pastor

Born 1966 in Hartford, Connecticut. Lives and works in Los Angeles

Solo Exhibitions

1994 Richard Telles Fine Art, Los Angeles
1995 Studio Guenzani, Milan
1996 Museum of Contemporary Art, Chicago. Traveled: Museum
of Contemporary Art, Los Angeles

Group Exhibitions

1994 FRAC, Dijon. *Surface de réparation*
1996 São Paulo Bienal. *Universalis*
Studio Guenzani, Milan. *Contrafigura*
1997 Louisiana Museum of Modern Art, Humlebaek. *Sunshine &
Noir: Art in L.A. 1960–1997*. Traveled: Kunstmuseum,
Wolfsburg; Castello di Rivoli, Turin; et al.
San Francisco Museum of Modern Art. *New Work:
Drawings Today*
San Francisco Museum of Modern Art. *Present Tense*
Whitney Museum of American Art, New York. Whitney Biennial
1998 Palazzo Re Rebaudengo, Guarene d'Alba. *L.A. Times*

Bibliography

Adams, Brooks. "Turtle Derby." *Art in America*, June 1997, pp. 34–40
Bishop, Janet, Gary Garrels, and John Weber. *Present Tense: Nine
Artists in the Nineties*. Exh. cat. San Francisco:
San Francisco Museum of Modern Art, 1997
Cruz, Amada. "Blatant Artifice." In *Jennifer Pastor*. Exh. cat.
Chicago: Museum of Contemporary Art, 1996
Cutjar, Mario. Review. *L.A. Weekly*, February 7–13, 1997, p. 51
Drohojowska-Philp, Hunter. "Turning Over a Brighter Leaf."
Los Angeles Times, November 24, 1996, pp. 59–60
Gerstler, Amy. Review. *Artforum*, November 1994, p. 93
Greene, David A. "Openings: Jennifer Pastor." *Artforum*,
September 1996, pp. 98–99
Kandel, Susan. "Interview." *Index*, June 1996, pp. 28–33
———. "Jennifer Pastor: Dream Day Residue." *Art & Text*, 1996,
pp. 51–53
———. Review. *Los Angeles Times*, May 9, 1994, p. F7
Knight, Christopher. "Pastor Giddily Embraces the Trash Vernacular."
Los Angeles Times, December 19, 1996, pp. 1, 10
Morgan, Susan. "A Sculptor Reinvents the Four Seasons." *Elle*,
July 1996, p. 26
Pagel, David. "Entering a New Dimension." *Los Angeles Times*,
August 25, 1994, pp. 7, 87
Phillips, Lisa, and Louise Neri. *1997 Whitney Biennial*. Exh. cat.
New York: Whitney Museum of American Art, 1997
Rugoff, Ralph. "The Garden of Uncanny Delight." *Los Angeles
Weekly*, May 13, 1994, p. 31
———. "L.A.'s Female Art Explosion." *Harper's Bazaar*, April 1997,
pp. 204–5, 246
Weissman, Benjamin. "Seasonal Change." *Frieze*,
November/December 1996, pp. 46–49

Elizabeth Peyton

Born 1965 in Danbury, Connecticut. Lives and works in New York

Solo Exhibitions

1995 Burkhard Riemschneider, Cologne
Gavin Brown's enterprise, New York
1996 Gavin Brown's enterprise, New York
neugerriemschneider, Berlin
1997 Galerie Daniel Buchholz, Cologne
Gavin Brown's enterprise, New York
Regen Projects, Los Angeles
Saint Louis Art Museum. Traveled: Seattle Art Museum
1998 Kunstmuseum, Wolfsburg. Traveled: Museum für
Gegenwartskunst, Basel
Sadie Coles HQ, London
1999 Castello di Rivoli, Turin
Gavin Brown's enterprise, New York
neugerriemschneider, Berlin
Regen Projects, Los Angeles
2000 Gavin Brown's enterprise, New York
Sadie Coles HQ, London
Westfälischer Kunstverein, Münster
2001 Deichtorhallen, Hamburg
Gavin Brown's enterprise, New York
2002 neugerriemschneider, Berlin
Salzburger Kunstverein, Salzburg

Group Exhibitions

1995 Venice Biennale. *Campo*
1996 Center for Curatorial Studies, Bard College,
Annandale-on-Hudson, N.Y. *a/drift: Scenes from the
Penetrable Culture*
São Paulo Bienal. *Universalis*
1997 The Museum of Modern Art, New York. *Projects 60:
John Currin, Elizabeth Peyton, Luc Tuymans*
San Francisco Museum of Modern Art. *New Work:
Drawings Today*
1998 The Saatchi Gallery, London. *Young Americans 2*
1999 Whitechapel Art Gallery, London. *Examining Pictures:
Exhibiting Paintings*. Traveled: Museum of Contemporary
Art, Chicago; UCLA Hammer Museum, Los Angeles
2000 P.S.1 Contemporary Art Center, Long Island City, New York.
Greater New York
2001 The Museum of Modern Art, New York. *Collaborations with
Parkett: 1984 to Now*
The Museum of Modern Art, New York. *New to the Modern:
Recent Acquisitions*
2002 Centre national d'art et de culture Georges Pompidou, Paris.
Cher peintre: Peintures figuratives depuis l'ultime Picabia.
Traveled: Kunsthalle Wien, Vienna; Schirn Kunsthalle,
Frankfurt am Main

Bibliography

Adams, Brooks, and Lisa Liebmann. *Young Americans 2*. Exh. cat.
London: The Saatchi Gallery, 1998
Bonami, Francesco. Interview. *Flash Art*, March/April 1995,
pp. 84–86
Bonami, Francesco, and Judith Nesbitt. *Examining Pictures*.
Exh. cat. London: Whitechapel Art Gallery, and Manchester:
Cornerhouse Publications, 1999
Cotter, Holland. Review. *New York Times*, March 21, 1997
Decter, Joshua. *a/drift: Scenes from the Penetrable Culture*.
Exh. cat. Annandale-on-Hudson, N.Y.: Center for Curatorial
Studies, Bard College, 1996, p. 17
Doran, Anne. "Projects 60: John Currin, Elizabeth Peyton, Luc
Tuymans." *Time Out New York*, August 21–28, 1997, p. 39
Hickey, Dave. *Elizabeth Peyton*. Exh. cat. Basel: Museum für
Gegenwartskunst, and Wolfsburg: Kunstmuseum, 1998
Hoptman, Laura. *Projects 60: John Currin, Elizabeth Peyton,
Luc Tuymans*. Exh. brochure. New York: The Museum of
Modern Art, 1997
Leffingwell, Edward. Review. *Art in America*, March 2002,
pp. 128–29
Pagel, David. "Elizabeth Peyton." *Los Angeles Times*,
November 5, 1999, p. F26

Parkett no. 53 (1998): 58–92. Essays by Lisa Liebmann,
 Linda Pilgrim, David Rimanelli, and Philip Ursprung
Peyton, Elizabeth. *Craig*. Cologne: Edition Salzau and Verlag der
 Buchhandlung Walter König, 1998
Schjeldahl, Peter. "The Daub Also Rises." *Village Voice*,
 July 29, 1997, p. 85
———. "Peyton's Place." *Village Voice*, March 25, 1997
Searle, Adrian. "The Infants Liam and Noel on the Sofa.... Is This
 What Passes for the New American Dream?" *Guardian*,
 September 7, 1998, p. 19
Smith, Roberta. "Blood and Punk Royalty to Grunge Royalty."
 New York Times, March 24, 1995, p. C32
———. "Realism Reconsidered from Three Angles." *New York Times*,
 August 1, 1997, p. C25
Universalis. Exh. cat. São Paulo: São Paulo Bienal, 1996
Verzotti, Giorgio. Review. *Artforum*, February 2002, pp. 139–40

Neo Rauch

Born 1960 in Leipzig, East Germany. Lives and works in Leipzig

Solo Exhibitions
1989 Galerie am Thomaskirchhof, Leipzig
1991 Galerie Schwind, Frankfurt am Main
1993 Galerie Alvensleben, Munich
 Galerie EIGEN + ART, Leipzig
 Galerie Voxx, Chemnitz
 Imkabinett Galerie, Berlin
1994 Kunstverein Elsterpark e. V., Leipzig
1995 Dresdner Bank, Leipzig
 Galerie EIGEN + ART, Berlin
 Goethe House, New York
 Overbeck-Gesellschaft, Lübeck. *Marineschule*
1997 Galerie EIGEN + ART, Berlin. *Manöver*
 Museum der bildenden Künste, Leipzig
1998 Galerie der Stadt Backnang
 Galerie EIGEN + ART, Berlin
2000 David Zwirner, New York
 Galerie EIGEN + ART, Berlin and Leipzig
 Galerie für zeitgenössische Kunst, Leipzig. *Randgebiet*.
 Traveled: Haus der Kunst, Munich; Kunsthalle Zürich
2001 Deutsche Guggenheim, Berlin
2002 David Zwirner, New York

Group Exhibitions
1993 Marstall, Berlin. *Künstler träumen Berlin*
1996 Goethe House, New York
 Kunstverein Düsseldorf. *Der Blick ins 21ste*
1997 Germanisches Nationalmuseum, Nuremberg. *Lust und Last*.
 Traveled: Museum der bildenden Künste, Leipzig
1998 Espace des Arts, Chalon-sur-Saône. *Transmission*
1999 Institute of Contemporary Arts, London. *The Golden Age*
 Moderna Museet, Stockholm. *After the Wall*
 P.S.1 Contemporary Art Center, Long Island City, New York.
 Children of Berlin
2001 Sammlung Goetz, Munich. *The Mystery of Painting*
 Venice Biennale
2002 Centre national d'art et de culture Georges Pompidou, Paris.
 Cher peintre: Peintures figuratives depuis l'ultime Picabia.
 Traveled: Kunsthalle Wein, Vienna; Schirn Kunsthalle,
 Frankfurt am Main
 Contemporary Arts Museum, Houston. *Pertaining
 to Painting*

Bibliography
Beaucamp, Eduard. "Schattenboxen im Randgebiet." *Frankfurter
 Allgemeine Zeitung* feuilleton no. 5, January 6, 2001, p. 41
Birnbaum, Daniel. Review. *Artforum*, March 2001, pp. 136–37
Brock, Bazon, Martin Schick, and Christoph Tannert. *Neo Rauch*.
 Exh. cat. Backnang: Galerie der Stadt Backnang, 1998
Fleck, Robert, Ulf Küster, and Norman Rosenthal. *Neo Rauch*.
 Exh. cat. Leipzig: Museum der bildenden Künste, 1997
Fricke, Harald. Review. *Artforum*, March 1999
Grimes, Nancy. "Neo Rauch." *Artnews*, June 2000, p. 144–45
Guth, Peter. "Machtspiele gegen die terroristische Realität: Neue
 Bilder von Neo Rauch in Leipzig." *Frankfurter Allgemeine
 Zeitung*, May 16, 1997
Jones, Kristin M. "Neo Rauch." *Frieze*, June/August 2000, pp. 116–17
Mack, Gerhard. "Mit den Waffen des Malers." *Art: Das
 Kunstmagazin*, January 2001, pp. 12–23
Manöver. Exh. cat. Leipzig: Galerie EIGEN + ART, 1997
Mayer, Thomas. "Etwas Rauch über den Wolkenkratzern."
 Leipziger Volkszeitung, March 3, 2000
Neo Rauch. Exh. cat. Munich: Galerie Alvensleben, 1993
Neo Rauch: Marineschule. Exh. cat. Lübeck:
 Overbeck-Gesellschaft, 1995
Schumacher, Rainald, ed. *The Mystery of Painting*. Exh. cat.
 Munich: Sammlung Goetz, 2001
Smith, Roberta. Review. *New York Times*, April 26, 2002, p. E33
Volk, Gregory. Review. *Art in America*, May 2000, pp. 161–62
Werner, Klaus, ed. *Neo Rauch: Randgebiet*. Exh. cat. Leipzig:
 Galerie für Zeitgenössische Kunst, 2000
Wiensowski, Ingeborg. "Neo Rauch." *Spiegel*, December 2000, p. 30

Matthew Ritchie

Born 1964 in London, England. Lives and works in New York

Solo Exhibitions
1995 Basilico Fine Arts, New York. *Working Model*
1996 Atle Gerhardsen, Oslo. *The Hard Way, Chapter III*
 Basilico Fine Arts, New York. *The Hard Way, Chapter II*
 Galerie Météo, Paris. *The Hard Way, Chapter I*
 http://adaweb.walkerart.org/influx/hardway/
1997 Nexus Contemporary Art Center, Atlanta. *Omniverse*
1998 Basilico Fine Arts, New York. *The Gamblers*
 Galeria Camargo Vilaça, São Paulo
 Paco Imperial, Rio de Janeiro
1999 Atle Gerhardsen, Oslo. *The Working Group*
 Cleveland Center for Contemporary Art. *The Big Story*
2000 Andrea Rosen Gallery, New York. *Parents and Children*
 Museum of Contemporary Art, Miami. *The Fast Set*
2001 Dallas Museum of Art
 White Cube/Jay Jopling, London. *The Family Farm*
2002 Andrea Rosen Gallery, New York

Group Exhibitions
1996 San Francisco Museum of Modern Art. *New Work:
 Drawings Today*
1997 Whitney Museum of American Art, New York. Whitney Biennial
1998 Southeastern Center of Contemporary Art, Winston-Salem.
 Parallel Worlds
1999 Thread Waxing Space, New York. *Conceptual Art,
 a Neurobiological Praxis*
2000 The Aldrich Museum of Contemporary Art,
 Ridgefield, Conn. *Faith*
 Musée des Beaux-Arts de Nantes. *Vision Machine*
2001 Castello di Rivoli, Turin. *Form Follows Fiction*
 Museum Abteiberg, Mönchen-Gladbach. *futureland2001.com*
 The Museum of Modern Art, New York. *Collaborations with
 Parkett: 1984 to Now*
 San Francisco Museum of Modern Art. *010101: Art in
 Technological Times*
2002 Musée d'Art Moderne de la Ville de Paris. *Urgent Painting*
 Sydney Biennale. *(The World May Be) Fantastic*

Bibliography
Berman, Jennifer. "Matthew Ritchie." *Bomb*, Spring 1997, pp. 60–65
Cotter, Holland. Review. *New York Times*, November 15, 1996, p. C21
———. Review. *New York Times*, November 24, 2000, p. E36
Cream. London: Phaidon, 1998
Danto, Arthur C. "The 1997 Whitney Biennal." *Nation*, 1997,
 pp. 30–34
Ellis, Patricia. "Matthew Ritchie: That Sweet Voodoo You Do."
 Flash Art, November/December 2000, pp. 88–91
Galison, Peter, and Caroline Jones. "Theories and the Dead."
 Parkett no. 61 (2001): 148–53

Kastner, Jeffrey. "The Weather of Chance: Matthew Ritchie and the Butterfly Effect." *Art/Text*, May–July 1998, pp. 54–59

Marcus, Ben. "The Last You Need to Know about Radio." *Parkett* no. 61 (2001): 162–69

Phillips, Lisa, and Louise Neri. *1997 Whitney Biennial*. Exh. cat. New York: Whitney Museum of American Art, 1997

Princenthal, Nancy. "The Laws of Pandemonium." *Art in America*, May 2001, pp. 144–49

Rabinowitz, Cay Sophie. "Not Two, Not Three, Not Even Four Dimensions." *Parkett* no. 61 (2001): 138–41

Relyea, Lane. "Virtually Formal." *Artforum* 37, no. 1 (September 1998): 126–33, 173

Ritchie, Matthew. "Love, Sweat, and Tears." *Flash Art*, November/December 1998, pp. 78–80

———. "The New City." *Art/Text* no. 65 (May–July 1999): 74–79

Saltz, Jerry. "Out There." *Village Voice*, November 28, 2000, p. 79

Schaffner, Ingrid. Review. *Artforum*. March 1997, p. 93

Searle, Adrian. "Nowhere to Run." *Frieze* no. 34 (May 1997): 42–47

Smith, Roberta. Review. *New York Times*, March 10, 1995, p. C20

Ugo Rondinone

Born 1963 in Brunnen, Switzerland. Lives and works in New York

Solo Exhibitions

1989 Galerie Pinx, Oskar Schmidt, Vienna
1991 Galerie Martina Detterer, Frankfurt am Main
Galerie Pinx, Oskar Schmidt, Vienna
Galerie Walcheturm, Zurich
1992 Galerie Walcheturm, Zurich
1994 Centre d'Art Contemporain Martigny
Galerie Daniel Buchholz, Cologne
Galerie Six Friedrich, Munich
1995 ARC/Musée d'Art Moderne de la Ville de Paris. *Migrateurs*
Galerie Walcheturm, Zurich
1996 Le Case d'arte, Milan
Centre d'Art Contemporain, Geneva. *Heyday*
Museum für Gegenwartskunst, Zurich. *Dog Days Are Over*
1997 Le Consortium, Dijon. *Where Do We Go from Here*
Galleria Raucci/Santa Maria, Naples. *Still Smoking*
1998 Galerie João Graça, Lisbon. *In the Sweet Years Remaining*
Galerie Schipper & Krome, Berlin
Galerie Six Friedrich, Munich
Krobath & Wimmer, Vienna. *So Much Water, So Close to Home*. Traveled: P.S.1 Contemporary Art Center, Long Island City, New York
1999 Galerie für zeitgenössische Kunst, Leipzig. *Guided by Voices*. Traveled: Kunsthaus, Glarus
Hauser & Wirth & Presenhuber, Zurich. *Moonlighting*
2000 Galleria Raucci/Santa Maria, Naples. *A Doubleday and a Pastime*
Matthew Marks Gallery, New York. *Love Invents Us*
Sadie Coles HQ, London. *Hell Yes!*
2001 Galerie Schipper & Krome, Berlin. *Slow Graffitti*
Palazzo delle Esposizioni, Rome. *Kiss Tomorrow Goodbye*
2002 Krobath & Wimmer, Vienna
Kunsthalle Wien, Vienna
Matthew Marks Gallery, New York. *A Horse with No Name*
Sadie Coles HQ, London

Group Exhibitions

1992 Centre Culturel Suisse, Paris. *Oh! Cet écho!*
Frankfurter Kunstverein, Frankfurt am Main. *Die Sprache der Kunst*
1993 Shedhalle, Zurich. *Changing I*
1994 Kunsthaus Zürich. *Endstation Sehnsucht*
1996 São Paulo Bienal. *Where Do We Go from Here?*
1997 Le Magasin, Grenoble. *Dramatically Different*
Swiss Institute, New York. *Disaster and Recovery*
1998 Centre d'Art Contemporain, Geneva. *Aids Worlds*
Stedelijk Museum, Amsterdam. *From the Corner of the Eye*
1999 Istanbul Biennial. *The Passion and the Wave*
Melbourne Biennial. *Signs of Life*
MUHKA, Antwerp. *Trouble Spot: Painting*

2000 capc Musée d'art contemporain, Bordeaux. *Présumé innocent*
Kiasma Museum of Contemporary Art, Helsinki. *Under the Same Sky*
Neues Kunstmuseum Luzern, Lucerne. *Landschaftsräume*
P.S.1 Contemporary Art Center, Long Island City, New York. *Volume: Bed of Sound*
Stedelijk Museum voor Actuele Kunst, Gent. *Over the Edge*
2001 Irish Museum of Modern Art, Dublin
Museo de Arte Moderno, Buenos Aires. *Mouvements immobiles*

Bibliography

Belmont, Geraldine. Review. *Flash Art*, January/February 2000, pp. 122–23

Bonami, Francesco. "Ugo Rondinone: 'Grounding.'" *Parkett* no. 52 (1998): 104–15

Bovier, Lionel. "Ugo Rondinone...Doesn't Live Here Anymore." *Flash Art* no. 193 (March/April 1997): 106–7

Codognato, Mario. Review. *Artforum* 36, no. 10 (Summer 1998): 140–41

Ellis, Patricia. "Ugo Rondinone." *InterVista*, January/February 2000, pp. 6–7

Hofleitner, Johanna. Review. *Art & Text* no. 53 (January 1996): 85

Hoptman, Laura. "Against Nature." *Parkett* no. 52 (1998): 132–43

Janus, Elizabeth. Review. *Artforum* 37, no. 3 (November 1998): 102–3

Johnson, Ken. Review. *New York Times*, April 5, 2002

Lewisohn, Cedar. "Trans-Europe Express." *Flash Art*, January/February 2000, p. 47

Reust, Hans Rudolf. Review. *Artforum* 34, no. 2 (October 1995): 109–10

Schenker, Christoph. Review. *Flash Art* no. 168 (January/February 1993): 100

Schwabsky, Barry. Review. *Artforum*, Summer 2000, p. 183

Smith, Roberta. Review. *New York Times*, March 31, 2000, p. 35

Troncy, Eric. "Ugo Rondinone: Where Do We Go, Ugo?" *Artpress* no. 227 (September 1997): 32–37

Verwoert, Jan. "Pictures Came and Broke My Heart." *Parkett* no. 52 (1998): 116–31

Shahzia Sikander

Born 1969 in Lahore, Pakistan. Lives and works in New York

Solo Exhibitions

1996 Project Row Houses, Houston. *Knock Knock Who's There? Mithilia, Mithilia Who?*
1997 Deitch Projects, New York. *Miniatures and Murals*
The Renaissance Society at the University of Chicago
1999 Hirshhorn Museum and Sculpture Garden, Washington, D.C.
Kemper Museum of Contemporary Art, Kansas City, Mo.
Whitney Museum of American Art at Philip Morris, New York. *Acts of Balance*
2001 ArtPace, San Antonio. *Intimacy*

Group Exhibitions

1994 Pacific Asia Museum, Pasadena. *A Selection of Contemporary Paintings from Pakistan*
1997 Queens Museum of Art, Flushing, New York. *Out of India: Contemporary Art of the South Asian Diaspora*
Whitney Museum of American Art, New York. Whitney Biennial
Yerba Buena Center for the Arts, San Francisco. *Three Great Walls*
1998 The Aldrich Museum of Contemporary Art, Ridgefield, Conn. *Pop Surrealism*
Center for Curatorial Studies, Bard College, Annandale-on-Hudson, N.Y. *Liberating Tradition*
1999 Asia-Pacific Triennial of Contemporary Art, Brisbane
Museo de la Ciudad de Mexico, Mexico City. *Cinco continentes y una ciudad*
Museum Ludwig, Cologne. *Kunstwelten im Dialog*
Whitney Museum of American Art, New York. *The American Century: Art & Culture, 1900–2000*, part 2

2000 P.S.1 Contemporary Art Center, Long Island City, New York. *Greater New York*
2001 ArtPace, San Antonio
Asia Society, New York. *Conversations with Tradition: Nilima Sheikh and Shahzia Sikander*
2002 Musée d'Art Moderne de la Ville de Paris. *Urgent Painting*

Bibliography

Baker, Kenneth. "Uprooted." *San Francisco Chronicle*, May 22, 1997
Bhabha, Homi. "Chillava Klatch: Shahzia Sikander interviewed by Homi Bhabha." In *Shahzia Sikander*. Exh. cat. Chicago: The Renaissance Society at the University of Chicago, 1998
——. "Miniaturizing Modernity." *Public Culture* 2, no. 1 (Winter 1999)
——. *Shahzia Sikander, a Happy Dislocation*. Ed. Elaine Kim. Exh. cat. Austin: Blanton Museum of Art, University of Texas at Austin, 1999
Cotter, Holland. Review. *New York Times*, June 9, 2000
Devji, Faisal. "Translated Pleasures." In *Shahzia Sikander*. Exh. cat. Chicago: The Renaissance Society at the University of Chicago, 1998
Farver, Jane. *Out of India: Contemporary Art of the South Asian Diaspora*. Exh. cat. Queens, N.Y.: Queens Museum of Art, 1997
Fletcher, Valerie. *Shahzia Sikander*. Exh. cat. Washington, D.C.: Hirshhorn Museum and Sculpture Garden, Smithsonian Institution, 1999
Friis-Hansen, Dana. "Full Blown." *Art Asia Pacific* no. 16 (1997): 44–49
Haider, Masood. "Sikander's Art Defines East-West Divide." *Dawn* (Pakistan), December 10, 1997, p. 11
Jana, Reena. "Cultural Weaving." *Asian Art News*, March/April 1997
Johnston, Patricia. "Studio. Shahzia Sikander: Reinventing the Miniature." *Artnews* 97, no. 2 (February 1998): 86–88
Klein, Richard, and Harry Philbrick. *Pop Surrealism*. Exh. cat. Ridgefield, Conn.: The Aldrich Museum of Contemporary Art, 1998
Phillips, Lisa, and Louise Neri. *1997 Whitney Biennial*. Exh. cat. New York: Whitney Museum of American Art, 1997
Sand, J. Olivia. "Interview." *Asian Art*, January 2002
Scheps, Marc, et al. *Kunstwelten im Dialog*. Exh. cat. Cologne: Museum Ludwig, 1999
Schwabsky, Barry. "A Painter of Miniatures on a Maximum Scale." *New York Times*, May 14, 2000
Sirhandi, Marcella. *A Selection of Contemporary Paintings from Pakistan*. Exh. cat. Pasadena: Pacific Asia Museum, 1994
"Today's Artist: Shahzia Sikander interviewed by Max Henry." *Art Newspaper*, June/July 2000

David Thorpe

Born 1972 in London, England. Lives and works in London

Solo Exhibitions

1999 Maureen Paley/Interim Art, London
2000 Maureen Paley/Interim Art, London

Group Exhibitions

1997 Grazer Kunstverein, Graz. *Need for Speed*
1998 Chisenhale Gallery, London. *Post Neo-Amateurism*
De Praktijk, Amsterdam. *Ruislip*
Institute of Contemporary Arts, London. *Die Young Stay Pretty*
Morrison Judd Gallery, London. *Cluster Bomb*
Stephen Friedman Gallery, London. *Sociable Realism*
2000 Cornerhouse, Manchester. *Future Perfect: Art on How Architecture Imagined the Future*. Traveled: Centre for Visual Arts, Cardiff
Stedelijk Van Abbemuseum, Eindhoven. *Twisted: Urban and Visionary Landscapes in Contemporary Painting*
2001 One in the Other, London. *Sages, Scientists and Madmen*
2002 Bart Wells Institute, London. *The Necessary Enemy*

Bibliography

Beard, Alan. "The Lookout." *Frieze* no. 47 (July/August 1999)
Beech, Dave. "Sociable Realism." *Art Monthly* no. 214 (March 1998)
Chung, Karen. "Cut-and-Paste Poet." *Wallpaper** 36 (March 2001)
Collings, Matthew. "Being Entertained." *Modern Painters*, December 1998
Garnett, Robert. "Die Young Stay Pretty." *Art Monthly* no. 222 (1998): 98–99
Gellatly, Andrew. Review. *Frieze* no. 52 (May 2000)
Grant, Simon. "Housing Estate Art." *Guardian*, December 11–17, 1999
Guldemond, Jaap, ed. *Twisted: Urban and Visionary Landscapes in Contemporary Painting*. Exh. cat. Eindhoven: Stedelijk Van Abbemuseum, and Rotterdam: NAI, 2000
Herbert, Martin. Review. *Time Out London*, January 12–19, 2000
Judd, Ben. "The Lie of the Land." *Flash Art* 32, no. 205 (March/April 1999)
McLaren, Duncan. "David Thorpe." *Independent on Sunday*, December 12, 1999
Prince, Nigel. "Future Perfect." *Untitled* no. 23 (2000)
Searle, Adrian. "Dumb and Dumber." *Guardian*, December 1, 1998
von Planta, Regina. "Profile: Paper Moon." *Art Monthly* no. 233 (February 2000)
——. Review. *Kunst-Bulletin* no. 12 (December 1999)

Kara Walker

Born 1969 in Stockton, California. Lives and works in New York

Solo Exhibitions

1995 Center for Curatorial Studies, Bard College, Annandale-on-Hudson, N.Y. *Look Away! Look Away! Look Away!*
Nexus Contemporary Art Center, Atlanta. *The Battle of Atlanta: Being the Narrative of a Negress in the Flames of Desire—A Reconstruction*
Wooster Gardens, New York. *The High and Soft Laughter of the Nigger Wenches at Night*
1996 Bernard Toale Gallery, Boston. *Ol' Marster Paintin's and Silhouette Cuttings*
Wooster Gardens, New York. *From the Bowels to the Bosom*
1997 Huntington Beach Arts Center. *Kara Walker*
The Renaissance Society at the University of Chicago. *Presenting Negro Scenes Drawn upon My Passage through the South and Reconfigured for the Benefit of Enlightened Audiences Wherever Such May Be Found, By Myself, Missus K.E.B. Walker, Colored*. Traveled: The Contemporary Arts Center, Cincinnati; Henry Art Gallery, University of Washington, Seattle; et al.
San Francisco Museum of Modern Art. *Upon My Many Masters—An Outline*
1998 Wooster Gardens, New York
1999 Brent Sikkema, New York. *Another Fine Mess*
CCAC Institute, Oakland/San Francisco. *Kara Walker: No mere words can Adequately reflect the Remorse this Negress feels at having been Cast into such a lowly state by her former Masters and so it is with a Humble heart that she brings about their physical Ruin and earthly Demise*. Traveled: UCLA Hammer Museum, Los Angeles
Centre d'Art Contemporain, Geneva. *Why I Like White Boys, an Illustrated Novel by Kara E. Walker Negress*
2000 Des Moines Art Center
2001 Brent Sikkema Gallery, New York. *American Primitive*
2002 Hannover Kunstverein. *For the Benefit of All the Races of Mankind (Mos' Specially the Master One, Boss). An Exhibition of Artifacts, Remnants and Effluvia EXCAVATED from the Black Heart of a Negress*
Mannheimer Kunstverein, Mannheim. Traveled: Museum Weserburg, Bremen; Deutsche Guggenheim, Berlin; et al.
São Paulo Bienal. *Kara Walker: Slavery! Slavery!*

Group Exhibitions

1995 Musée d'Art Moderne de la Ville de Paris. *La Belle et la bête*
1996 The Institute of Contemporary Art, Boston. *New Histories*
1997 Walker Art Center, Minneapolis. *No Place (Like Home)*
Whitney Museum of American Art, New York. Whitney Biennial
1998 Hayward Gallery, London. *Secret Victorians: Contemporary Artists and a 19th-Century Vision*. Traveled: The Minories, Colchester; Arnolfini, Bristol; et al.

1999 Carnegie Museum of Art, Pittsburgh. *Carnegie International 1999/2000*
Contemporary Arts Museum, Houston. *Other Narratives*
Istanbul Biennial. *The Passion and the Wave*
Museum Ludwig, Cologne. *Kunstwelten im Dialog*
2000 Historisches Museum, Frankfurt am Main. *Das Gedächtnis der Kunst*
Museum of Contemporary Art, Chicago. *Age of Influence: Reflections in the Mirror of American Culture*
2001 Barbican Gallery, London. *The Americans: New Art*
Castello di Rivoli, Turin. *Form Follows Fiction*
Kunstbau Lenbachhaus, Munich. *Schatten Risse, Silhouetten und Cutouts*
The Museum of Modern Art, New York. *Collaborations with Parkett: 1984 to Now*
The Museum of Modern Art, New York. *New to the Modern: Recent Acquisitions*

Bibliography

Ackermann, Marion, and Helmut Friedel, eds. *Schatten Risse, Silhouetten und Cutouts.* Exh. cat. Munich: Kunstbau Lenbachhaus, 2001
Alberro, Alexander, and Gary Garrels. *Kara Walker: Upon My Many Masters—An Outline.* Exh. cat. San Francisco: San Francisco Museum of Modern Art, 1997
Armstrong, Elizabeth, Deepali Dewan, et al. *No Place (Like Home).* Exh. cat. Minneapolis: Walker Art Center, 1997
Camhi, Leslie. "Cutting Up." *Village Voice*, April 9, 1996
Cotter, Holland. Review. *New York Times*, March 3, 1995
———. Review. *New York Times*, November 20, 1998
Dalton, Karen C. C., Michael D. Harris, and Lowery Sims. "The Past Is Prologue but Are Parody and Pastiche Progress?" *International Review of African American Art* 14, no. 3 (1997)
Dubois Shaw, Gwendolyn. "Final Cut." *Parkett* no. 60 (2000): 129–33
Feldman, Melissa E., and Ingrid Schaffner. *Secret Victorians: Contemporary Artists and a 19th-Century Vision.* Exh. cat. London: Hayward Gallery, 1998
Frankel, David. Review. *Artforum*, April 1999, p. 122
Golden, Thelma. "Oral Mores: A Postbellum Shadow Play." *Artforum*, September 1996
Grynsztejn, Madeleine, ed. *Carnegie International 1999/2000.* Exh. cat. Pittsburgh: Carnegie Museum of Art, 1999
Hannaham, James. "Pea, Ball, Bounce: Interview with Kara Walker." *Interview*, November 1998
———. "The Shadow Knows: A Hysterical Tragedy of One Young Negress and Her Art." *In New Histories.* Exh. cat. Boston: The Institute of Contemporary Art, 1996
Janus, Elizabeth. "As American as Apple Pie." *Parkett* no. 60 (2000): 130–41
Jenkins, Sydney O. *This Is Not the Place.* Exh. cat. Mahwah: Ramapo College of New Jersey, 2000
Jones, Ronald. "Crimson Herring." *Artforum*, Summer 1998
Phillips, Lisa, and Louise Neri. *1997 Whitney Biennial.* Exh. cat. New York: Whitney Museum of American Art, 1997
Princenthal, Nancy. Review. *Art in America*, February 1999
Saltz, Jerry. "Making the Cut." *Village Voice*, November 24, 1998
Smith, Roberta. Review. *New York Times*, May 5, 1995
Szabo, Julia. "Kara Walker's Shock Art." *New York Times Magazine*, March 23, 1997
Tate, Greg. "In Praise of Shadow Boxers: The Crisis of Originality and Authority in African-American Visual Art vs. the Wu-Tang Clan." In *Other Narratives.* Exh. cat. Houston: Contemporary Arts Museum, 1999, pp. 39–44
Walker, Hamza. "Kara Walker: Cut It Out." *Nka: Journal of Contemporary African Art* no. 11–12 (Fall/Winter 2000)
———. "Nigger Lover or Will There Be Any Black People in Utopia?" *Parkett* no. 60 (2000): 152–60
Walker, Kara. *Freedom, A Fable. A Curious Interpretation of the Wit of a Negress in Troubled Times.* Santa Monica: Peter Norton Family Foundation, 1997
Wasserman, Tina. *Kara Walker.* Exh. cat., with design and text by the artist. Chicago: The Renaissance Society at the University of Chicago, 1997

Richard Wright

Born 1960 in Glasgow, Scotland. Lives and works in Glasgow

Solo Exhibitions
1999 BQ, Cologne
2000 BQ, Cologne
2001 Kunsthalle Bern
Tate Liverpool
2002 Kunstverein Düsseldorf

Group Exhibitions
1994 CCA, Glasgow. *New Art in Scotland.* Traveled: Aberdeen Art Gallery
1995 The Art Gallery of Ontario, Toronto. *30 Seconds plus Title*
1996 Ikon Gallery, Birmingham. *Loaded: A Contemporary View of British Painting*
Musée d'Art Moderne de la Ville de Paris. *Life/Live.* Traveled: Centro Cultural de Belem, Lisbon
Museum of Modern Art, Oxford. *About Vision: New British Painting in the 1990s.* Traveled: Christchurch Mansion, Ipswich; Fruitmarket Gallery, Edinburgh; et al.
1997 Hayward Gallery, London. *Material Culture: The Object in British Art of the '80s and '90s*
Museum of Contemporary Art, Sydney. *Pictura Britannica.* Traveled: South Australian Museum, Adelaide; Contemporary Art Museum, Wellington
1998 Institute of Contemporary Arts, London. *Surfacing: Contemporary Drawing*
Museet for Samtidskunst, Oslo. *Netwerk Scotland*
1999 Centre Cultural Tecla Sala, Barcelona. *De coraz(i)on*
Forde Espace d'Art Contemporain, Geneva. *A Radiant Future*
2000 Edinburgh. *The British Art Show 5.* Traveled: Southampton, Cardiff, et al.
Gagosian Gallery, New York
Tate Britain, London. *Intelligence: New British Art*
2001 Dundee Contemporary Arts, Dundee. *Here and Now*
Walker Art Center, Minneapolis. *Painting at the Edge of the World*

Bibliography

About Vision: New British Painting of the 1990's. Oxford, U.K.: Museum of Modern Art, 1996
Bumpus, Judith, Tony Godfrey, et al. *The British Art Show 5.* Exh. cat. London: Hayward Gallery, 2000
Button, Virginia, and Charles Esche. *Intelligence: New British Art 2000.* Exh. cat. London: Tate Publishing, 2000
Dalrymple, Clarissa. "Richard Wright." *Artforum* 39, no. 5 (January 2001): 118
De coraz(i)on. Exh. cat. Barcelona: Centre Cultural Tecla Sala, 1999
Farquharson, Alex. *Frieze*, April 2001, pp. 80–83
Lawson, Thomas. *Richard Wright.* Newcastle-upon-Tyne: Locus+, and Milton Keynes: Milton Keynes Gallery, 2000
Life/Live. Exh. cat. Paris: Musée d'Art Moderne de la Ville de Paris, 1996
Material Culture: The Object in British Art of the '80s and '90s. London: Exh. cat. Hayward Gallery, 1997
Netwerk Scotland. Exh. cat. Oslo: Museum for Samtidskunst, 1998
Pictura Britannica. Sydney: Museum of Contemporary Art, 1997
Pure Fantasy. Llandudno: Oriel Mostyn, 1997
Richard Wright. Cologne: BQ, 1999
Wakefield, Neville. "Richard Wright: The Painting Is on the Wall." *Elle Décor*, April 2001, pp. 98–102

index of illustrations

photograph
credits

Plate 1: courtesy the artist. © Jennifer Pastor

Plates 2–9: courtesy Richard Telles Fine Art. © Jennifer Pastor

Plates 10, 11: Thomas Griesel, The Museum of Modern Art, New York. © Russell Crotty

Plates 12–14: courtesy Matthew Marks Gallery, New York

Plate 15: courtesy Sadie Coles HQ, London. © Laura Owens

Plates 16–21: courtesy Gavin Brown's enterprise, New York

Plates 22, 23: John Wronn, The Museum of Modern Art, New York. Courtesy Gavin Brown's enterprise, New York

Plates 24, 25: Robert McKeever. Courtesy Gagosian Gallery, New York

Plate 26: Heidi Kosaniuk. Courtesy Modern Institute, Glasgow, and Gagosian Gallery, New York

Plate 27: Cathy Carver. Courtesy Modern Institute, Glasgow, and Gagosian Gallery, New York

Plates 28–31: Brian Forrest. Courtesy Angles Gallery, Santa Monica

Plates 32–33: courtesy Toba Khedoori, Regen Projects, Los Angeles, and David Zwirner, New York

Plates 34–38: courtesy The Project, New York

Plate 39: Thomas Griesel, The Museum of Modern Art, New York. © Los Carpinteros

Plate 40: Thomas Griesel, The Museum of Modern Art, New York. Courtesy Los Carpinteros and Grant Selwyn Fine Art, Los Angeles

Plates 41–43: courtesy Maureen Paley Interim Art, London

Plates 44–48: courtesy Galerie EIGEN + ART, Leipzig and Berlin

Plates 49–53: courtesy Maureen Paley Interim Art, London

Plates 54–68: courtesy neugerriemschneider, Berlin

Plates 69–72: The Over Holland Collection. © Zeno X Gallery, Antwerp

Plates 73–79: © Matthew Ritchie

Plate 80: John Wronn, The Museum of Modern Art, New York. © Matthew Ritchie

Plates 81–96: courtesy Galerie NEU, Berlin

Plates 97–105: courtesy Brent Sikkema, New York

Plate 106: Susan and Lewis Manilow. Courtesy Brent Sikkema, New York

Plate 107: courtesy Shahzia Sikander and Brent Sikkema, New York

Plates 108–10: courtesy Galleri Magnus Karlsson, Stockholm

Plates 111, 112: courtesy Jockum Nordström, Galleri Magnus Karlsson, Stockholm, and David Zwirner, New York

Plates 113, 114: © Barry McGee

Plates 115, 116: Roberto Marossi. Courtesy Fondazione Prada, Milan. © Barry McGee

Plate 117: Joshua White. Courtesy Blum & Poe, Santa Monica. © Yoshitomo Nara, all rights reserved

Plates 118, 119: Thomas Griesel, The Museum of Modern Art, New York. © Yoshitomo Nara, all rights reserved

Plates 120, 121: Joshua White. Courtesy Blum & Poe, Santa Monica. © Yoshitomo Nara, all rights reserved

Plates 122, 123: Joshua White. Courtesy Blum & Poe, Santa Monica. © Takashi Murakami, all rights reserved

Plates 124–27: courtesy Tomio Koyama, Tokyo. © Takashi Murakami, all rights reserved

Plates 128–32: courtesy Gavin Brown's enterprise, New York

Plates 133–34: Thomas Griesel, The Museum of Modern Art, New York. © Elizabeth Peyton

Plates 135–38: Andy Keate. Courtesy asprey jacques, London

Plate 139: Michael Bevilacqua. Courtesy Andrea Rosen Gallery, New York. © John Currin

Plates 140–44: Oren Slor. Courtesy Andrea Rosen Gallery, New York. © John Currin

Plate 145: Thomas Griesel, The Museum of Modern Art, New York. Courtesy Andrea Rosen Gallery, New York. © John Currin

Chapter 1, fig. 1: The Royal Collection © 2002, Her Majesty Queen Elizabeth II

Chapter 1, fig. 2: Kupferstichkabinett der Akademie der bildenden Künste, Vienna

Chapter 2, fig. 1: John Wronn, The Museum of Modern Art, New York

Chapter 4, fig. 1: © Institut Claude-Nicolas Ledoux

Chapter 6, fig. 1: Joachim Blauel—ARTOTHEK—Schack—Galerie

Chapter 7, fig. 1: John Wronn, The Museum of Modern Art, New York. © Raymond Pettibon

Chapter 7, fig. 2: courtesy the artist and Paul Morris Gallery, New York. © R. Crumb, 2002

Chapter 8, fig. 1: Museo de Arte de Ponce, The Luis A. Ferré Foundation, Inc., Ponce, Puerto Rico

Chapter 8, figs. 2, 3: © The British Museum, London

Correction

In the exhibition, Paul Noble's *Nobsend* replaces the artist's *Nobslum*, listed in the Catalogue of the Exhibition, p. 172. The date, medium, dimensions, and collection information listed for *Nobslum* apply accurately to *Nobsend*.

lenders to the exhibition

Emmanuel Hoffman Foundation, Basel
MORA Foundation, London
The Museum of Modern Art, New York
New Museum of Contemporary Art, New York
The Whitney Museum of American Art, New York
Carnegie Museum of Art, Pittsburgh
San Francisco Museum of Modern Art
Magasin 3 Stockholm Konsthall
Kunstmuseum Wolfsburg

Matt Aberle, Los Angeles
Kevin Appel
Oliver Barker, London
Carel Balth
Chris Gorell Barnes, London
Michael Benevento
Barry Blumberg
Stafford Broumand
Daniel Buchholz and Christopher Mueller, Cologne
Brian D. Butler, Santa Monica
James Casebere
Arthur and Jeanne Cohen, Beverly Hills
Sadie Coles, London
Collection Dumont-Schutte
Collection Kaufmann, Berlin
Collection Schröder
Collection Weiler, Frankfurt am Main
Carol and M. George Craford
Russell Crotty
Jeffrey Deitch
Norman Dubrow
Yilmaz Dziewior
Stefan Edlis
Martin and Rebecca Eisenberg
Muffy and Xavier Flouret
Kenneth L. Freed, Boston
Anthony W. Ganz
Barbara Gladstone
Goetz Collection, Munich
Carol and Arthur Goldberg, New York
Karola Grässlin, Cologne
The Greenberg Rohatyn Collection
Alvin Hall, New York
Aliya Hasan, M.D.
The Marieluise Hessel Collection
Susan and Michael Hort
Mark Hubbard
Tony Just and Elizabeth Peyton
Salman Khokhar
Marvin and Alice Kosmin, New York
Christian Larsen
Alexander Lasarenko
Raymond Learsy and Melva Bucksbaum
Ninah and Michael Lynne
Marcia Goldenfeld Maiten and Barry Maiten, Los Angeles
Susan and Lewis Manilow
Tina Max
Julie Mehretu, New York
Warren and Victoria Miro
Nina and Frank Moore
Steven and Heather Mnuchin, New York
Takashi Murakami
Eileen and Peter Norton, Santa Monica
Markus Nöthen, Cologne
Susanne Nöthen, Cologne
Patricia and Morris Orden, New York
The Over Holland Collection
Michael and Judy Ovitz Collection
Meredith Palmer, New York
Tom Peters, Los Angeles
Elizabeth Peyton
Lois Plehn
Mima and Cesar Reyes, San Juan, Puerto Rico
A. G. Rosen

Rubell Family Collection
Sammlung Hauser und Wirth, St. Gall
Schimmel Collection
Schorr Family Collection
Samuel and Shanit Schwartz, Beverly Hills
Ann and Mel Schaffer Family Collection
Shahzia Sikander, New York
John A. Smith and Vicky Hughes, London
Laura Steinberg and B. Nadal-Ginard, Chestnut Hill, Massachusetts
Jennifer and David Stockman
David Teiger
Richard Telles and Robert Lade
Mario Testino
Dean Valentine and Amy Adelson, Los Angeles
Christophe Van de Weghe, New York
Ella Venet, New York
Joel Wachs
Dianne Wallace, New York
Mr. and Mrs. Jeffrey R. Winter
Candace A. Younger

Angles Gallery, Santa Monica
Gavin Brown's enterprise, New York
CRG Gallery, New York
Greene Naftali, New York
Marc Jancou Fine Art, New York
Maureen Paley Interim Art, London
Matthew Marks Gallery, New York
Mitchell-Innes & Nash, New York
Shoshana Wayne Gallery, Santa Monica
Brent Sikkema, New York
works on paper, inc., Los Angeles
Zeno X Gallery, Antwerp

Anonymous lenders

Sammlung Deutsche Bank, Frankfurt